W9-CPA-563

DRAWING *the* LIVING FIGURE

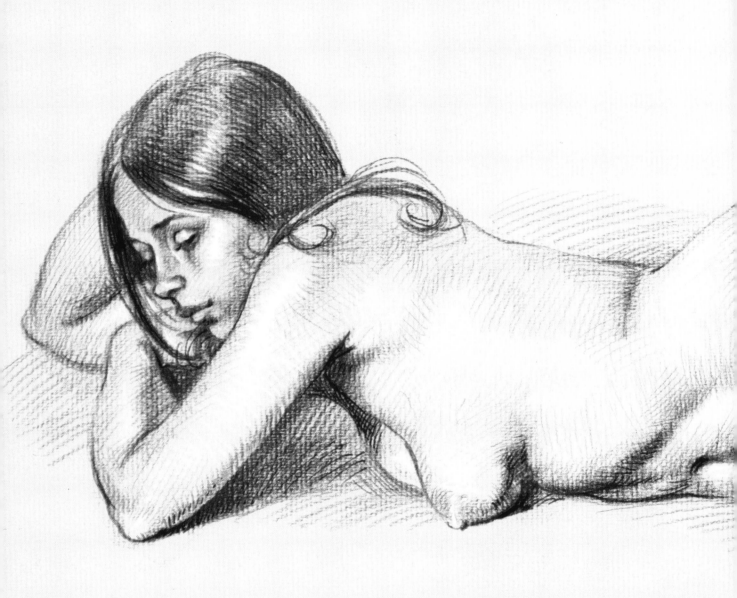

BY JOSEPH SHEPPARD

DRAWING
the LIVING
FIGURE

sheppud 83

WATSON-GUPTILL PUBLICATIONS/NEW YORK

Copyright © 1984 by Watson-Guptill Publications

First published 1984 in New York by Watson-Guptill Publications,
a division of Billboard Publications, Inc.,
1515 Broadway, New York, N.Y. 10036

Library of Congress Cataloging in Publication Data

Sheppard, Joseph, 1930-
 Drawing the living figure.

 Bibliography: p.
 Includes index.
 1. Human figure in art. 2. Drawing—Technique.
I. Title.
NC765.S436 1984 743′.4 84-5117
ISBN 0-8230-1386-3

All rights reserved. No part of this publication may be
reproduced or used in any form or by any means—graphic,
electronic, or mechanical, including photocopying, recording,
taping, or information storage and retrieval systems—without
written permission of the publisher.

Manufactured in U.S.A.

First Printing, 1984

1 2 3 4 5 6 7 8 9 / 89 88 87 86 85 84

Edited by Candace Raney
Designed by Bob Fillie
Graphic production by Hector Campbell
Text set in 9-point Trump Medieval

To my mother who taught me how to work.

CONTENTS

INTRODUCTION

Why another anatomy book?

Some time ago, I was talking about anatomy books with my long-time friend, Don Holden, who serves as Editorial Consultant to my publisher, Watson-Guptill. The conversation came around to *Anatomy: A Complete Guide for Artists*, which we'd planned together, and which I wrote for Watson-Guptill in 1975. Frankly, we were patting ourselves on the back about the unexpected popularity of the book, which was published at a time when there were so many other good anatomy books in print. And we were speculating about *why*.

I mentioned that many readers seemed to like one aspect of the book in particular: the sections on *surface anatomy* that follow the usual sections on bones and muscles. These were the sections that were drawn from live models, explaining how the underlying bones and muscles created the forms and the surface landmarks of the living figure.

Don had heard the same thing from other readers. He added: "So far as I know, all the classic books on artistic anatomy deal with bones and muscles—following the standard approach of peeling back the skin to show what's underneath—and do very little about the effect of the bones and muscles upon the surface forms of the live model. Richer's *Artistic Anatomy* has some sections on surface anatomy, of course, and Hale's two books of master drawings, *Drawing Lessons from the Great Masters* and *Anatomy Lessons from the Great Masters*, deal with surface anatomy in an informal way. These are all first-rate books. But I can't actually recall any book that deals *entirely* with surface anatomy in a systematic way."

And so it struck us both that there was a real need for a new kind of anatomy book, illustrated with drawings made from live models, and then supplemented with diagrams that explained how the surface forms were created by the bones and muscles beneath the skin. The book you're now reading is a result of that conversation.

As you'll see, the first chapter is a brief review of the anatomical basics. If you've never studied artistic anatomy before, I hope this will serve as a good, simple introduction to the subject. And if you *do* know something about artistic anatomy, I hope this chapter will serve as a rapid refresher course.

After this brief anatomical review, each chapter is devoted to a specific pose or action of the figure: standing, seated, crouching, twisting, and so on. Each chapter looks at male and female figures—as they take this pose—from various viewpoints. For example, the chapter on the standing figure shows male and female models in front, back, side, and three-quarter views. Most important of all, each pose or action is illustrated by a full page drawing of a live model whose surface forms are explained by adjacent diagrams of the bones and muscles that create the bumps and hollows of that particular body.

To make the facts as accessible as possible, I've simplified the anatomical content of the book in several ways.

First of all, you'll see that each life drawing—and its explanatory diagrams—focuses *only* on those bones and muscles that are shown with particular clarity in that pose. In the interest of readability, I don't try to label and diagram every single bone and muscle on every page, which would make that page look like one of those maps that's so covered with words that you can't find the land underneath! I proceed on the assumption that each drawing reveals certain important facts about surface anatomy—which you'll absorb gradually as you turn the pages of the book—and that all the essential information will be covered by the time you reach the last page.

I've also tried to simplify anatomical language wherever I can, cutting out (or at least cutting down) the traditional Latin terminology. For example, when I talk about the part of the bone that's closest to the center of the body, I simply call it the *head* of the bone. And the part that's most distant is called the *end* of the bone. In the same way, I stick to terms like *hipbone*, *heel bone*, and *kneecap* instead of the more traditional Latin nomenclature.

Whenever possible, I've grouped muscles that are normally seen as a single form. So, instead of identifying individual extensors, flexors, and adductors, I talk about the extensor group, the flexor group, and the adductor group.

It may also simplify things for you if I give you a few definitions before you start to read the book. There are ten words that you ought to know because they come up so often in the captions.

(1) An *abductor* is a muscle that pulls away from the midline of the body.

(2) An *adductor* is a muscle that pulls toward the midline of the body.

(3) A *condyle* is a large bump on a bone.

(4) A *crest* is a ridge on a bone, or perhaps a kind of border.

(5) An *extensor* is a muscle that causes some part of the body to straighten out.

(6) A *flexor* is a muscle that causes some part of the body to bend.

(7) A *protuberance* is a small bump on a bone.

(8) A *spine* is a sharp ridge of bone.

(9) A *supinator* is a muscle that turns the palm of the hand upward.

(10) A *tensor* is a muscle that performs a tightening function.

I might add that bones and muscles are often shown here in foreshortened positions that are frequently taken by the live model, but which rarely appear in anatomy books.

Let me conclude by emphasizing that there's no such thing as the *ultimate* book on artistic anatomy. If you're serious about drawing, painting, or sculpting the human figure, I don't think you can ever own *enough* books on the subject! Every good book on the subject has something special to contribute. (I've listed some of my favorites in the suggested reading list at the back of this book.) I hope that my new book will complement my own *Anatomy: A Complete Guide for Artists*—as well as the other anatomy books in your library—by deepening your understanding of the living figure who stands before you, waiting to be drawn.

REVIEW
of ANATOMY

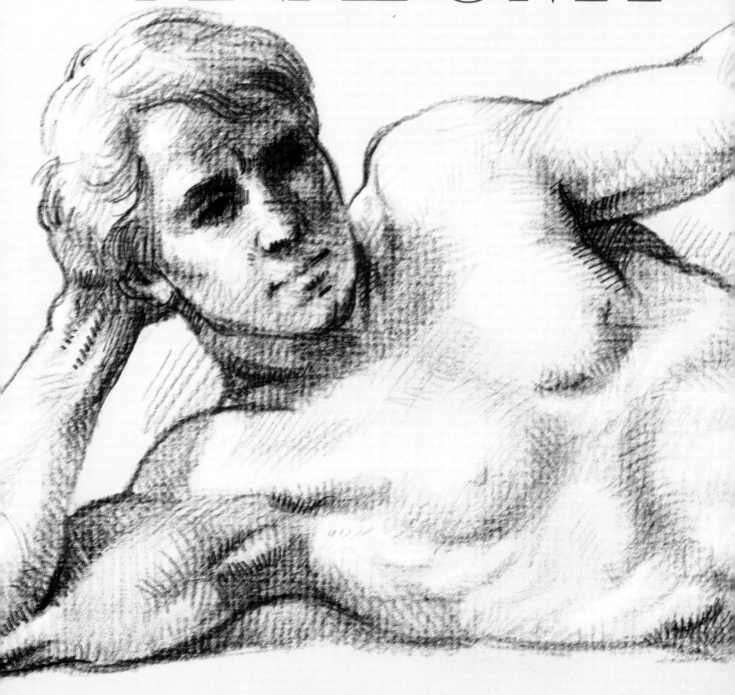

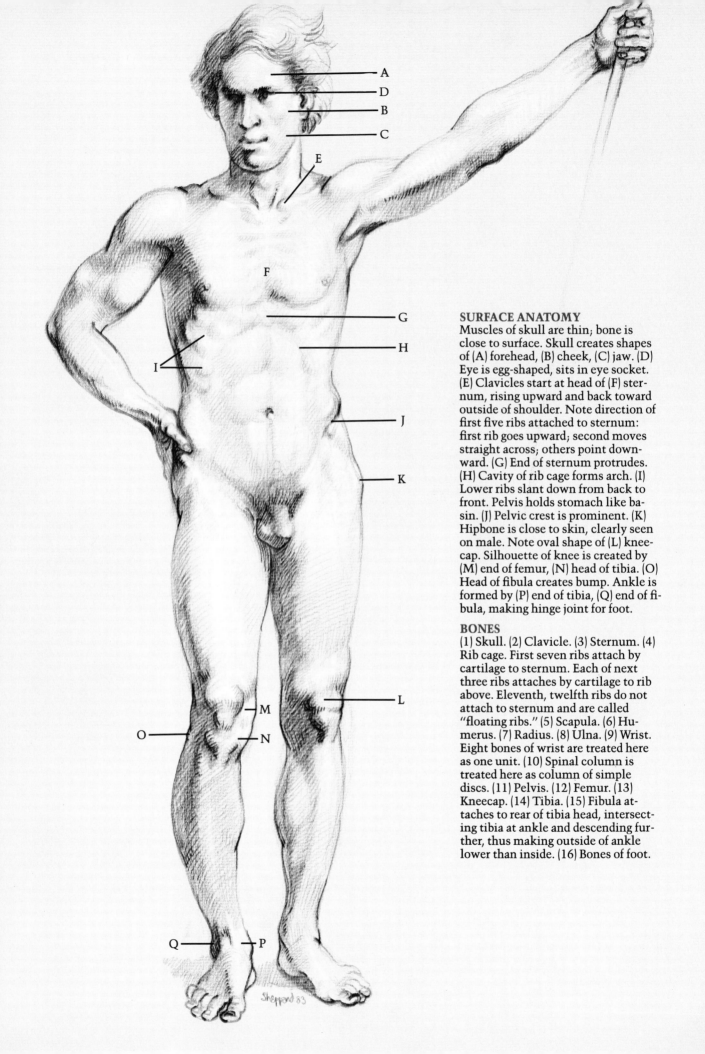

SURFACE ANATOMY
Muscles of skull are thin; bone is close to surface. Skull creates shapes of (A) forehead, (B) cheek, (C) jaw. (D) Eye is egg-shaped, sits in eye socket. (E) Clavicles start at head of (F) sternum, rising upward and back toward outside of shoulder. Note direction of first five ribs attached to sternum: first rib goes upward; second moves straight across; others point downward. (G) End of sternum protrudes. (H) Cavity of rib cage forms arch. (I) Lower ribs slant down from back to front. Pelvis holds stomach like basin. (J) Pelvic crest is prominent. (K) Hipbone is close to skin, clearly seen on male. Note oval shape of (L) kneecap. Silhouette of knee is created by (M) end of femur, (N) head of tibia. (O) Head of fibula creates bump. Ankle is formed by (P) end of tibia, (Q) end of fibula, making hinge joint for foot.

BONES
(1) Skull. (2) Clavicle. (3) Sternum. (4) Rib cage. First seven ribs attach by cartilage to sternum. Each of next three ribs attaches by cartilage to rib above. Eleventh, twelfth ribs do not attach to sternum and are called "floating ribs." (5) Scapula. (6) Humerus. (7) Radius. (8) Ulna. (9) Wrist. Eight bones of wrist are treated here as one unit. (10) Spinal column is treated here as column of simple discs. (11) Pelvis. (12) Femur. (13) Kneecap. (14) Tibia. (15) Fibula attaches to rear of tibia head, intersecting tibia at ankle and descending further, thus making outside of ankle lower than inside. (16) Bones of foot.

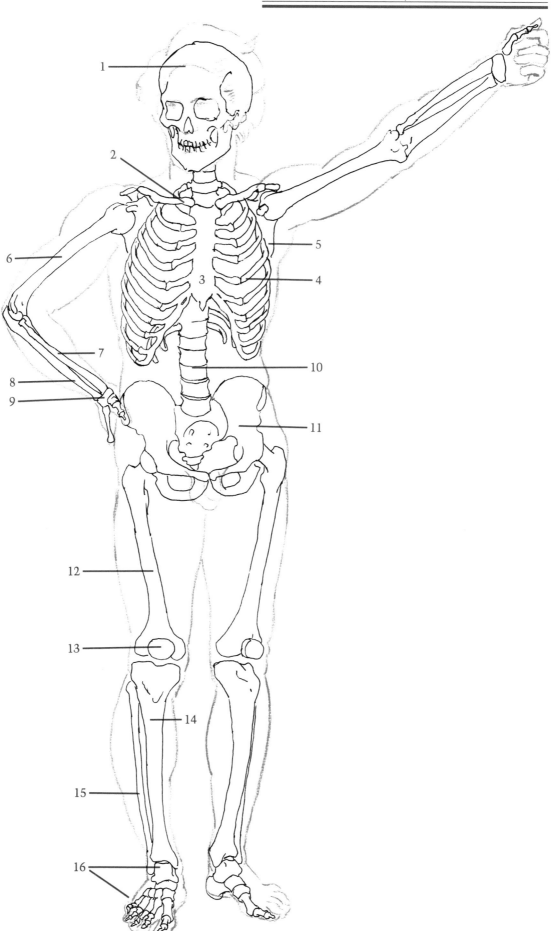

1

2

5

6

3

4

7

10

8

9

11

12

13

14

15

16

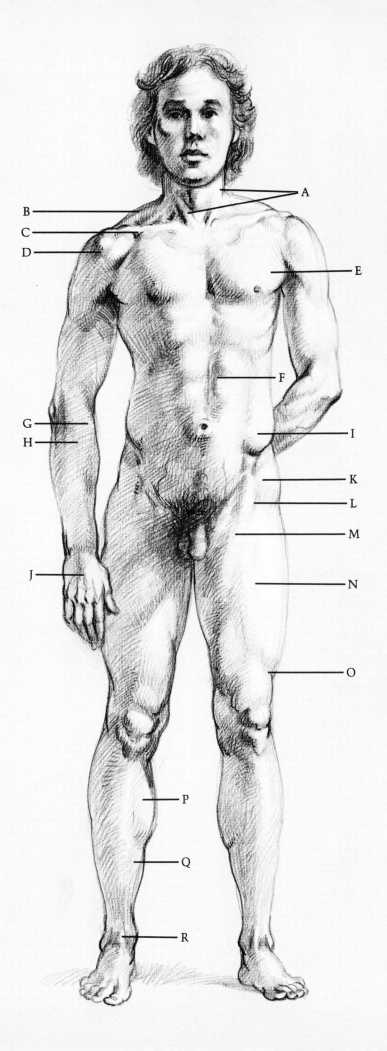

SURFACE ANATOMY

(A) Sternomastoid muscles create "V" shape. (B) Trapezius creates shoulder silhouette. (C) Pectoralis and deltoid meet to form cavity between them. (D) Note division of deltoid. (E) Pectoralis inserts into arm under deltoid. (F) Rectus abdominis is divided. (G) Long supinator and (H) wrist extensor both cross over from outside of elbow to thumb side of wrist. (I) External oblique inserts into top of pelvic crest. (J) Tendons of finger extensor are distinct. (K) Tensor fasciae latae angles toward outer contour. (L) See upside-down "V" where (M) sartorius and tensor fasciae latae overlap (N) rectus femoris. When knee is locked, (O) band of Richer pulls muscles in. (P) Gastrocnemius and (Q) soleus are calf muscles that attach in back of leg; they are seen from front. (R) Tendon of big toe extensor is prominent.

MUSCLES

(1) Stermomastoid. (2) Trapezius originates in back, inserts on top outside area of clavicle. (3) Pectoralis. (4) Deltoid. (5) Brachialis. (6) External head of triceps (one of three heads of triceps muscle). (7) Long supinator (turns forearm, palm out). (8, 9, 10) Extensors of wrist. (11) Abductor of thumb (pulls thumb toward back of hand). (12, 13) Extensors of thumb. (14) Extensor of fingers. (15) Biceps. (16) Rectus abdominis. (17) External oblique. (18) Tensor fasciae latae. (19) Sartorius. (20) Abductors. Several muscles are treated here as one unit. (21) Rectus femoris. (22) Vastus. Two parts are treated as one large muscle under rectus femoris. (23) Band of Richer changes shape of thigh when knee is locked. (Many bands that hold muscles in place are omitted). (24) Long peroneus. (25) Long extensor of toes. (26) Tibialis anterior. (27) Extensor of big toe. (28) Gastrocnemius. (29) Soleus. (30) Long flexor of toes. (31) Inside calf muscle mass is lower than outside mass.

1

2

3

4

5

6

15

16

7

17

8

9

18

10

19

12

14

20

13

21

22

23

28

31

24

25

26

29

27

30

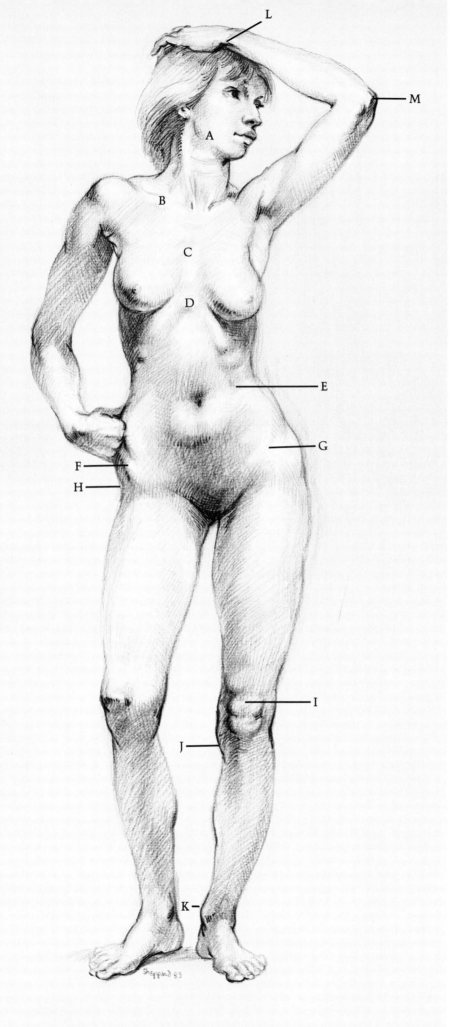

SURFACE ANATOMY

(A) Jawbone determines contour of face. (B) Note slant of clavicle. (C) Sternum shows rib attachments. (D) Cavity of ribcage is narrower on female than on male. (E) Lower ribs are evident. (F) Female pelvis is wider than male. (G) Crest of pelvis is partly covered by body fat. (H) Hipbone is close to skin, creating cavity on hip surface of females and fat males. (I) Kneecap and fat below form figure "8". (J) Shape of head of tibia slants inward. (K) Inside of ankle is always higher than outside. (L) End of ulna is prominent on little finger side of wrist. (M) Head of ulna forms elbow.

BONES

(1) Skull. (2) Clavicle. (3) Scapula. Clavicle and scapula form shoulder socket for humerus—a ball and socket joint. (4) Sternum. (5) Rib cage. (6) Humerus. (7) Radius is always on outside of elbow and thumb side of wrist. Radius head, at elbow, is small. End of radius, at wrist, is large. (8) Ulna is on inside of elbow. Head is large; end is small. (9) Wrist. (10) Bones of the palm. (11) Spinal column. (12) Pelvis. Female pelvis is usually wider than male with crests projecting farther forward. (13) Femur. (14) Kneecap. (15) Tibia. (16) Fibula. Inside of ankle is always higher than outside. (17) Bones of foot.

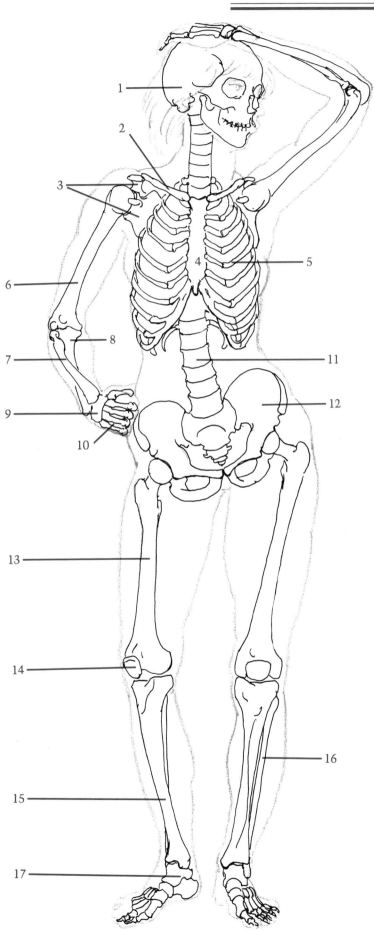

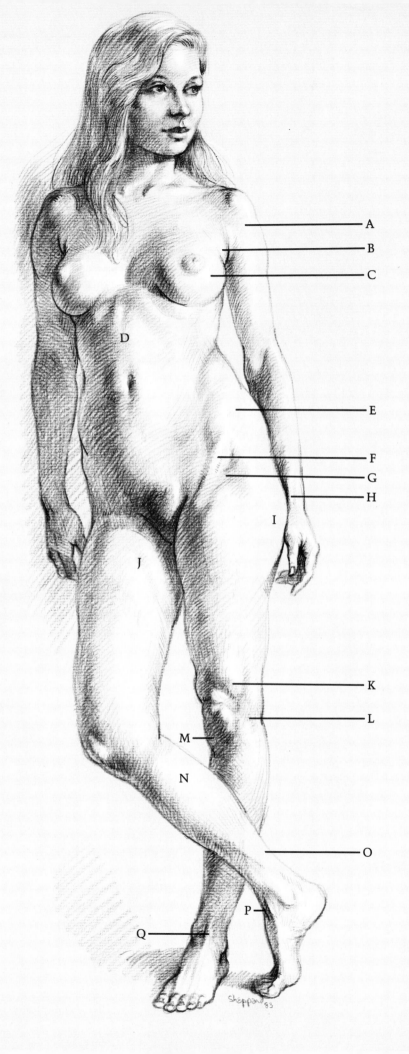

SURFACE ANATOMY

(A) Deltoid attaches to clavicle. (B) Pectoralis lies beneath (C) breast. (D) Vertical division of rectus abdominis is distinct—except on extremely fat figures. (E) External oblique and female body fat cover most of pelvic crest. (F) Sartorius helps to form (G) upside down "V" shaped cavity. (H) Tendon of thumb extensor makes sharp ridge. (I) Female body fat covers hipbone. (J) Indentation is formed by sartorius. (K) Outside of vastus is prominent when knee is locked. (L) Iliotibial band descends outside of thigh like stripe, attaches to outside of tibia head. (M) Small fat deposit appears under kneecap. (N) Calf muscles attach to heel bone by (O) Achilles tendon. (P) Tibialis anterior tendon makes bridge between ankle and foot. (Q) Tendon of toe extensor is prominent.

MUSCLES

(1) Sternomastoid. (2) Deltoid. (3) Pectoralis attaches along sternum and clavicle. (4) Biceps. (5) Brachialis. (6) Rectus abdominis. (7) External oblique. (8) Group of thumb muscles. Three muscles run obliquely across back of forearm into thumb. (9) Rectus femoris. (10) Vastus (inside part). (11) Tensor fasciae latae. (12) Gluteus. (13) Sartorius descends across front of thigh into inside head of tibia. (14) Vastus (outside part). (15) Iliotibial band. (16) Biceps femoris (biceps of leg). (17) Long extensor of toes. (18) Long peroneus. (19) Gastrocnemius. (20) Soleus. (21) Peroneus tertius. (22) Tibialis anterior. (23) Extensor of big toe.

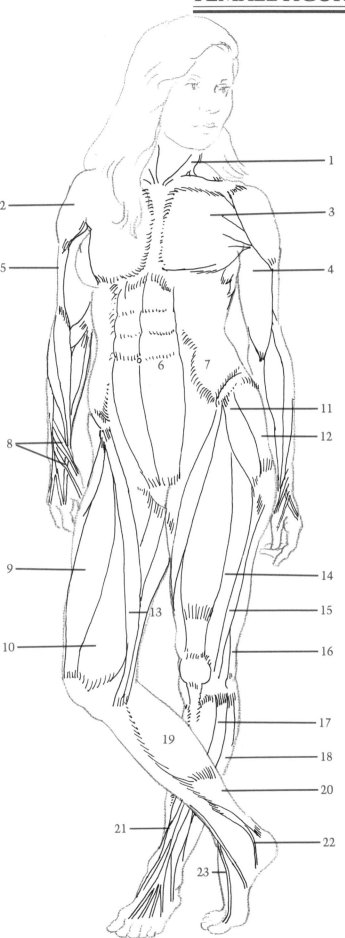

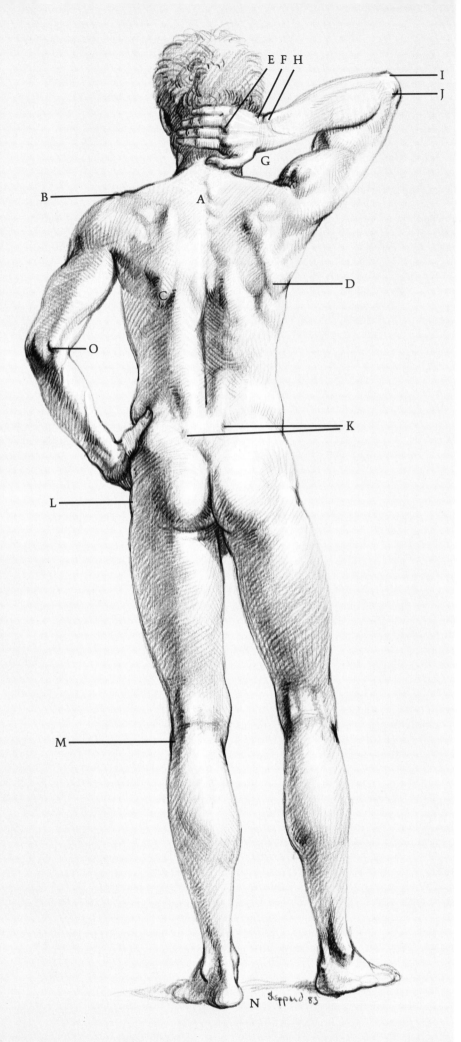

SURFACE ANATOMY

(A) First four vertebrae of ribcage are distinct. (B) Note slight "step down" where head of scapula joins end of clavicle. (C) Edge of scapula protrudes. (D) Lower end of scapula swings upward and outward when arm is raised. (E) Knuckles appear where palm bones join finger bones. (F) Wrist forms flat area between hand and forearm. (G) Radius is longer than (H) ulna at wrist. (I) Hook of ulna and (J) head of radius are prominent. (K) Dimples are caused by pelvic crests. (L) Hipbone is close to surface. (M) Head of fibula creates bump. (N) Heel is off-center—toward little-toe side. (O) Inside end of humerus is always prominent.

BONES

(1) Spinal column is made up of twenty-four vertebrae, divided into three groups: seven cervical vertebrae of neck support skull and are most flexible (partly covered here by hand); twelve dorsal vertebrae of rib cage; five lumbar vertebrae of lower back, which are largest. (2) Scapula. (3) Clavicle. (4) Humerus. Head of humerus is round like ball. (5) Ulna. (6) Radius. (7) Wrist. (8) Pelvis. Both sides of pelvis contain sockets to fit heads of femurs. These are ball-and-socket joints that enable femur to rotate freely in all directions. (9) Femur. Upper part of femur protrudes, forms hipbone, always appears next to skin. (10) Tibia. (11) Fibula. (12) Bones of foot. Movements of foot on ankle are more limited than those of hand on wrist. Major foot movement is hinge-like.

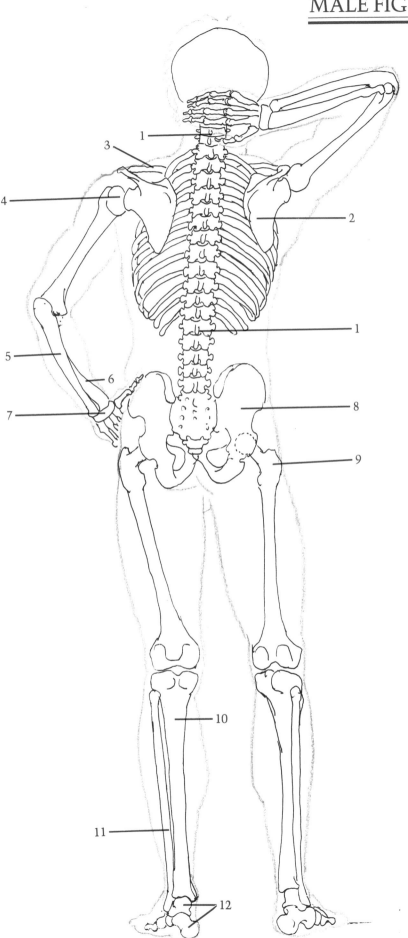

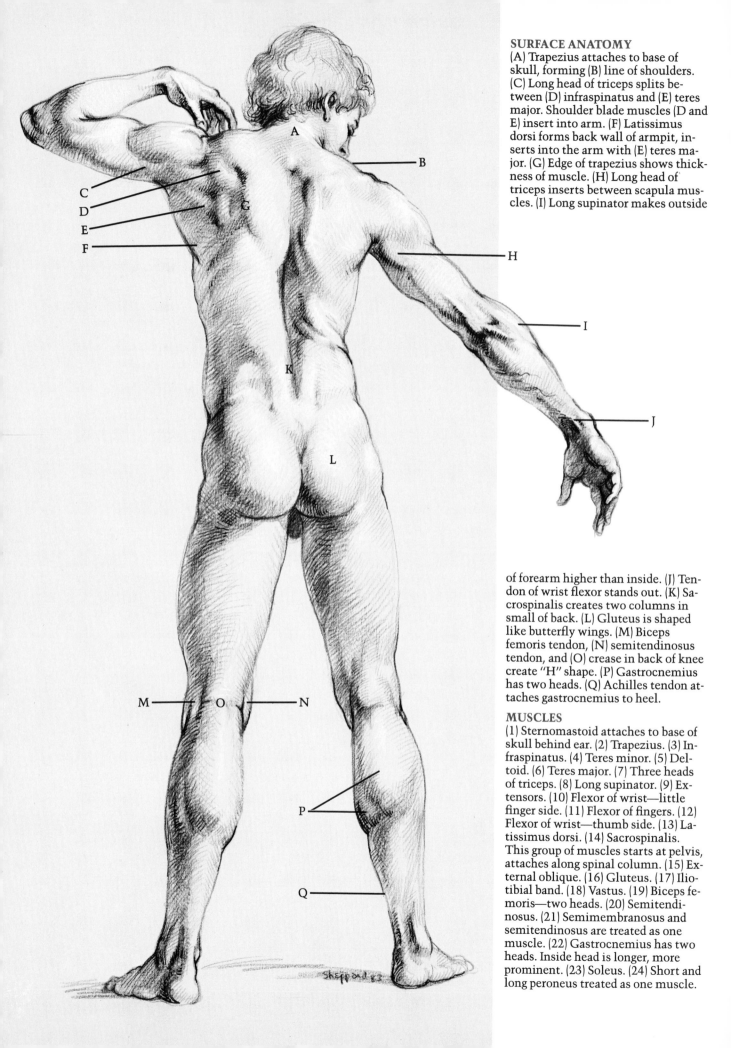

SURFACE ANATOMY
(A) Trapezius attaches to base of skull, forming (B) line of shoulders. (C) Long head of triceps splits between (D) infraspinatus and (E) teres major. Shoulder blade muscles (D and E) insert into arm. (F) Latissimus dorsi forms back wall of armpit, inserts into the arm with (E) teres major. (G) Edge of trapezius shows thickness of muscle. (H) Long head of triceps inserts between scapula muscles. (I) Long supinator makes outside

of forearm higher than inside. (J) Tendon of wrist flexor stands out. (K) Sacrospinalis creates two columns in small of back. (L) Gluteus is shaped like butterfly wings. (M) Biceps femoris tendon, (N) semitendinosus tendon, and (O) crease in back of knee create "H" shape. (P) Gastrocnemius has two heads. (Q) Achilles tendon attaches gastrocnemius to heel.

MUSCLES
(1) Sternomastoid attaches to base of skull behind ear. (2) Trapezius. (3) Infraspinatus. (4) Teres minor. (5) Deltoid. (6) Teres major. (7) Three heads of triceps. (8) Long supinator. (9) Extensors. (10) Flexor of wrist—little finger side. (11) Flexor of fingers. (12) Flexor of wrist—thumb side. (13) Latissimus dorsi. (14) Sacrospinalis. This group of muscles starts at pelvis, attaches along spinal column. (15) External oblique. (16) Gluteus. (17) Iliotibial band. (18) Vastus. (19) Biceps femoris—two heads. (20) Semitendinosus. (21) Semimembranosus and semitendinosus are treated as one muscle. (22) Gastrocnemius has two heads. Inside head is longer, more prominent. (23) Soleus. (24) Short and long peroneus treated as one muscle.

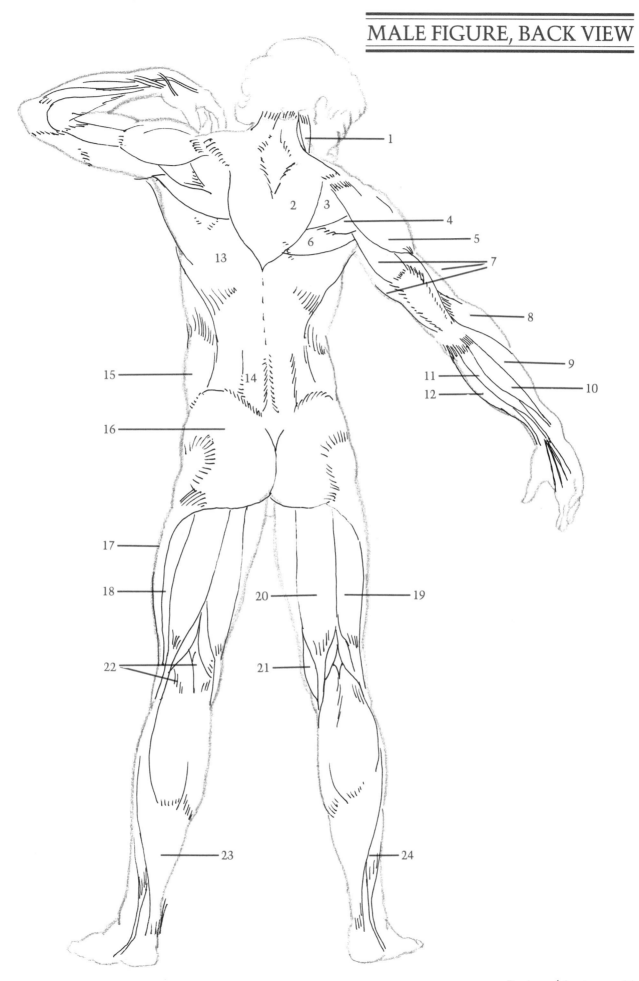

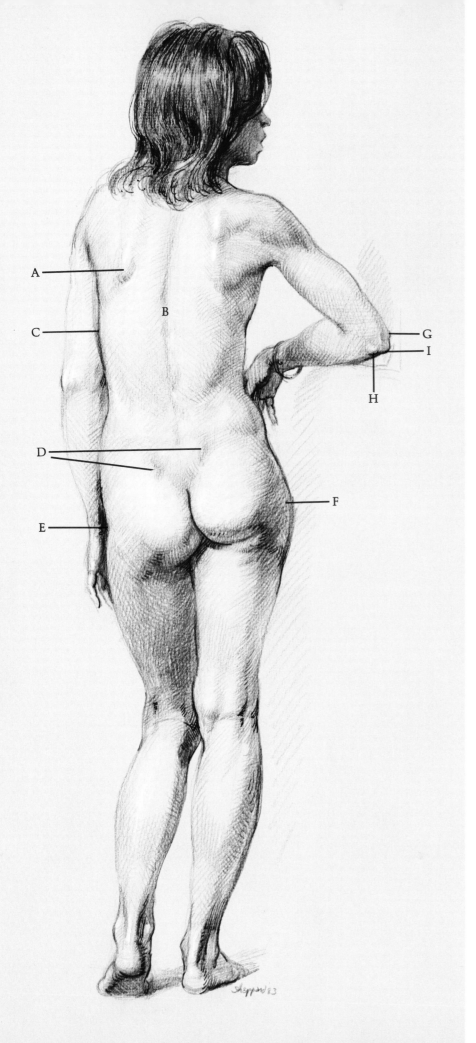

SURFACE ANATOMY

(A) Edge of scapula is distinct even on soft female figure. (B) Spinal column creates center line. (C) Outside edge of rib cage forms contour of torso. (D) Dimples are created by pelvic crest. Protruding part of (E) left femur (hipbone) forms a cavity. (F) Right femur is pushed out when weight is put on it. When weight is put on either leg, that hip is higher than other. Triangle is formed by (G) outside and (H) inside end of humerus and (I) head of ulna.

BONES

(1) Skull. (2) Spinal column. (3) Scapula. (4) Rib cage. (5) Elbow of straight arm. When forearm is locked in open position, three prominent protuberances of elbow (shown by dots) are in straight line. (6) Elbow of bent arm. When forearm is bent, head of ulna drops. Three prominent protuberances (shown by dots) form triangle. (7) Ulna. (8) Pelvis. (9) Femur. (10) Tibia. (11) Fibula. (12) Bones of foot. Heel is off-center, toward little-toe side.

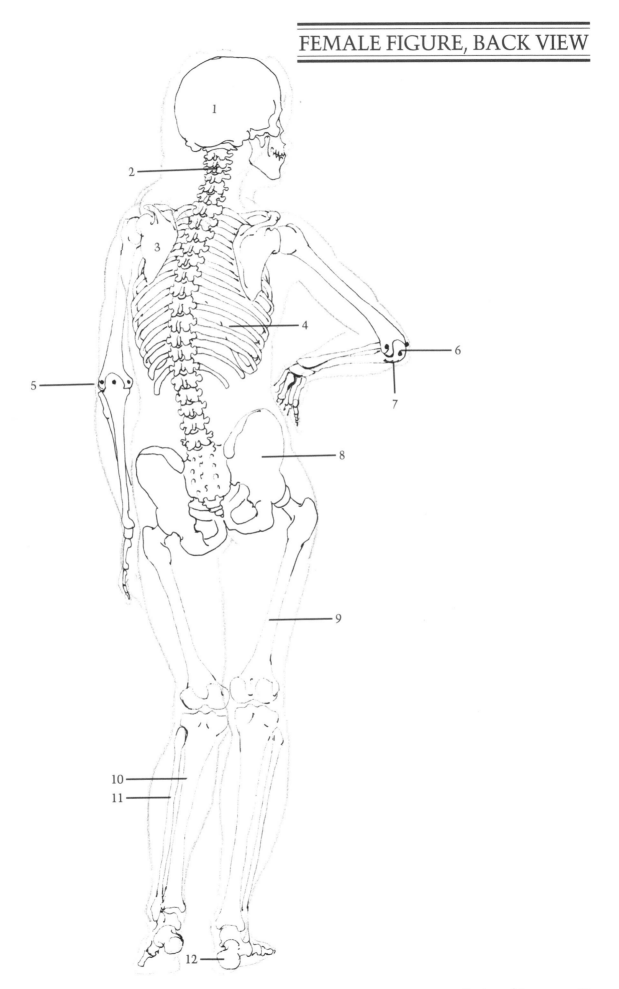

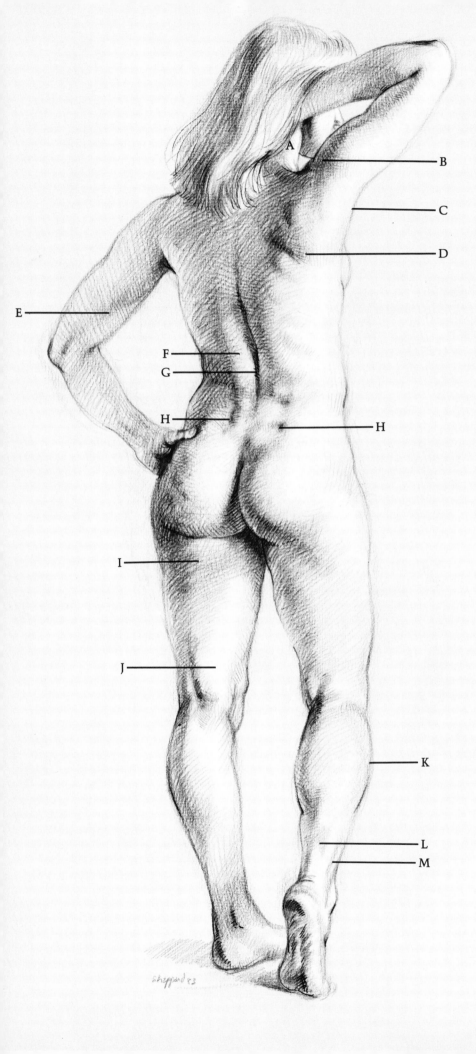

SURFACE ANATOMY

(A) Sternomastoid contour is evident even in back view. (B) Deltoid is softer on female than male. (C) Latissimus dorsi forms back wall of arm pit. (D) Shoulder muscles attach to scapula, connect to arm. (E) Note division between triceps and biceps. (F) Between sacrospinalis muscles, deep crevice (G) is formed, following spinal column. (H) Dimples appear where crest of pelvis is close to surface. (I) Female body fat is deposited under buttocks. (J) Tendons on back and inside of leg form one mass. (K) Outside of calf is higher than inside. (L) Achilles tendon is thick and rounded. (M) Peroneus muscles create small ridge.

MUSCLES

(1) Deltoid. (2) Triceps. (3) Flexor of wrist—little finger side. (4) Flexor of fingers. (5) Flexor of wrist—thumb side. All three flexors are generally treated as one group. (6) Biceps. (7) Trapezius. (8) Latissimus dorsi. (9) External oblique. (10) Sacrospinalis. (11) Gluteus. (12) Iliotibial band. (13) Gastrocnemius. (14) Peroneus. (15) Biceps femoris. (16) Semitendinosus. (17) Adductor group. (18) Sartorius. (19) Soleus. (20) Flexor of toes.

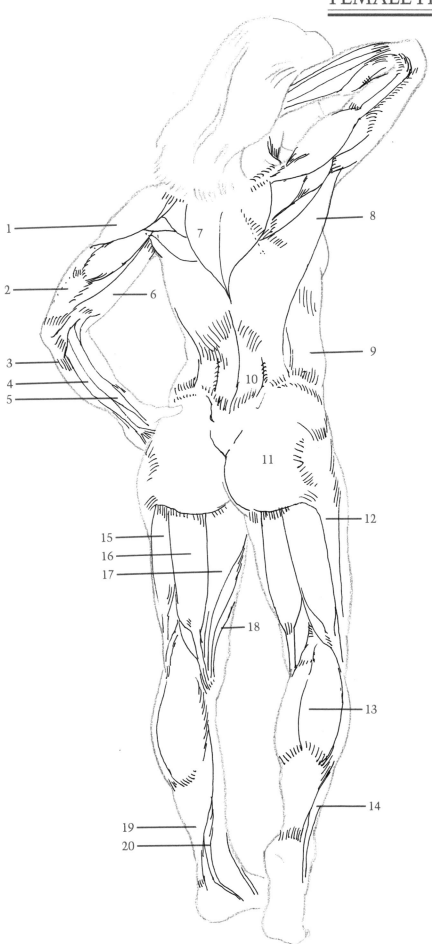

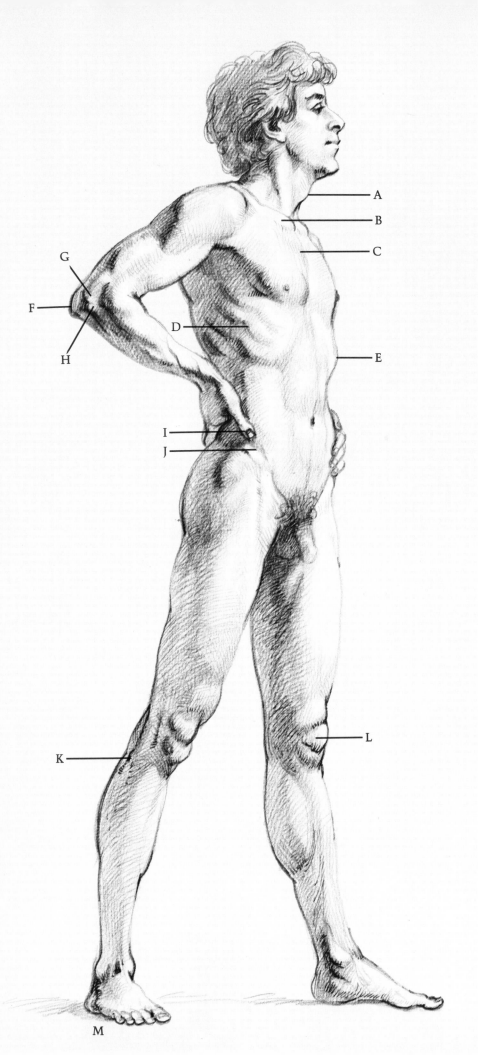

SURFACE ANATOMY

Skull dictates shape of cheeks, jaw. (A) Two bones of "Adam's apple" are suspended, held in place by muscle. They are more obvious in male than female. (B) Clavicle slants back from (C) sternum, and up toward shoulder. (D) Ribs slant down from rear to front. (E) Rib cage determines shape of upper torso. (F) Head of ulna forms hook over end of humerus. (G) Outside end of humerus is shaped like small ball on which (H) head of radius rotates. (I) Thumb has only two bones. (J) Pelvic crest is obvious on male figure. (K) Head of fibula attaches to back of tibia. (L) Kneecap is oval. (M) Pads on outside of foot make flat form.

BONES

(1) Skull is made up of two distinct pieces: back of head; upper part of face and jaw. (2) Adam's apple—two small bones. (3) Spinal column. (4) Rib cage. Twelve pairs of ribs attach to twelve vertebrae of rib cage in back. They swing obliquely downward to front. (5) Pelvis. Crest of pelvis is next to skin, showing clearly on men, most women. (6) Femur. (7) Kneecap. (8) Tibia. (9) Fibula. (10) Bones of foot. Big toe has one less bone than other toes, is often shorter than second toe.

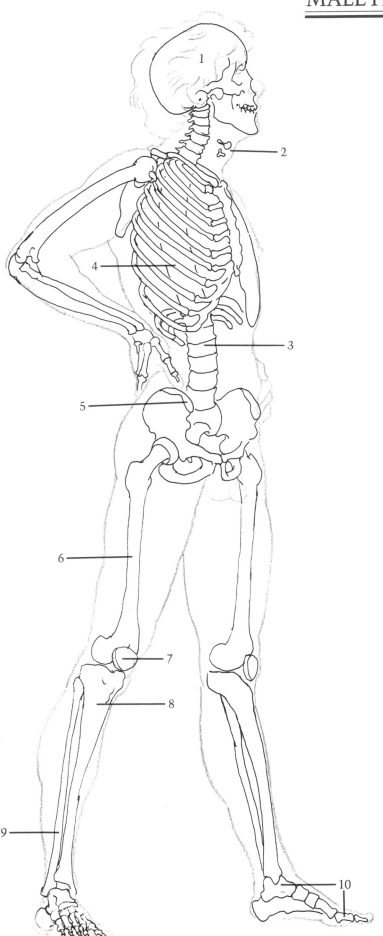

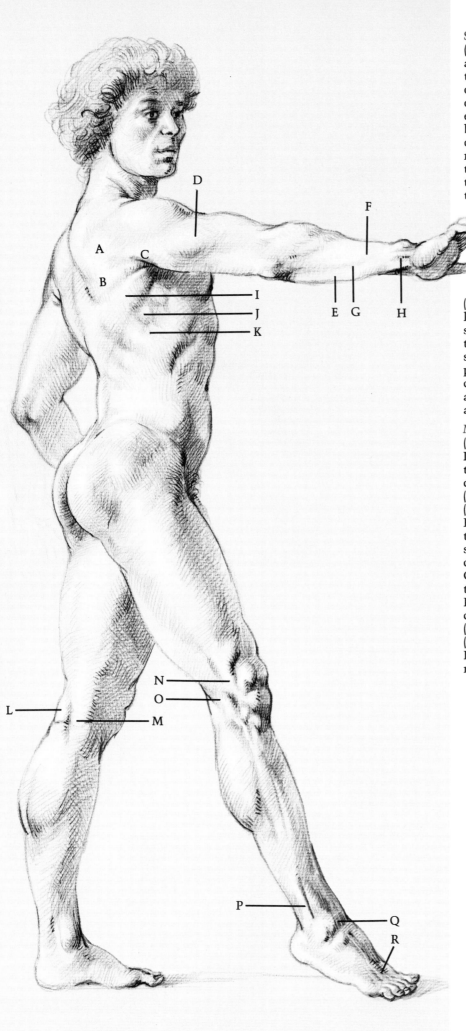

SURFACE ANATOMY

(A) Infraspinatus and (B) teres major are split by (C) long head of triceps as they insert into arm. (D) Short head of triceps is flexed when arm is held out. (E) Flexors on palm side and (F) extensors for back of hand are divided by (G) ulna. (H) Tendon of wrist flexor creates small ridge when fingers are raised. (I) Latissimus dorsi covers (J) top of serratus muscles. Serratus intersect with (K) external oblique attachments like interlocked fingers.

(L) Gastrocnemius head inserts into leg behind (M) group of tendons on inside of leg. (N) Iliotibial band and (O) tendon of biceps femoris form two straps on outside of knee. (P) Long peroneus creates sharp ridge. (Q) Tendons form bridge at ankle between leg and foot. (R) Tendons of toe extensors are evident when toes are extended.

MUSCLES

(1) Sternomastoid. (2) Trapezius. (3) Infraspinatus. (4) Teres major. (5) Latissimus dorsi. (6) Deltoid. (7) Brachialis. (8) Biceps. (9) Long supinator. (10) Extensors of wrist and fingers. (11) Triceps. (12) Flexor of wrist. (13) Flexor of fingers. (14) Serratus attach to first nine ribs, insert into underside of scapula. (15) Rectus abdominis. (16) External oblique. (17) Gluteus. (18) Iliotibial band. (19) Rectus femoris. (20) Vastus. (21) Band of Richer. (22) Biceps femoris. (23) Adductor group. (24) Semitendinosus. (25) Sartorius. (26) Gastrocnemius. (27) Soleus. (28) Long peroneus. (29) Extensor of toes. (30) Tibialis anterior. (31) Flexor of toes.

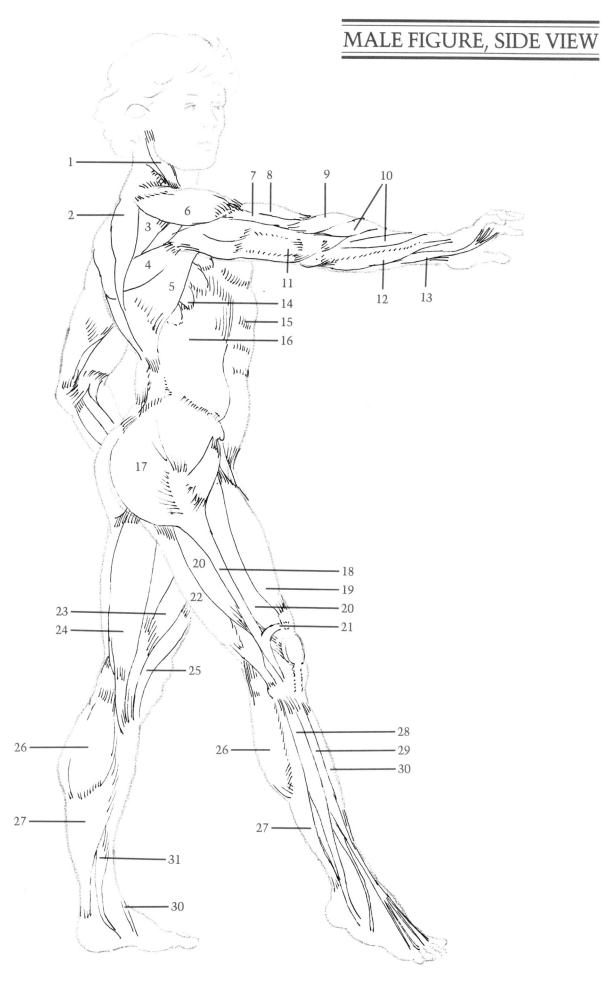

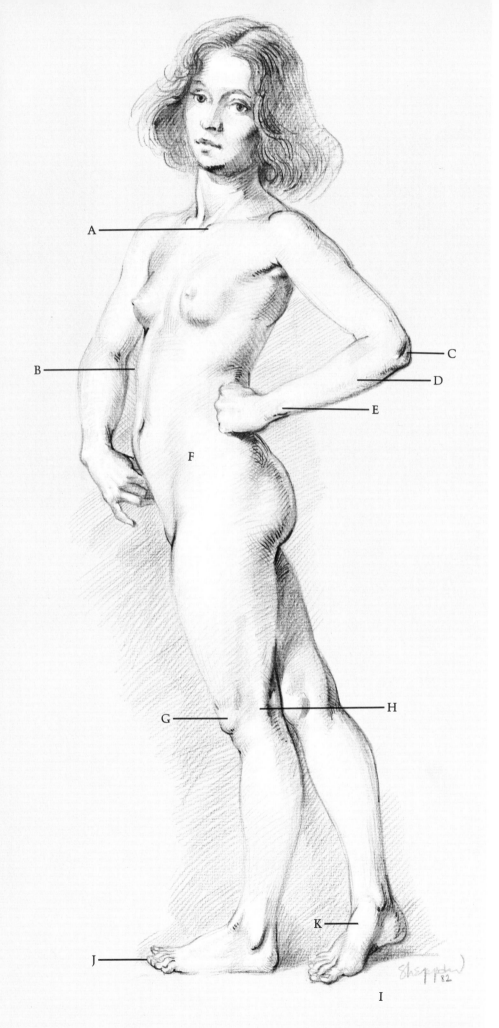

SURFACE ANATOMY
(A) Clavicle starts at pit of neck. (B) Observe swelling shape of rib cage. (C) Head of ulna forms hook at elbow. (D) Entire length of ulna shows. (E) End of ulna is most prominent bone at wrist. (F) Pelvic crest is covered by flesh, but is slightly visible where it ends—typical on females. (G) Kneecap sits in front of end of femur. (H) Head of fibula attaches to outside and back of tibia head. (I) Inside of foot has high arch. (J) Second toe is often longer than big toe. (K) Note arch on big toe inside of foot.

BONES
(1) Skull. (2) Spinal column. (3) Humerus. (4) Radius. (5) Ulna. When palm is turned inward radius rotates around ulna, crossing obliquely down from outside of elbow to inside (thumb side) of wrist. (6) Wrist bones. (7) Bones of palm—five. (8) Bones of fingers. Each finger has three bones, except thumb, which has two. (9) Pelvis. (10) Femur. (11) Kneecap. (12) Tibia. (13) Fibula. (14) Bones of foot. Two important arches are formed, serving as springs, absorbing much of body weight. One arch (A) from heel to toe, is more evident on inside of the foot. Other arch (B) runs from side to side; big-toe side is highest point of arch.

1

2

3

4

5

6

7

8

9

10

11

12

13

B

A

14

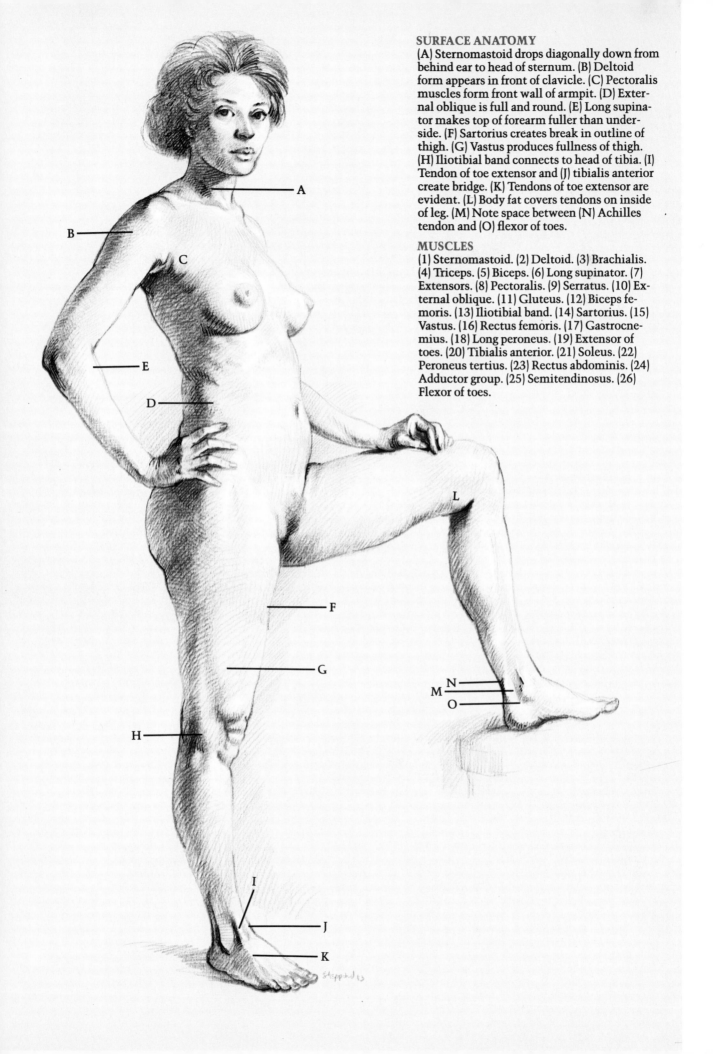

SURFACE ANATOMY

(A) Sternomastoid drops diagonally down from behind ear to head of sternum. (B) Deltoid form appears in front of clavicle. (C) Pectoralis muscles form front wall of armpit. (D) External oblique is full and round. (E) Long supinator makes top of forearm fuller than underside. (F) Sartorius creates break in outline of thigh. (G) Vastus produces fullness of thigh. (H) Iliotibial band connects to head of tibia. (I) Tendon of toe extensor and (J) tibialis anterior create bridge. (K) Tendons of toe extensor are evident. (L) Body fat covers tendons on inside of leg. (M) Note space between (N) Achilles tendon and (O) flexor of toes.

MUSCLES

(1) Sternomastoid. (2) Deltoid. (3) Brachialis. (4) Triceps. (5) Biceps. (6) Long supinator. (7) Extensors. (8) Pectoralis. (9) Serratus. (10) External oblique. (11) Gluteus. (12) Biceps femoris. (13) Iliotibial band. (14) Sartorius. (15) Vastus. (16) Rectus femoris. (17) Gastrocnemius. (18) Long peroneus. (19) Extensor of toes. (20) Tibialis anterior. (21) Soleus. (22) Peroneus tertius. (23) Rectus abdominis. (24) Adductor group. (25) Semitendinosus. (26) Flexor of toes.

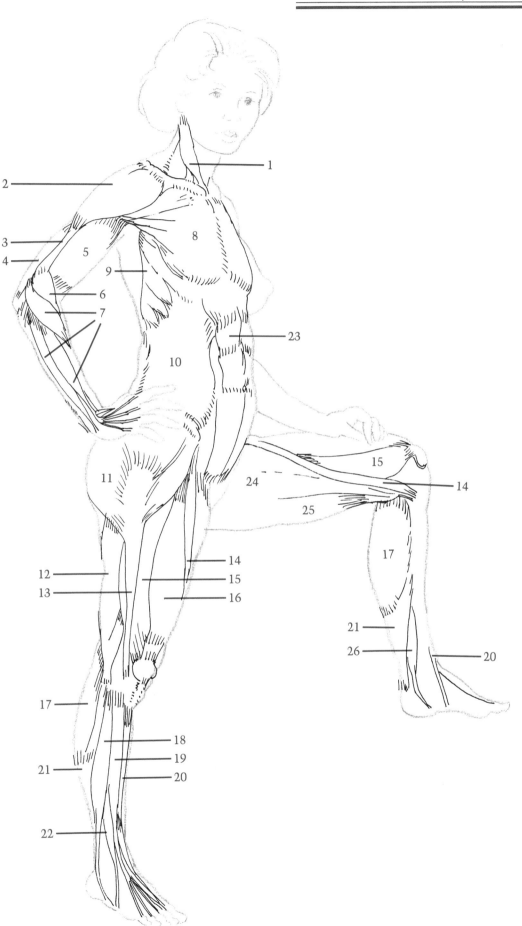

STANDING FIGURE

The standing figure is seen with less foreshortening than other poses.

There are three ways a figure can stand: with all the weight on one leg and balanced with the other; with the weight evenly distributed on both legs; or with the weight on one leg and the other raised.

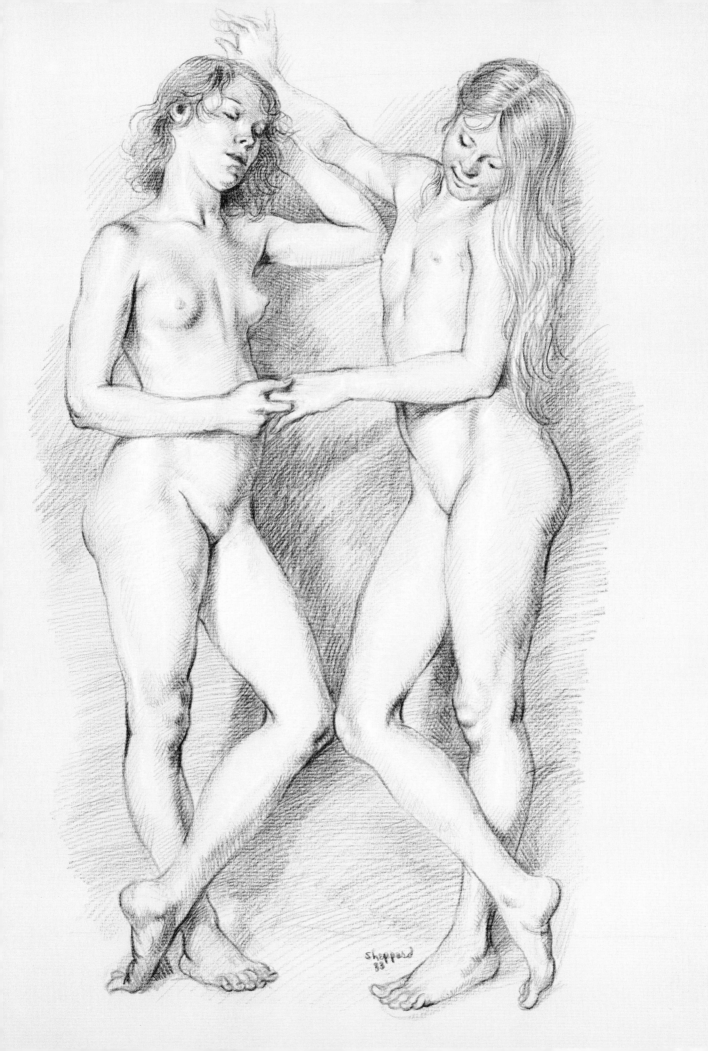

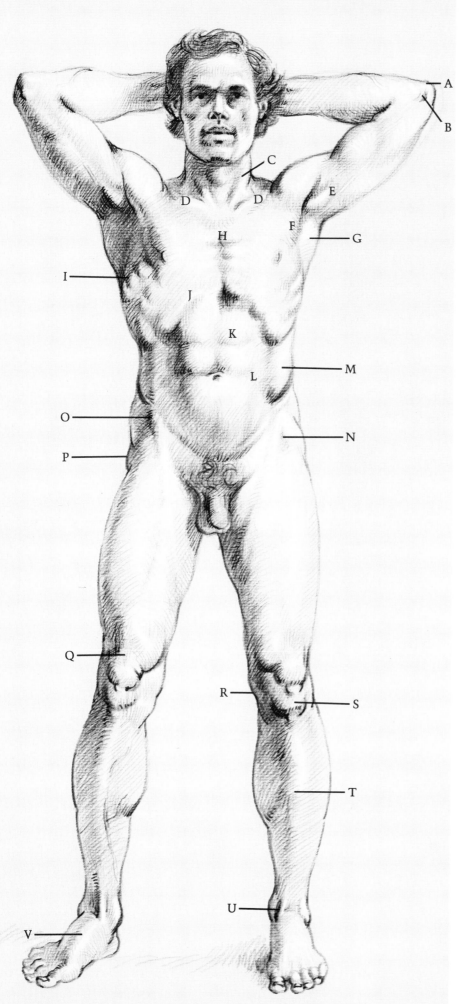

SURFACE ANATOMY

(A) Elbow or "funny-bone" is hook of ulna. (B) Inside of humerus end is always prominent. (C) Sternomastoid muscles insert into sternum in "V" shape and attach to sternum between (D) clavicles. (E) Coracobrachialis flexes in armpit when arm is raised. Walls of armpit are formed by (F) pectoralis, (G) latissimus dorsi. (H) Sternum shows beginning of ribs. (I) Serratus are more evident when arms are raised. (J) Edge of rib cage creates arch. (K) Rectus abdominis divides laterally. (L) Thin sheath of rectus abdominis connects with (M) external oblique. (N) Hollow is upside down "V" shape. (0) Sartorius is attached to end of pelvic crest. (P) Hipbone protrudes because it is next to skin.

(Q) Tendon of rectus femoris forms flat area above kneecap. (R) Slant of inside of knee is caused by shape of bones. (S) Fat deposit appears below kneecap. (T) Front edge of tibia creates curved edges. (U) Tendons from extensors are in front of ankle. (V) Arch is high on big-toe side.

BONES

(1) Clavicles start at sternum, then angle up and back, like wings. (2) Rib cage is shaped like an egg with small end up. (3) Note direction of ribs attached to sternum. First rib goes up; second moves straight across; others angle downward. (4) Ribs start high in back, slant downward toward front. (5) Radius crosses over from outside of elbow. (6) Inside of humerus end protrudes. (7) Head of ulna is hook-shaped. (8) Head of humerus is ball-shaped. (9) Scapula's two prongs and clavicle form socket for head of humerus. (10) Pelvis. (11) Crest of pelvis is close to skin. (12) Ball-shaped head of femur fits into pelvic socket. (13) Outside of hipbone is next to surface. (14) Femur angles down from outside of hip to inside of knee. (15) Kneecap is attached below by strong ligament; resembles "lollypop" on stick. (16) Edge of tibia is next to surface. (17) Inside of ankle is higher than outside.

MUSCLES

(18) Deltoid helps to lift arm. (19) Biceps. (20) Triceps. (21) Coracobrachialis is small muscle that becomes prominent when arm is raised. (22) Teres major and latissimus dorsi create back wall of armpit. (23) Latissimus dorsi inserts into humerus between coracobrachialis and triceps. (24) Pectoralis creates front wall of armpit. (25) Serratus muscles wrap around rib cage like fingers. (26) Violin-shape is formed by hollow of rib cage, external oblique muscles, and basin of stomach. (27) Inside form of vastus muscle is tear-shaped. (28) Tensor fasciae latae. (29) Rectus femoris runs down front of thigh, inserts into upside down, "V" shaped hollow. (30) Sartorius and tensor fasciae latae form upside down "V". Sartorius descends obliquely down leg and is longest muscle in body. (31) Rectus femoris attaches to kneecap with beltlike tendon. (32) Kneecap. (33) Outside of calf is higher than inside of calf. (34) Inside of ankle is higher than outside.

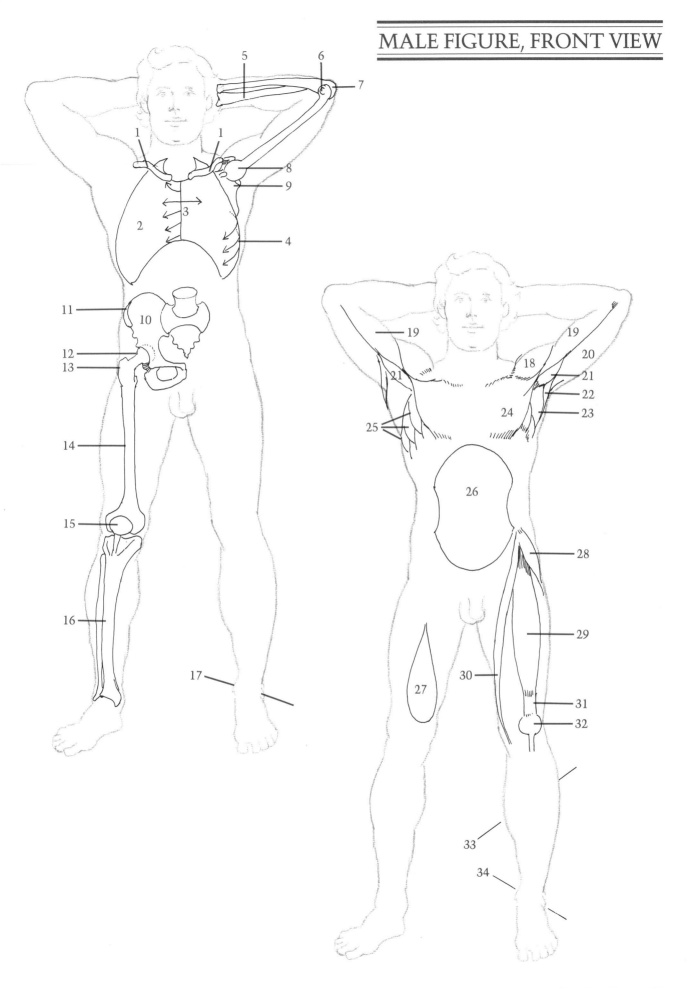

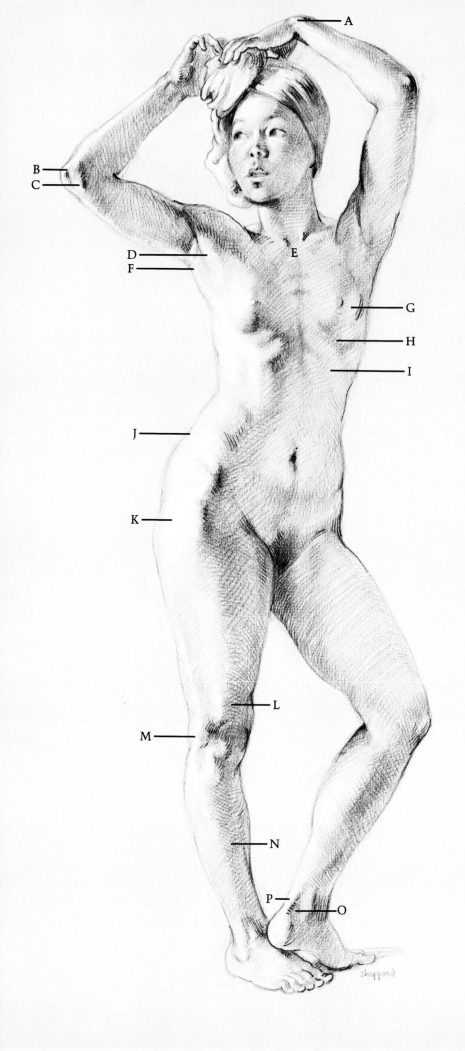

SURFACE ANATOMY

(A) Ulna is prominent at wrist. (B) Head of ulna hooks over end of humerus. (C) Inside end of humerus protrudes at elbow. (D) Pectoralis forms front wall of armpit. (E) "V" shape is created by sternomastoids. (F) Latissimus dorsi forms back wall of armpit. (G) Shape of breast elongates when arms are raised. (H) Arch of rib cage is narrower on female. (I) Cavity of rib cage is less distinct on female. (J) Female body fat covers pelvic crest. (K) Female hips are wider than male. (L) Indentation is caused by band of Richer. (M) Iliotibial band attaches to head of tibia. (N) Front of tibia ("shinbone") is next to skin. (O) Note cavity between (P) Achilles tendon and ankle.

BONES

(1) Radius is wider than ulna at wrist. (2) Ulna is thinner than radius at wrist, but shows prominent bump. (3) Radius attaches on outside of elbow and thumbside of wrist. (4) Hook of ulna. (5) Inside of humerus end protrudes. (6) Humerus head is ball-shaped. (7) Scapula creates socket for head of humerus. (8) Rib cage is narrower on females than males. (9) Sternum shows rib attachments. (10) Clavicle has "S" shape. (11) Pelvis of female is wider than male. (12) Hipbone creates depression where it is close to skin. (13) Femur angles inward from hip to knee. (14) End of femur. (15) Kneecap acts as lock to keep knee from bending forward. (16) Fibula attaches to back of tibia. (17) Entire front edge of tibia (shinbone) is next to skin.

MUSCLES

(18) Sternomastoid is vertical when head is turned. (19) External oblique inserts into ribs, attaches to pelvic crest. (20) Fat covers muscle and bone. (21) Gluteus. (22) Hipbone protrudes. (23) Stomach sits in pelvic basin. (24) Tensor fasciae latae. (25) Vastus. (26) Iliotibial band creates stripelike identation down outside of leg. (27) Biceps femoris. (28) Kneecap. (29) Fat deposit appears under kneecap. (30) Long peroneus. (31) Extensor of toes. (32) Tibialis anterior, long peroneus, and extensor of toes attach on outside of calf to tibia head, descend down to ankle and on into the foot. (33) Gastrocnemius. (34) Edge of tibia (shinbone) appears next to surface. (35) Peroneus tertius. (36) Sartorius divides inside of thigh from front. (37) Achilles tendon. (38) Space appears between tendon and ankle.

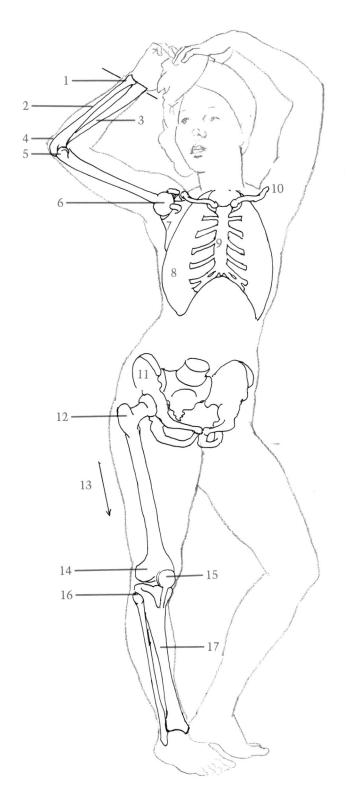

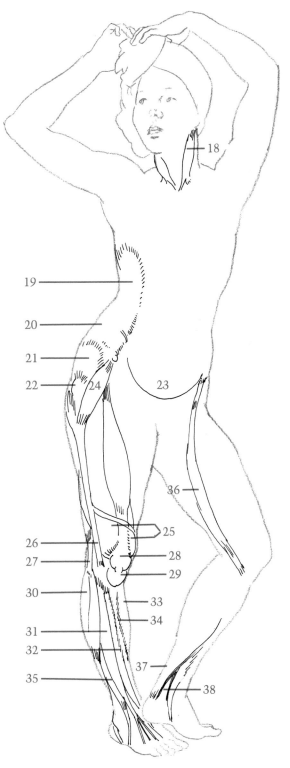

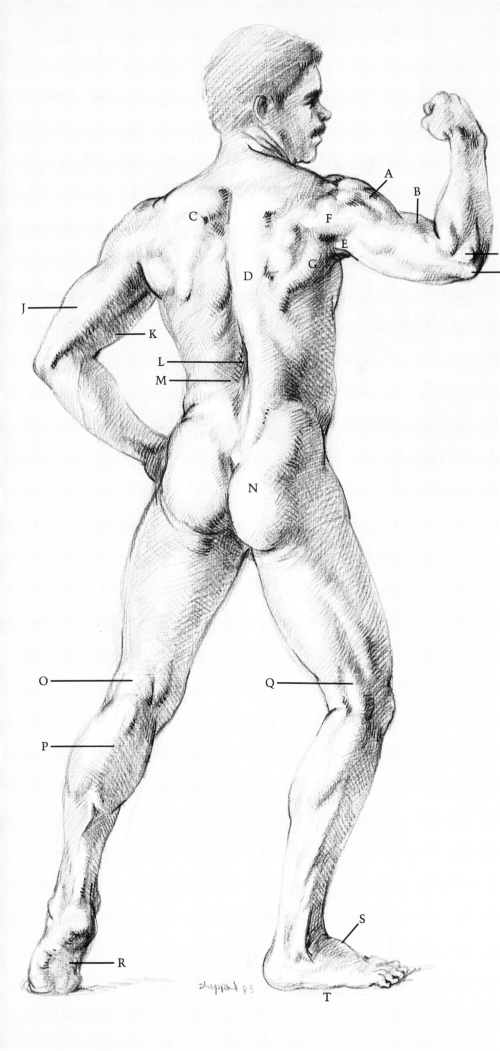

SURFACE ANATOMY

(A) Deltoid divides into three main sections: front, side, back. (B) Biceps and deltoid help lift arm. (C) Crest of scapula shows through muscles. (D) Observe edge of trapezius. (E) Long head of triceps inserts between (F) infraspinatus and (G) teres major and latissimus dorsi. (H) Head of radius and (I) hook of ulna ride on humerus. Note division between (J) triceps and (K) biceps. (L) Valley of spinal column is formed by (M) sacrospinalis. (N) Buttocks are shaped like butterfly wings. (O) "H" shape appears in back of knee. (P) Gastrocnemius contracts, becomes hard when weight is put on ball of foot. (Q) Biceps femoris is prominent when tense. (R) Arch on inside of foot is visible from beneath. (S) High arch on top of foot produces diagonal silhouette. (T) Outside of foot is covered with pads that flatten out.

BONES

(1) Skull rotates from side to side on second vertebra. (2) Spinal column is treated here as simple column without vertebrae. (3) Rib cage is treated as simple egg-shape, except for floating ribs. (4) Scapula looks like holster-and-gun shape, forms socket for head of humerus. (5) Head of humerus is ball-shaped. (6) Wrist bones. (7) End of ulna is prominent at wrist. (8) Head of radius is flat disk that rotates on humerus end. (9) Outside end of humerus is shaped like ball. (10) Hook of ulna. (11) Inside end of humerus. (12) Radius is longer bone at wrist. (13) Pelvic crest forms dimples. (14) Two large knobs on back of femur are where gastrocnemius attaches. (15) Kneecap.

MUSCLES

(16) Trapezius is kite-shaped or diamond-shaped. (17) Deltoid shows divisions, most distinct in strong, lean figures. (18) Long supinator. (19) Note thickness of triceps tendon. (20) Internal head of triceps. (21) Short head of triceps. (22) Long head of triceps inserts into shoulder. (23) Latissimus dorsi. (24) Sacrospinalis insert deep into the spine and ribs. These muscles show only in small of back, where they attach to pelvis area. (25) Valley appears between sacrospinalis. (26) Buttocks are in shape of butterfly wings. (27) Biceps femoris. (28) Semitendinosus. (29) "H" shape is caused by crease in back of leg, biceps femoris, semitendinosus. (30) Gastrocnemius. (31) Outside of calf is higher than inside. (32) Soleus. (33) Inside of ankle is higher than outside.

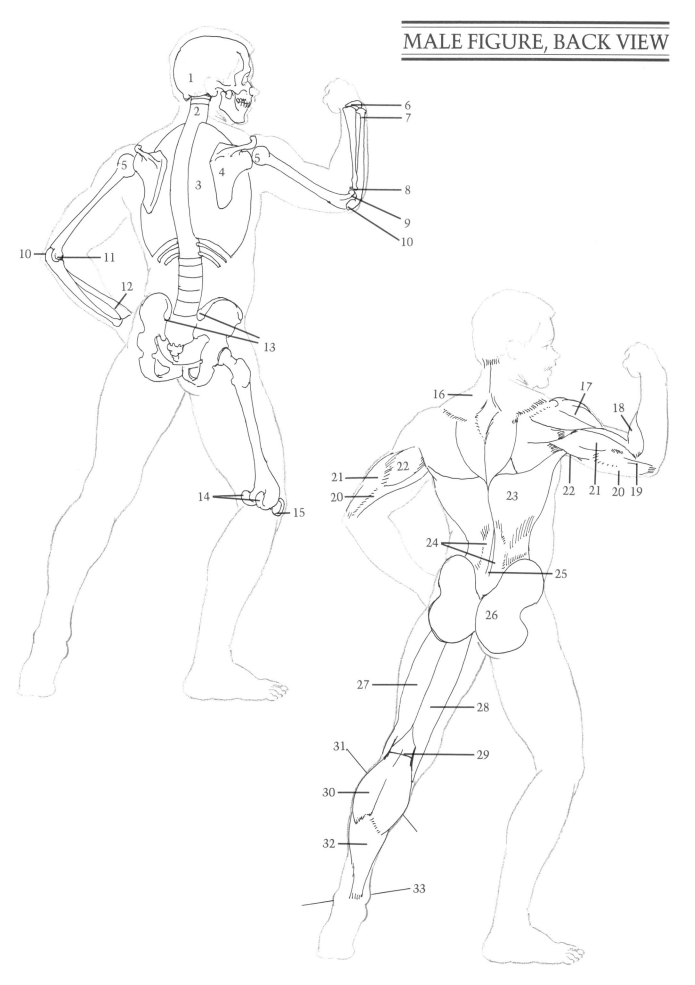

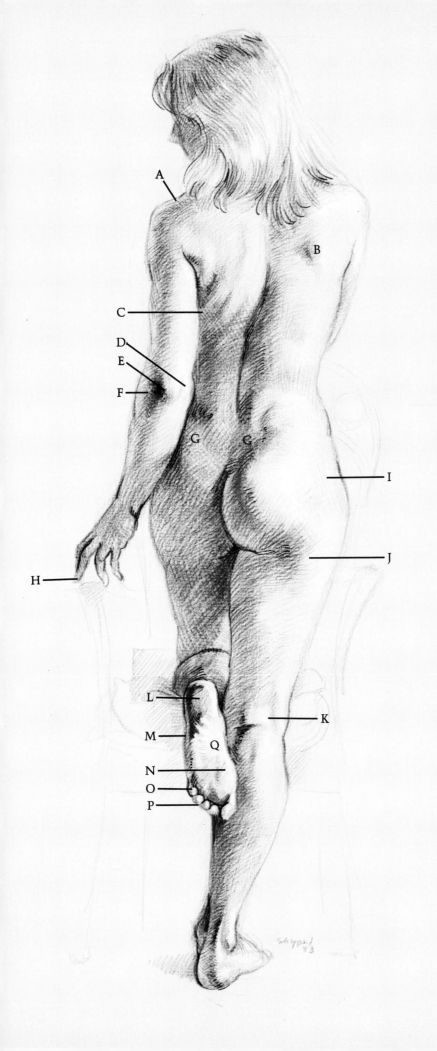

SURFACE ANATOMY

(A) Indentation appears where scapula and clavicle join. (B) Edge of scapula barely shows in female figure. (C) Fleshy folds are caused by turning. (D) Inside of end of humerus and (E) hook of ulna align with (F) radius head. (G) Dimples are caused by end of pelvic crest. (H) Middle finger is longest. (I) Female body fat covers hipbone and pelvic crest. (J) Fat deposit appears under buttocks. (K) "H" shape shows in back of knee. Four groups of pads appear on bottom of foot: (L) heel, (M) outside of foot, (N) ball of foot, (O) toes. (P) Small toes are fleshy and round. (Q) Instep and arch are on inside of foot. Note that heel is off-center and aligns with little toe.

BONES

(1) Spinal column ("backbone") has slight curve. (2) Rib cage. (3) Right scapula: inside edge is pulled away from rib cage when arm is forward. (4) Left scapula: outside edge is pulled away from rib cage when arm is back. (5) Head of humerus. Scapula socket follows head of humerus and direction of arm. (6) Inside end of humerus. (7) Hook of ulna. (8) Head of radius rotates on outside ball of humerus. Three protuberances (shown by dots) are in straight line when elbow is straight. (9) Radius end extends beyond ulna at wrist. (10) End of ulna. (11) Rib cage rotates slightly on vertebrae. (12) Crest of pelvis. (13) Femur. (14) Note angle of femur when leg is straight. (15) Head of fibula attaches on back of tibia head. (16) Tibia head. (17) Tibia end. (18) Fibula end and tibia end form hingelike socket for talus bone. (19) Talus bone is spool-shaped bone on top of foot. (20) Visualize imaginary line of pin for hinge joint. (21) Heel bone.

MUSCLES

(22) Deltoid. (23) Short head of triceps. (24) Long head of triceps. (25) Internal head of triceps. (26) Tendon of triceps is like strap. (27) Long supinator makes outside of forearm higher than inside. (28) Flexors of wrist and fingers. (29) Ulna is next to surface. (30) Sacrospinalis is like column in lower back, disappears as it attaches higher up back. (31) Trapezius covers upper tip of scapula. (32) Edge of scapula. (33) Latissimus dorsi covers lower tip of scapula. (34) Flat heart-shape appears over bone. (35) Gluteus looks like butterfly wing. (36) Body fat. (37) Fat deposit shows under buttocks. (38) Vastus. (39) Semitendinosus. (40) Biceps femoris and semitendonosus are like tongs wrapping around heads of gastrocnemius. (41) Iliotibial band. (42) "H" shape. (43) Gastrocnemius. (44) Heel pad. (45) Pad on outside of foot. (46) Inside arch. (47) Toe pad. (48) Ball of foot shows big-toe pad.

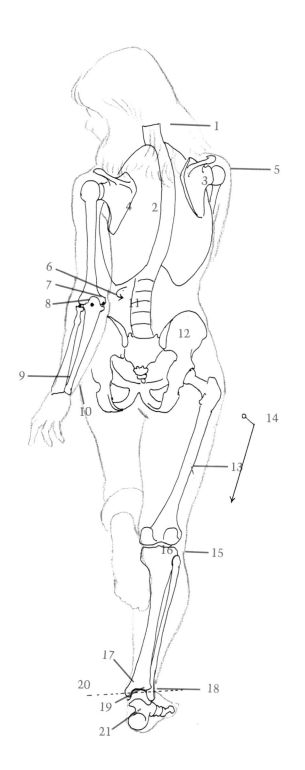

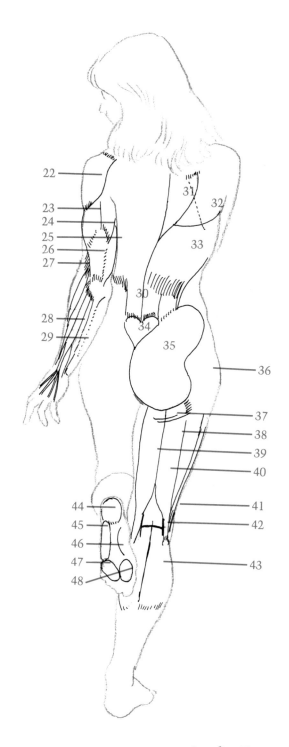

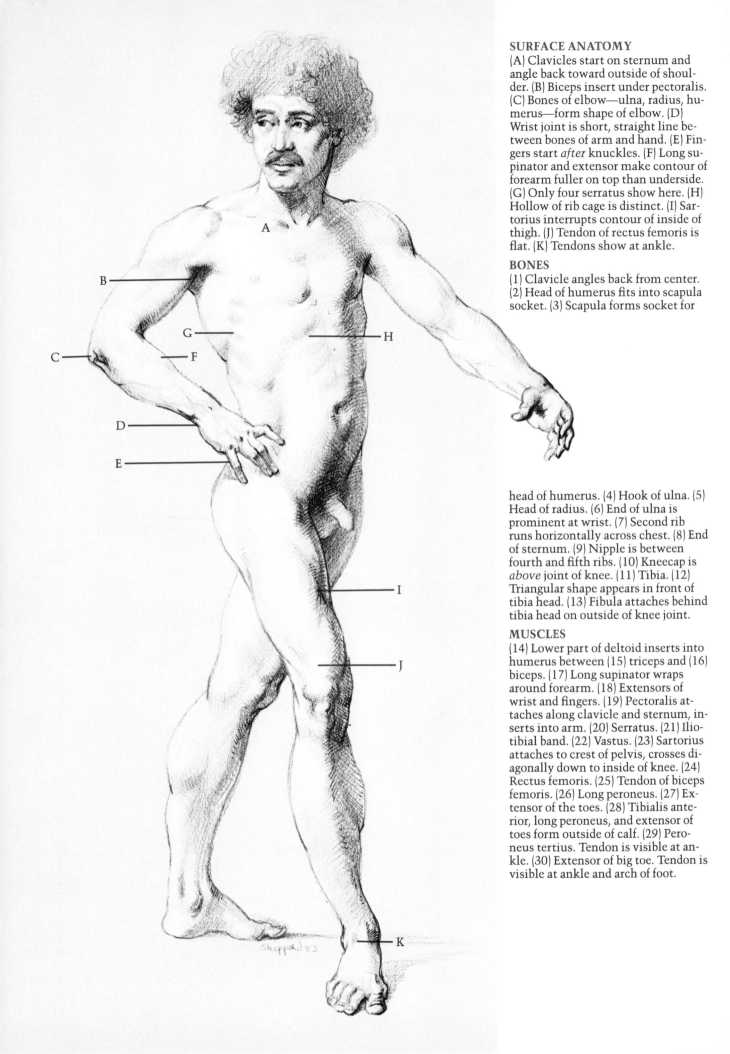

SURFACE ANATOMY
(A) Clavicles start on sternum and angle back toward outside of shoulder. (B) Biceps insert under pectoralis. (C) Bones of elbow—ulna, radius, humerus—form shape of elbow. (D) Wrist joint is short, straight line between bones of arm and hand. (E) Fingers start *after* knuckles. (F) Long supinator and extensor make contour of forearm fuller on top than underside. (G) Only four serratus show here. (H) Hollow of rib cage is distinct. (I) Sartorius interrupts contour of inside of thigh. (J) Tendon of rectus femoris is flat. (K) Tendons show at ankle.

BONES
(1) Clavicle angles back from center. (2) Head of humerus fits into scapula socket. (3) Scapula forms socket for

head of humerus. (4) Hook of ulna. (5) Head of radius. (6) End of ulna is prominent at wrist. (7) Second rib runs horizontally across chest. (8) End of sternum. (9) Nipple is between fourth and fifth ribs. (10) Kneecap is *above* joint of knee. (11) Tibia. (12) Triangular shape appears in front of tibia head. (13) Fibula attaches behind tibia head on outside of knee joint.

MUSCLES
(14) Lower part of deltoid inserts into humerus between (15) triceps and (16) biceps. (17) Long supinator wraps around forearm. (18) Extensors of wrist and fingers. (19) Pectoralis attaches along clavicle and sternum, inserts into arm. (20) Serratus. (21) Iliotibial band. (22) Vastus. (23) Sartorius attaches to crest of pelvis, crosses diagonally down to inside of knee. (24) Rectus femoris. (25) Tendon of biceps femoris. (26) Long peroneus. (27) Extensor of the toes. (28) Tibialis anterior, long peroneus, and extensor of toes form outside of calf. (29) Peroneus tertius. Tendon is visible at ankle. (30) Extensor of big toe. Tendon is visible at ankle and arch of foot.

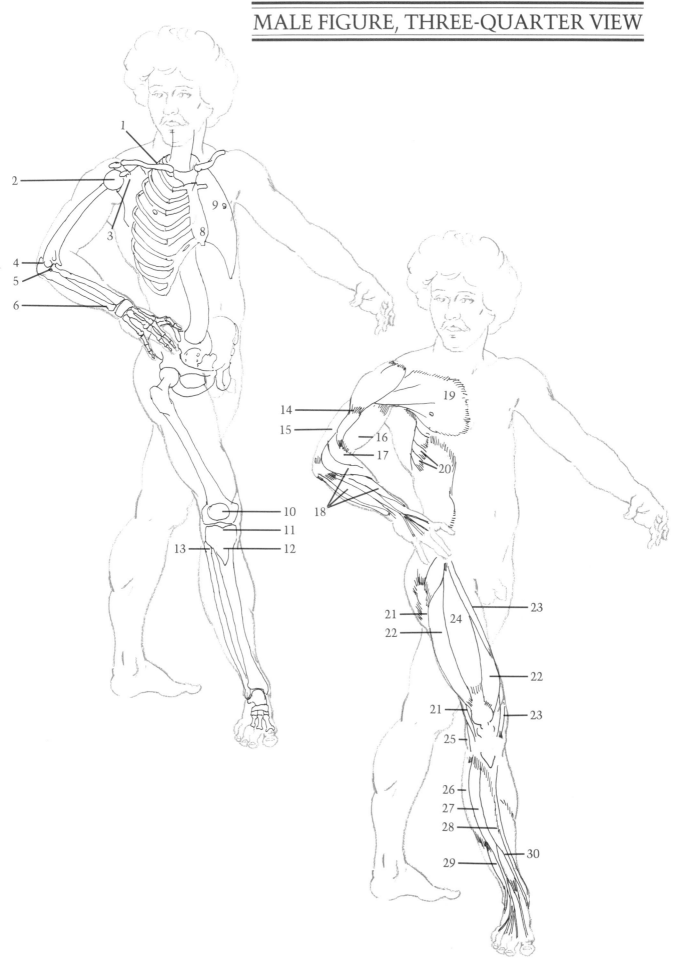

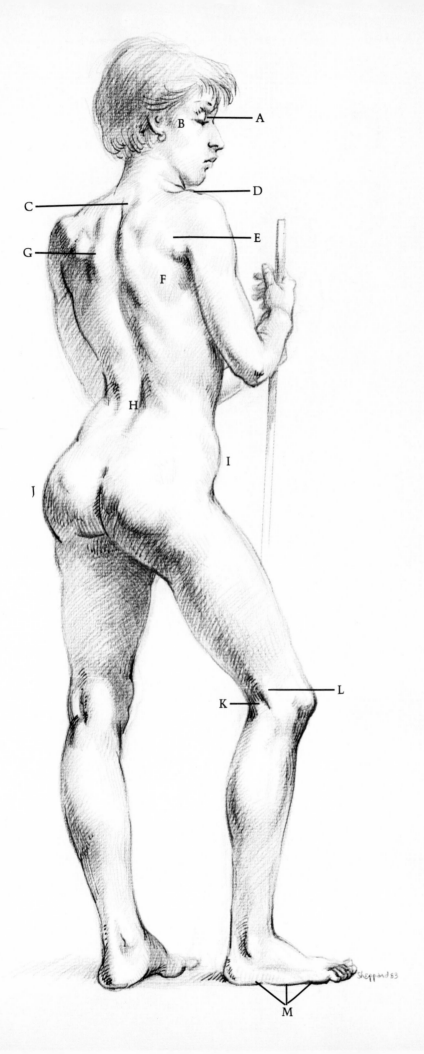

SURFACE ANATOMY

(A) Eye fits deep in eye socket of skull. (B) Cheekbone is next to skin. (C) First vertebra of rib cage protrudes at base of neck. (D) Head of scapula usually shows on top of shoulder. (E) Small fat deposits appear where arm joins torso. (F) End of right scapula and (G) edge of left scapula are visible. (H) Valley is created between two sacrospinalis columns. (I) Observe angle of pelvic crest. (J) When weight is carried on left leg, left knee is locked, and left hip is higher than right. (K) Tendon of biceps femoris attaches to fibula. (L) Tendon of iliotibial band is prominent on outside of knee. (M) Three pads of foot include heel, outside of foot, and toes—all making outside sole of foot appear flat.

BONES

(1) Eye socket. (2) Cheekbone. (3) First vertebra of rib cage shows at base of neck. (4) Scapula. (5) Head of scapula. Top part of scapula socket is always visible on top of shoulder. (6) Rib cage is egg-shaped, showing flating ribs. (7) Crest of pelvis angles down toward front and protrudes. (8) Femur. (9) Kneecap sits in front of femur. (10) Fibula. (11) Front of tibia (shinbone) has slight "S" curve. (12) Fibula at ankle is closer to heel than to front of foot. (13) Tibia on inside of ankle is further forward than fibula.

MUSCLES

(14) Trapezius attaches to base of skull. (15) Flat, diamond-shaped tendinous surface in center of trapezius exposes spines of vertebrae. (16) Trapezius inserts into vertebrae. (17) Sacrospinalis are cylindrical. (18) Flat heart-shape between gluteus muscles. (19) Gluteus. (20) Tensor fasciae latae. (21) Hipbone shows through muscles. (22) Iliotibial band is like stripe on outside of thigh. (23) Biceps femoris and iliotibial band create two straps on outside of knee. (24) Vastus. (25) Head of fibula shows muscle attachments. (26) Long peroneus, (27) extensor of the toes, (28) and tibialis anterior form outside of calf. (29) Pad of heel. (30) Pad of big toe (ball of foot). (31) Outside pad of foot. (32) Pad of toes.

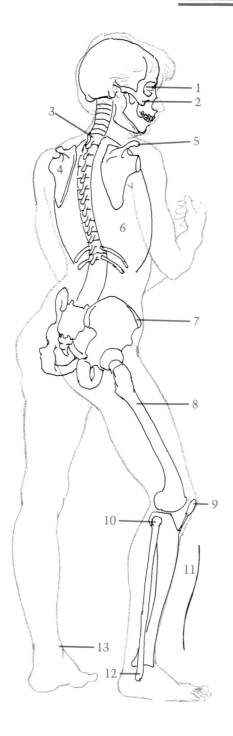

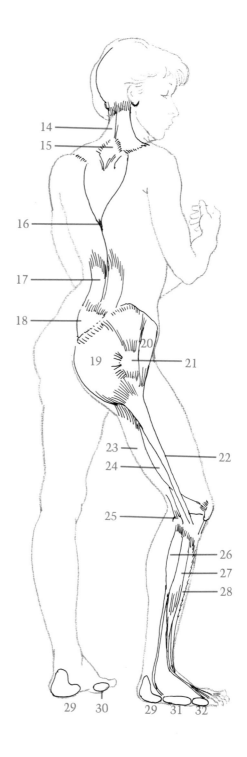

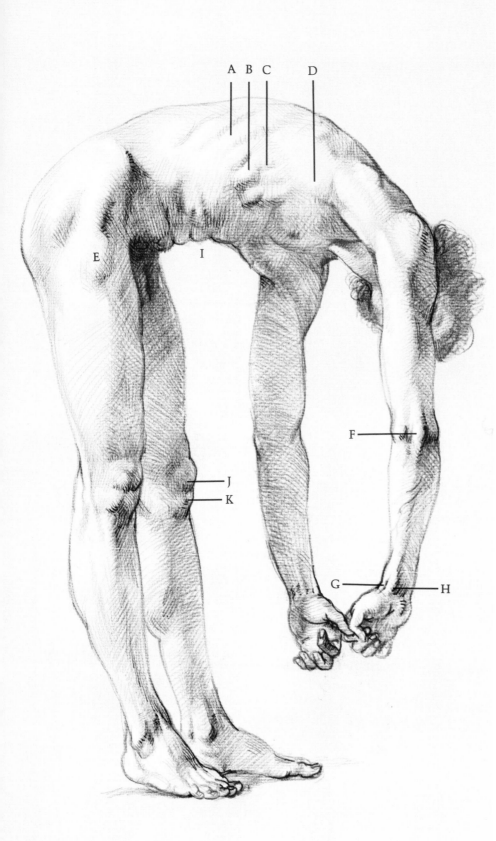

SURFACE ANATOMY

(A) Ribs slant down from back to front. (B) Top of external oblique interweaves with (C) serratus muscles. (D) Latissimus dorsi extends out into arm and forms back wall of armpit. (E) Tensor fasciae latae bulges in this position. (F) Three protuberances of elbow are in straight line when arm is extended. (G) Abductor of thumb and (H) flexors of wrist and finger show on underside of wrist. (I) Folds occur when body bends forward. (J) Kneecap and (K) fat deposit under knee are approximately same shape.

BONES

(1) Right side of pelvis. (2) Hipbone. (3) Femur. (4) Kneecap is attached to tibia by strong ligament, acts as a lock to prevent femur from bending forward. Femur can only bend backward. (5) Tibia. (6) End of fibula forms socket with end of tibia for talus bone of foot. (7) Talus. (8) Heel bone. (9) Humerus—front and back views. (10) Ball-shape appears on outside of end of humerus. (11) Head of radius rotates on ball-shaped end of humerus when thumb is turned in toward body. (12) Arrow shows direction of radius rotating around ulna. (13) Inside end of humerus always protrudes. (14) Hook of ulna acts as lock on elbow to keep arm from bending backwards. Dots show alignment of elbow bones. (15) Ulna is smaller, but more prominent bone at wrist, always appearing on little finger side of hand. (16) Radius always appears on thumb side of hand. (17) Group of wrist bones.

MUSCLES

(18) External oblique interlocks with serratus like interlocking fingers. (19) Serratus. (20) Latissimus dorsi inserts into arm. (21) Shapes of ribs show through latissimus dorsi. (22) Teres major. (23) Infraspinatus. (24) Deltoid. (25) Long head of triceps inserts into scapula between teres major and infraspinatus. (26) Internal head of triceps. (27) Short head of triceps shows on outside of arm. (28) Straplike tendon of triceps attaches to head of ulna. (29) Head of ulna. (30) "Ball" of thumb is formed by short abductor and flexor of thumb. (31) "Heel" of thumb is formed by abductor and short flexor of little finger. (32) Pad covers heads of finger bones. (33) Gluteus. (34) Tensor fasciae latae. (35) Vastus. (36) Rectus femoris. (37) Sartorius. (38) Tendon of biceps femoris. (39) Kneecap and (40) deposit of fat (similar in shape) form figure "8". (41) Tibia is "V" shape under "8" shape of kneecap and fat. (42) Note slight curve of shinbone showing through muscle.

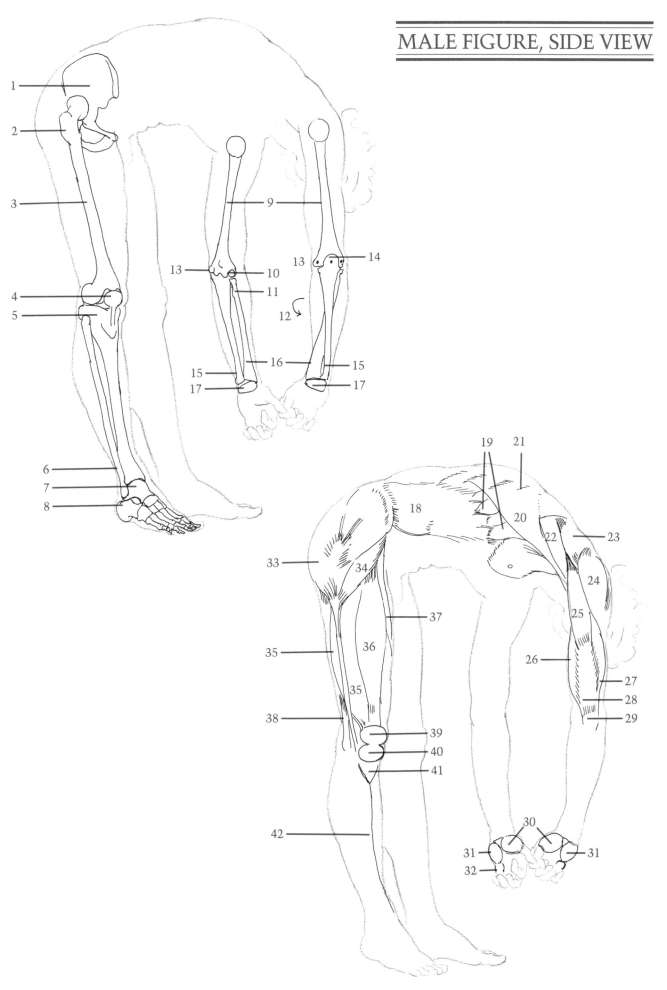

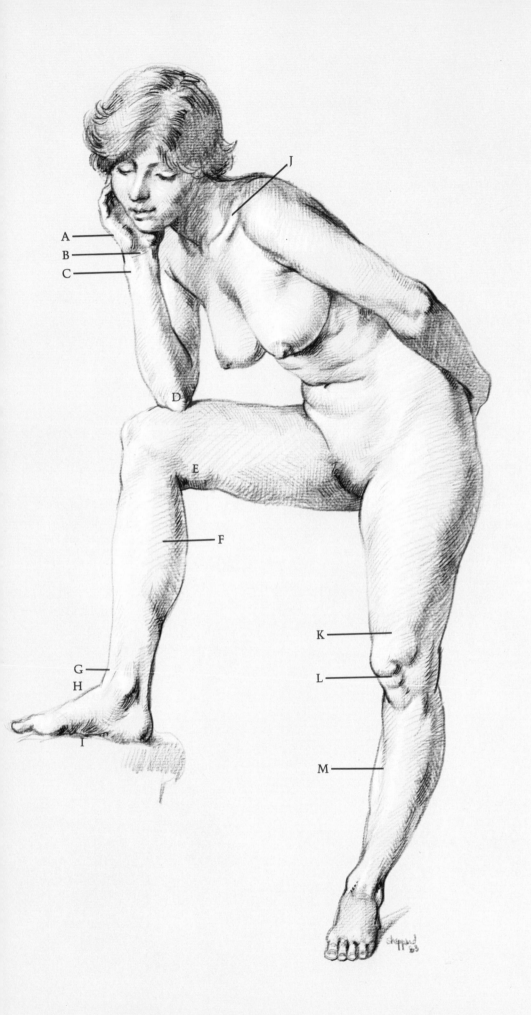

SURFACE ANATOMY

(A) "Heel" pad of hand and finger pad appear on little finger side of palm. (B) Flexor tendons make bridge across wrist. (C) End of ulna protrudes. (D) Hook of ulna is prominent when arm is bent. (E) Female fat covers tendons on inside of leg. (F) Gastrocnemius is largest, most important muscle on inside of calf. (G) Tibialis anterior creates bridge between lower leg and (H) arch of foot. (I) Instep arch is flattened by pressure. (J) "S" shaped clavicle starts at base of neck and angles back toward outside of shoulder. (K) Band of Richer causes indentation when knee is locked. (L) Note "8" and "V" shapes of kneecap, fat deposit, tibia head. (M) Shinbone is next to skin.

BONES

(1) Clavicle is "S" shaped. (2) Sternum. (3) Rib cage is egg-shaped. (4) Spinal column. (5) Pelvis. (6) Socket holds head of femur. (7) Femur. (8) End of femur rolls on head of tibia. (9) Head of tibia is flat-topped. (10) Kneecap—held in place by strong ligament—stays in place when leg is bent or straight. (11) Note slight "S" curve on front of shinbone. (12) Talus bone: top of bone is spoollike, riding in hingelike socket formed by tibia and fibula. (13) Big toe has only two bones, while rest of toes have three each. (14) Instep has strong arch.

MUSCLES

(15) Pectoralis. (16) Breast attaches on top of pectoralis. (17) Folds occur when body is bent forward. (18) Stomach fits into pelvic basin. (19) Sartorius. (20) Group of adductors. (21) Semi-tendinosus. (22) Fat deposits. (23) Tendons of adductors insert into inside of tibia head. (24) Gastrocnemius. (25) Soleus. (26) Flexor of the toes enters behind ankle, under arch, into sole of foot. (27) Achilles tendon. (28) Tibialis anterior. (29) "Ball" of foot pad. (30) Arch of instep. (31) Heel pad. (32) Vastus. (33) Rectus femoris. (34) Band of Richer shows only when leg is locked in straight position. (35) Kneecap and fat deposit form "8" shape. (36) Front of tibia head forms "V" shape not covered by muscles. (37) Gluteus. (38) Hipbone, next to surface, protrudes on males or thin people, but causes an indentation on females or heavy people. (39) Fat deposit. (40) Iliotibial band.

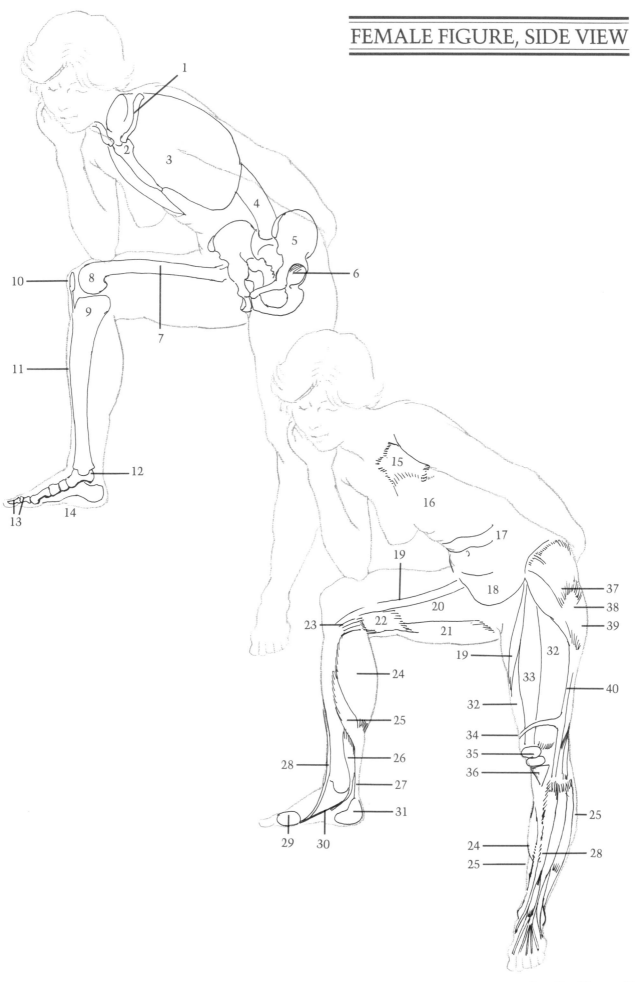

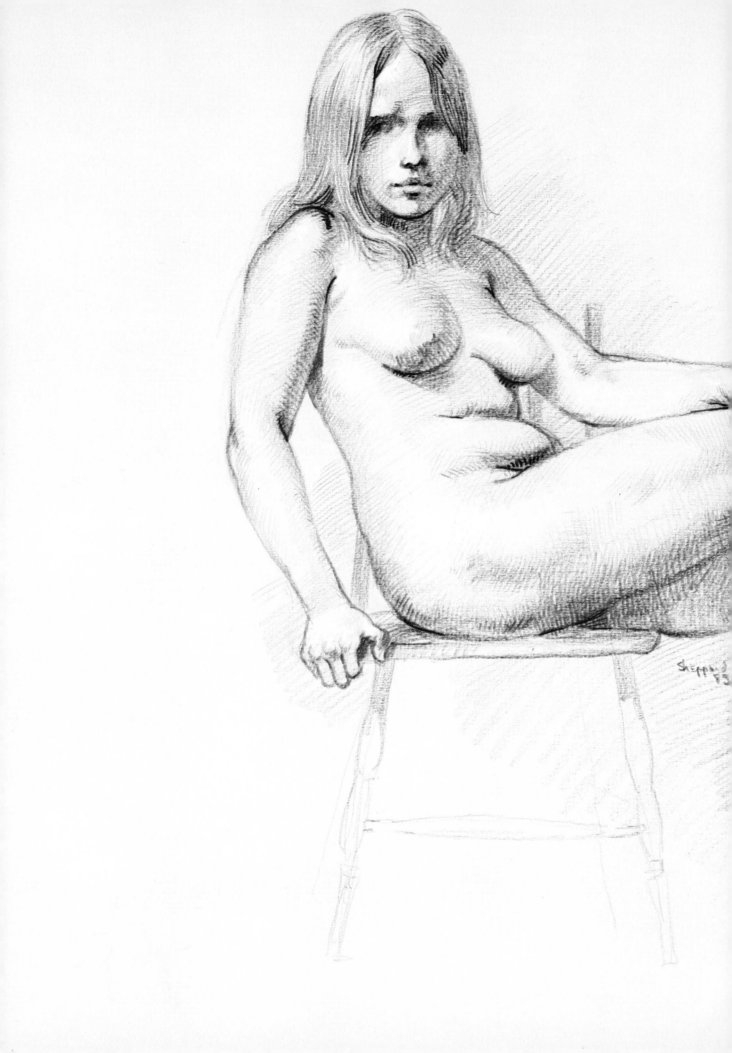

SEATED FIGURE

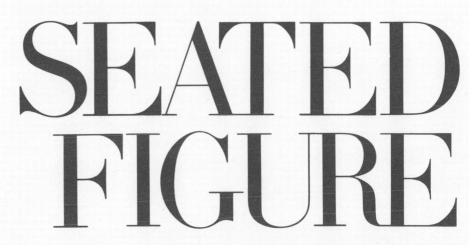

In the seated position the weight is transferred from the legs and feet to the buttocks and thighs. Sometimes the weight is also distributed to the arms and head. The legs as well as the arms are more likely to be foreshortened, creating more difficulty in drawing.

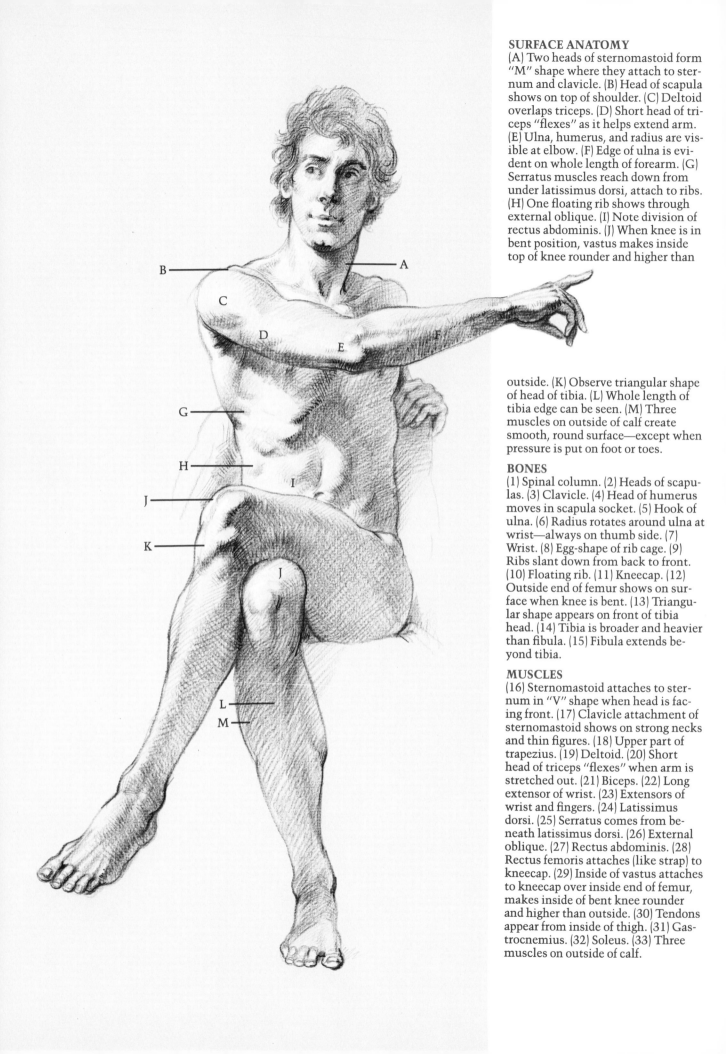

SURFACE ANATOMY

(A) Two heads of sternomastoid form "M" shape where they attach to sternum and clavicle. (B) Head of scapula shows on top of shoulder. (C) Deltoid overlaps triceps. (D) Short head of triceps "flexes" as it helps extend arm. (E) Ulna, humerus, and radius are visible at elbow. (F) Edge of ulna is evident on whole length of forearm. (G) Serratus muscles reach down from under latissimus dorsi, attach to ribs. (H) One floating rib shows through external oblique. (I) Note division of rectus abdominis. (J) When knee is in bent position, vastus makes inside top of knee rounder and higher than outside. (K) Observe triangular shape of head of tibia. (L) Whole length of tibia edge can be seen. (M) Three muscles on outside of calf create smooth, round surface—except when pressure is put on foot or toes.

BONES

(1) Spinal column. (2) Heads of scapulas. (3) Clavicle. (4) Head of humerus moves in scapula socket. (5) Hook of ulna. (6) Radius rotates around ulna at wrist—always on thumb side. (7) Wrist. (8) Egg-shape of rib cage. (9) Ribs slant down from back to front. (10) Floating rib. (11) Kneecap. (12) Outside end of femur shows on surface when knee is bent. (13) Triangular shape appears on front of tibia head. (14) Tibia is broader and heavier than fibula. (15) Fibula extends beyond tibia.

MUSCLES

(16) Sternomastoid attaches to sternum in "V" shape when head is facing front. (17) Clavicle attachment of sternomastoid shows on strong necks and thin figures. (18) Upper part of trapezius. (19) Deltoid. (20) Short head of triceps "flexes" when arm is stretched out. (21) Biceps. (22) Long extensor of wrist. (23) Extensors of wrist and fingers. (24) Latissimus dorsi. (25) Serratus comes from beneath latissimus dorsi. (26) External oblique. (27) Rectus abdominis. (28) Rectus femoris attaches (like strap) to kneecap. (29) Inside of vastus attaches to kneecap over inside end of femur, makes inside of bent knee rounder and higher than outside. (30) Tendons appear from inside of thigh. (31) Gastrocnemius. (32) Soleus. (33) Three muscles on outside of calf.

MALE FIGURE, FRONT VIEW

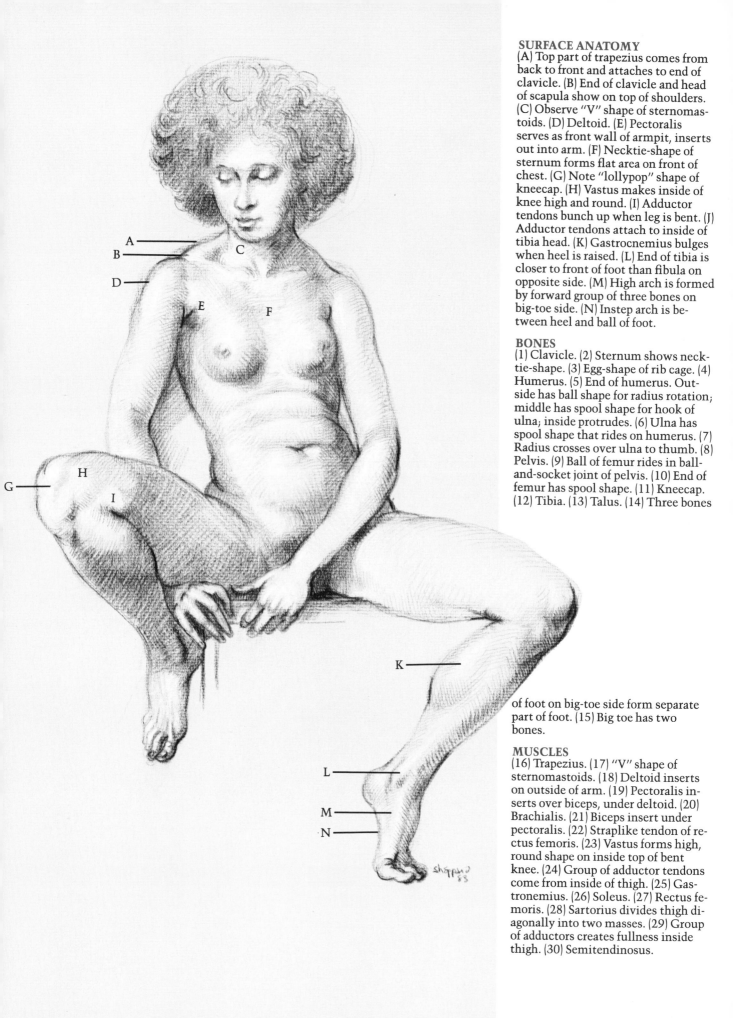

SURFACE ANATOMY
(A) Top part of trapezius comes from back to front and attaches to end of clavicle. (B) End of clavicle and head of scapula show on top of shoulders. (C) Observe "V" shape of sternomastoids. (D) Deltoid. (E) Pectoralis serves as front wall of armpit, inserts out into arm. (F) Necktie-shape of sternum forms flat area on front of chest. (G) Note "lollypop" shape of kneecap. (H) Vastus makes inside of knee high and round. (I) Adductor tendons bunch up when leg is bent. (J) Adductor tendons attach to inside of tibia head. (K) Gastrocnemius bulges when heel is raised. (L) End of tibia is closer to front of foot than fibula on opposite side. (M) High arch is formed by forward group of three bones on big-toe side. (N) Instep arch is between heel and ball of foot.

BONES
(1) Clavicle. (2) Sternum shows necktie-shape. (3) Egg-shape of rib cage. (4) Humerus. (5) End of humerus. Outside has ball shape for radius rotation; middle has spool shape for hook of ulna; inside protrudes. (6) Ulna has spool shape that rides on humerus. (7) Radius crosses over ulna to thumb. (8) Pelvis. (9) Ball of femur rides in ball-and-socket joint of pelvis. (10) End of femur has spool shape. (11) Kneecap. (12) Tibia. (13) Talus. (14) Three bones of foot on big-toe side form separate part of foot. (15) Big toe has two bones.

MUSCLES
(16) Trapezius. (17) "V" shape of sternomastoids. (18) Deltoid inserts on outside of arm. (19) Pectoralis inserts over biceps, under deltoid. (20) Brachialis. (21) Biceps insert under pectoralis. (22) Straplike tendon of rectus femoris. (23) Vastus forms high, round shape on inside top of bent knee. (24) Group of adductor tendons come from inside of thigh. (25) Gastronemius. (26) Soleus. (27) Rectus femoris. (28) Sartorius divides thigh diagonally into two masses. (29) Group of adductors creates fullness inside thigh. (30) Semitendinosus.

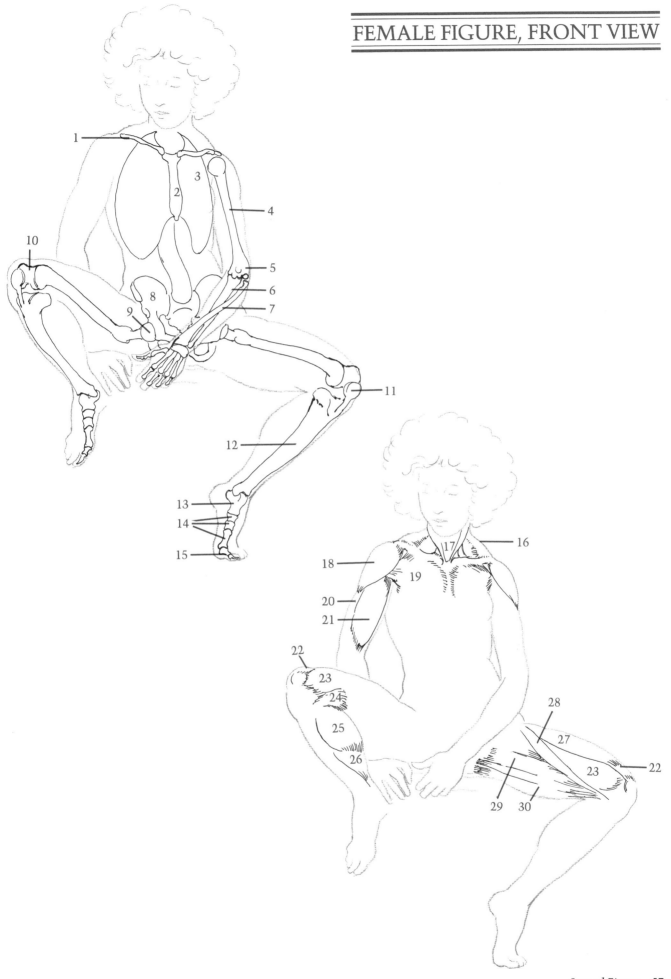

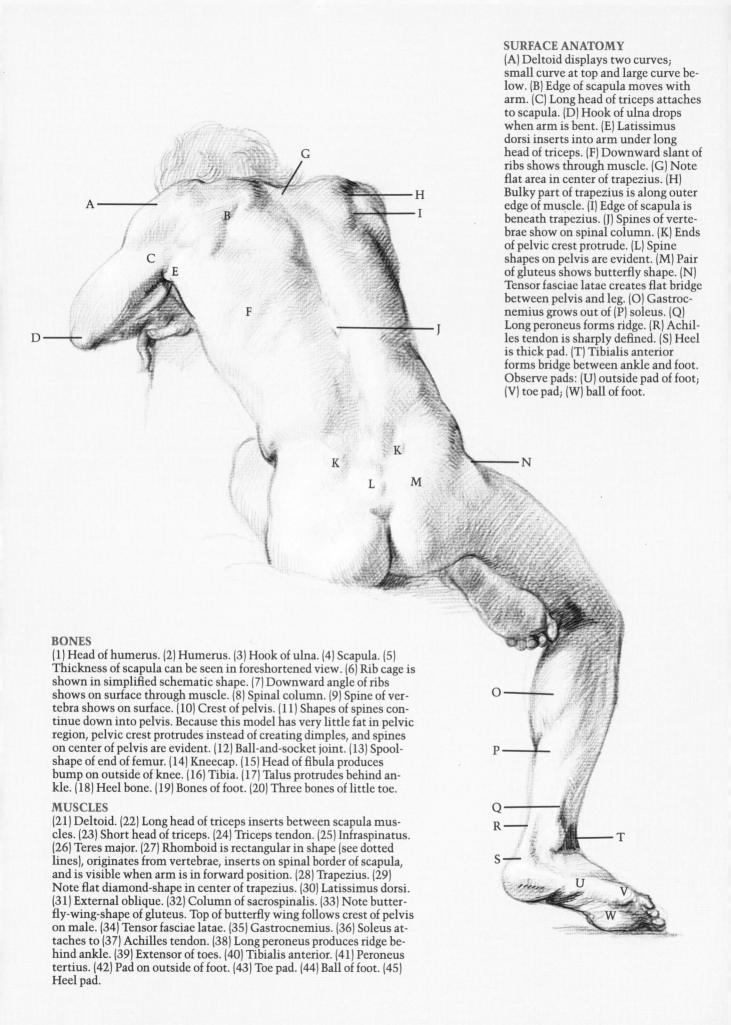

SURFACE ANATOMY
(A) Deltoid displays two curves; small curve at top and large curve below. (B) Edge of scapula moves with arm. (C) Long head of triceps attaches to scapula. (D) Hook of ulna drops when arm is bent. (E) Latissimus dorsi inserts into arm under long head of triceps. (F) Downward slant of ribs shows through muscle. (G) Note flat area in center of trapezius. (H) Bulky part of trapezius is along outer edge of muscle. (I) Edge of scapula is beneath trapezius. (J) Spines of vertebrae show on spinal column. (K) Ends of pelvic crest protrude. (L) Spine shapes on pelvis are evident. (M) Pair of gluteus shows butterfly shape. (N) Tensor fasciae latae creates flat bridge between pelvis and leg. (O) Gastrocnemius grows out of (P) soleus. (Q) Long peroneus forms ridge. (R) Achilles tendon is sharply defined. (S) Heel is thick pad. (T) Tibialis anterior forms bridge between ankle and foot. Observe pads: (U) outside pad of foot; (V) toe pad; (W) ball of foot.

BONES
(1) Head of humerus. (2) Humerus. (3) Hook of ulna. (4) Scapula. (5) Thickness of scapula can be seen in foreshortened view. (6) Rib cage is shown in simplified schematic shape. (7) Downward angle of ribs shows on surface through muscle. (8) Spinal column. (9) Spine of vertebra shows on surface. (10) Crest of pelvis. (11) Shapes of spines continue down into pelvis. Because this model has very little fat in pelvic region, pelvic crest protrudes instead of creating dimples, and spines on center of pelvis are evident. (12) Ball-and-socket joint. (13) Spool-shape of end of femur. (14) Kneecap. (15) Head of fibula produces bump on outside of knee. (16) Tibia. (17) Talus protrudes behind ankle. (18) Heel bone. (19) Bones of foot. (20) Three bones of little toe.

MUSCLES
(21) Deltoid. (22) Long head of triceps inserts between scapula muscles. (23) Short head of triceps. (24) Triceps tendon. (25) Infraspinatus. (26) Teres major. (27) Rhomboid is rectangular in shape (see dotted lines), originates from vertebrae, inserts on spinal border of scapula, and is visible when arm is in forward position. (28) Trapezius. (29) Note flat diamond-shape in center of trapezius. (30) Latissimus dorsi. (31) External oblique. (32) Column of sacrospinalis. (33) Note butterfly-wing-shape of gluteus. Top of butterfly wing follows crest of pelvis on male. (34) Tensor fasciae latae. (35) Gastrocnemius. (36) Soleus attaches to (37) Achilles tendon. (38) Long peroneus produces ridge behind ankle. (39) Extensor of toes. (40) Tibialis anterior. (41) Peroneus tertius. (42) Pad on outside of foot. (43) Toe pad. (44) Ball of foot. (45) Heel pad.

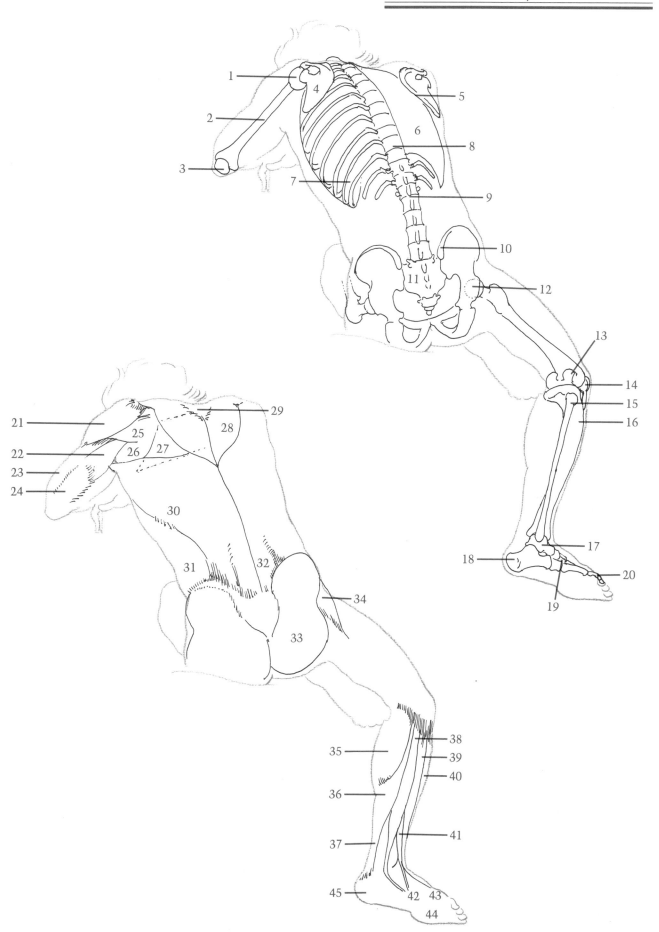

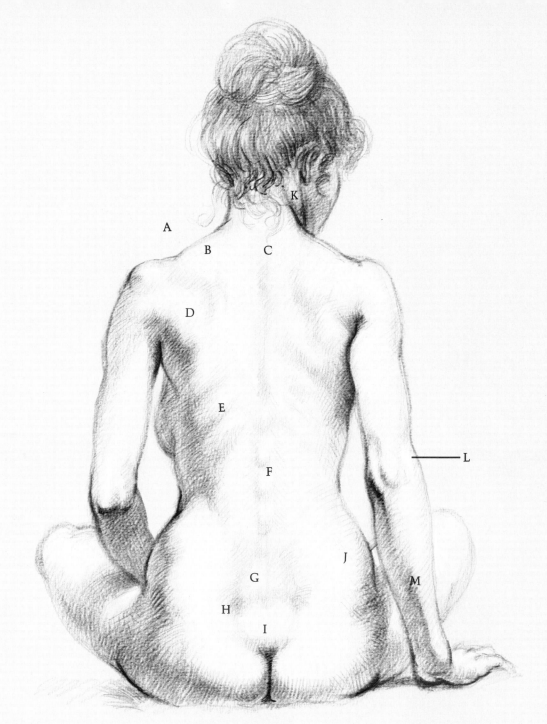

SURFACE ANATOMY

(A) Head of scapula creates bump on shoulder. (B) Trapezius forms outline of shoulder. (C) Spines of vertebrae show at base of neck. (D) Group of scapula muscles are covered with some fat tissue. (E) Ribs show through latissimus dorsi. (F) Spines of vertebrae can be seen in valley between muscles. (G) Beginning of sacrospinalis forms two columns at base of spine. (H) Dimple is produced by end of pelvic crest. (I) Note flat heart-shape of tail bone between gluteus muscles. (J) Large butterfly-wing-shapes are created by gluteus and fat tissue. (K) Sterno-mastoid attaches behind ear. (L) Outside contour of forearm is above elbow. (M) Edge of ulna is visible.

BONES

(1) Spinal column. (2) Rib cage. (3) Spines of vertebrae show between muscles. (4) Scapulas. (5) Head of humerus shows through muscle. (6) Ulna. (7) Radius crosses ulna to thumb side. (8) Wrist bones form arch. (9) Floating ribs. (10) Ends of pelvic crests create dimples. (11) Flat area of pelvis (tail bone).

MUSCLES

(12) Kite-shaped trapezius inserts into base of skull. (13) Sternomastoid. (14) Trapezius shows flat, diamond-shaped, tendinous surface. Spines of vertebrae are exposed. (15) Deltoid. (16) Group of scapula muscles. (17) Rhomboid fills in area between scapula muscles and latissimus dorsi. (18) Latissimus dorsi shows ribs through muscle. (19) External oblique. (20) Butterfly-shape of buttocks includes part of external oblique because of female hip fat. (21) Spines of vertebrae column appear. (22) Sacrospinalis. (23) Heart-shape shows between buttocks. (24) Fat covers crest of pelvis.

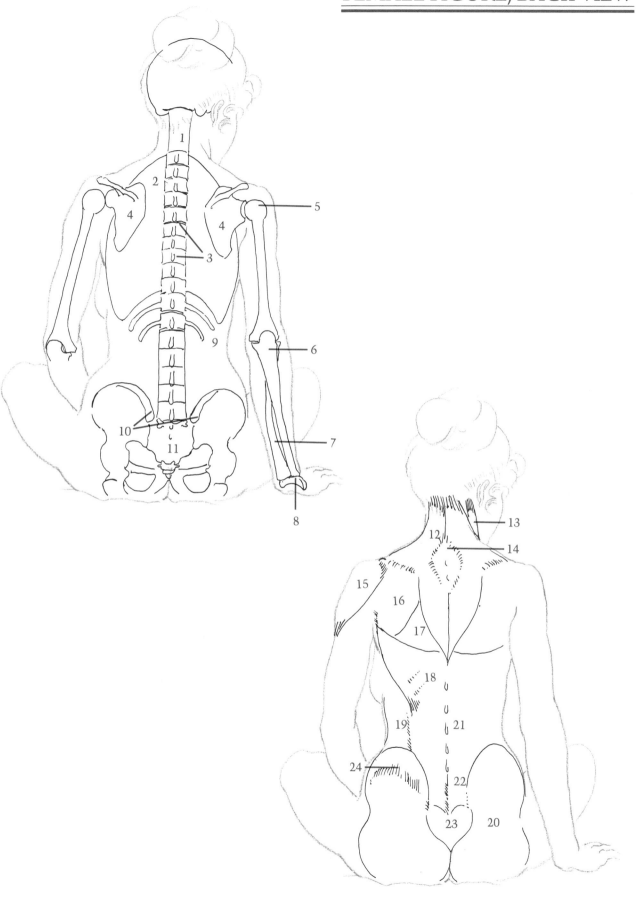

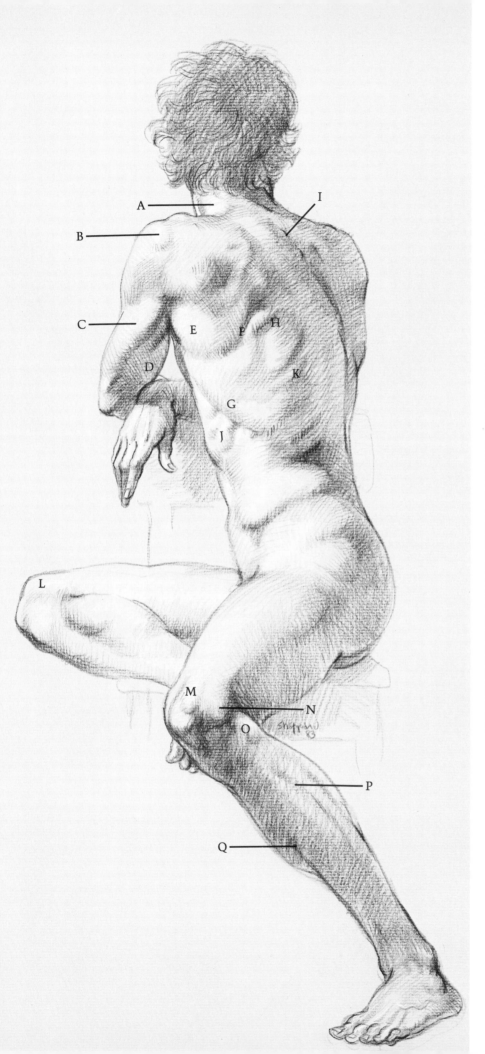

SURFACE ANATOMY

(A) Trapezius attaches to base of skull. (B) Deltoid shows bulge of humerus. (C) Long head of triceps runs diagonally. (D) Biceps curve is obvious in back view. (E) Teres major is bulky. (F) Edge of scapula is sharply defined. (G) Latissimus dorsi overlaps serratus. (H) Observe lower edge of rhomboid. (I) Spines show through flat diamond-shape of trapezius. (J) Serratus interlocks with external oblique. (K) Rib shows from beneath surface. (L) Inside of knee is high and round. (M) Note flat, straplike tendon of rectus femoris. (N) End of femur makes sharp edge. (O) Head of fibula is small bulge. (P) Divisions of three muscles appear on outside of calf. (Q) Front edge of tibia (shinbone) is next to skin.

BONES

(1) Spinal column is flexible and follows body movement. (2) Scapulas. (3) Rib cage. (4) Humerus. (5) Hook of ulna. (6) Wrist has arc-shape. (7) Five bones of hand. (8) Three bones of index finger. (9) Crest of pelvis. (10) Socket for femur. (11) Femur rides against (12) kneecap. (13) Tibia and (14) fibula form hingelike socket for (15) talus. (16) Heel bone. (17) Big toe has two bones. (18) Little toe and other toes have three bones.

MUSCLES

(19) Trapezius has kite-shape. (20) Diamond-shape appears within surface of trapezius. (21) Deltoid. (22) Long head of triceps. (23) Infraspinatus. (24) Teres major. (25) Biceps. (26) Rhomboid. (27) Latissimus dorsi reveals slant of ribs beneath surface. (28) External oblique reveals floating ribs showing through. (29) Tensor fasciae latae. (30) Gluteus. (31) Rectus femoris. (32) Vastus. (33) Iliotibial band. (34) Biceps femoris attaches to head of fibula. (35) Extensor of big toe. (36) Peroneus tertius. (37) Long peroneus connects ankle with foot. Heel is behind.

MALE FIGURE, THREE-QUARTER VIEW

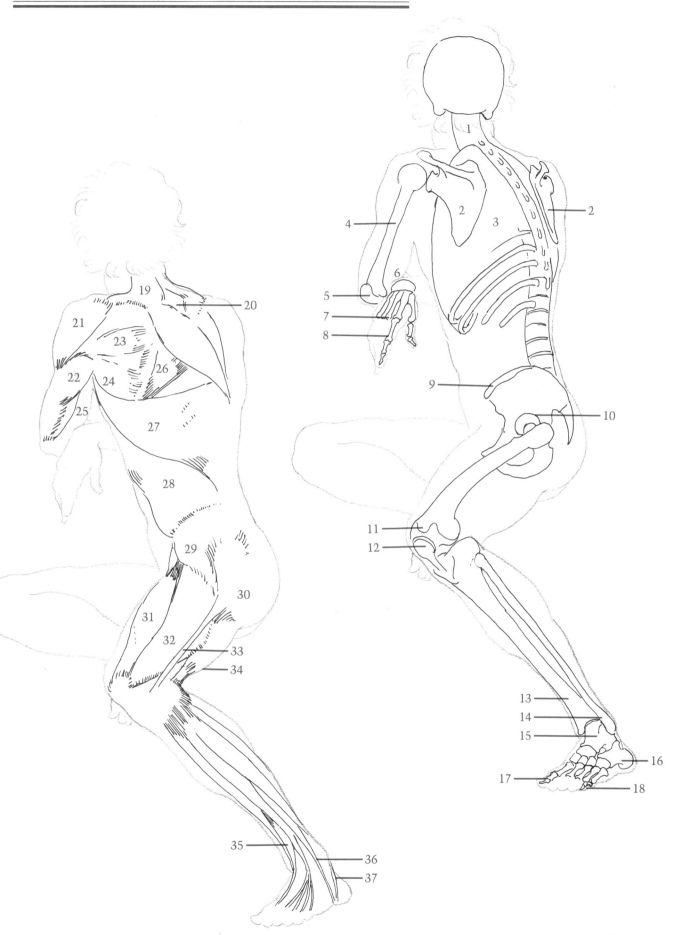

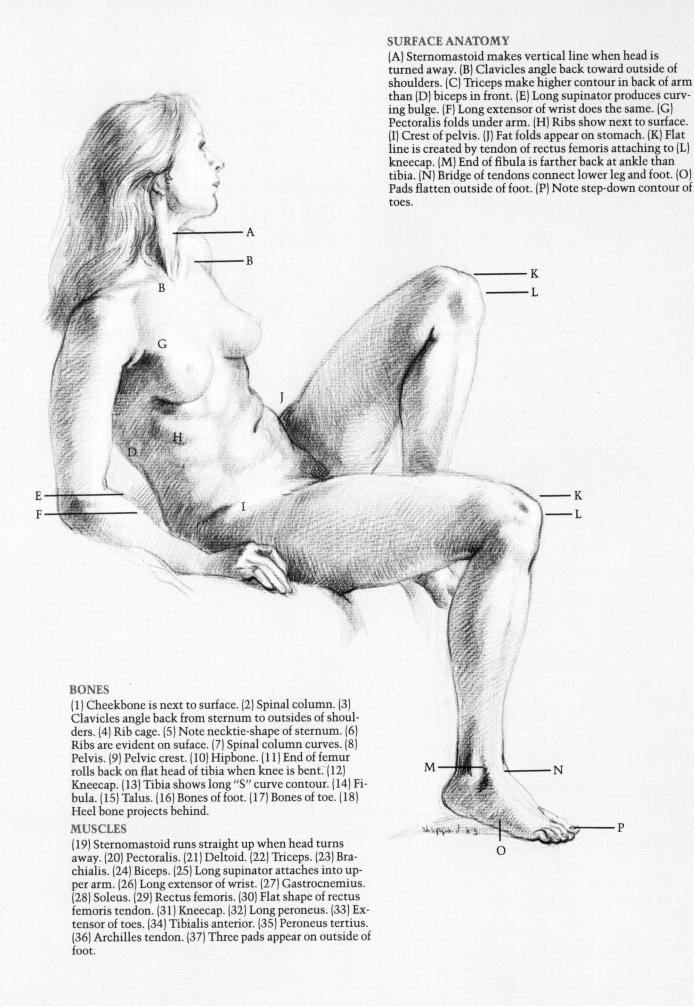

SURFACE ANATOMY

(A) Sternomastoid makes vertical line when head is turned away. (B) Clavicles angle back toward outside of shoulders. (C) Triceps make higher contour in back of arm than (D) biceps in front. (E) Long supinator produces curving bulge. (F) Long extensor of wrist does the same. (G) Pectoralis folds under arm. (H) Ribs show next to surface. (I) Crest of pelvis. (J) Fat folds appear on stomach. (K) Flat line is created by tendon of rectus femoris attaching to (L) kneecap. (M) End of fibula is farther back at ankle than tibia. (N) Bridge of tendons connect lower leg and foot. (O) Pads flatten outside of foot. (P) Note step-down contour of toes.

BONES

(1) Cheekbone is next to surface. (2) Spinal column. (3) Clavicles angle back from sternum to outsides of shoulders. (4) Rib cage. (5) Note necktie-shape of sternum. (6) Ribs are evident on suface. (7) Spinal column curves. (8) Pelvis. (9) Pelvic crest. (10) Hipbone. (11) End of femur rolls back on flat head of tibia when knee is bent. (12) Kneecap. (13) Tibia shows long "S" curve contour. (14) Fibula. (15) Talus. (16) Bones of foot. (17) Bones of toe. (18) Heel bone projects behind.

MUSCLES

(19) Sternomastoid runs straight up when head turns away. (20) Pectoralis. (21) Deltoid. (22) Triceps. (23) Brachialis. (24) Biceps. (25) Long supinator attaches into upper arm. (26) Long extensor of wrist. (27) Gastrocnemius. (28) Soleus. (29) Rectus femoris. (30) Flat shape of rectus femoris tendon. (31) Kneecap. (32) Long peroneus. (33) Extensor of toes. (34) Tibialis anterior. (35) Peroneus tertius. (36) Archilles tendon. (37) Three pads appear on outside of foot.

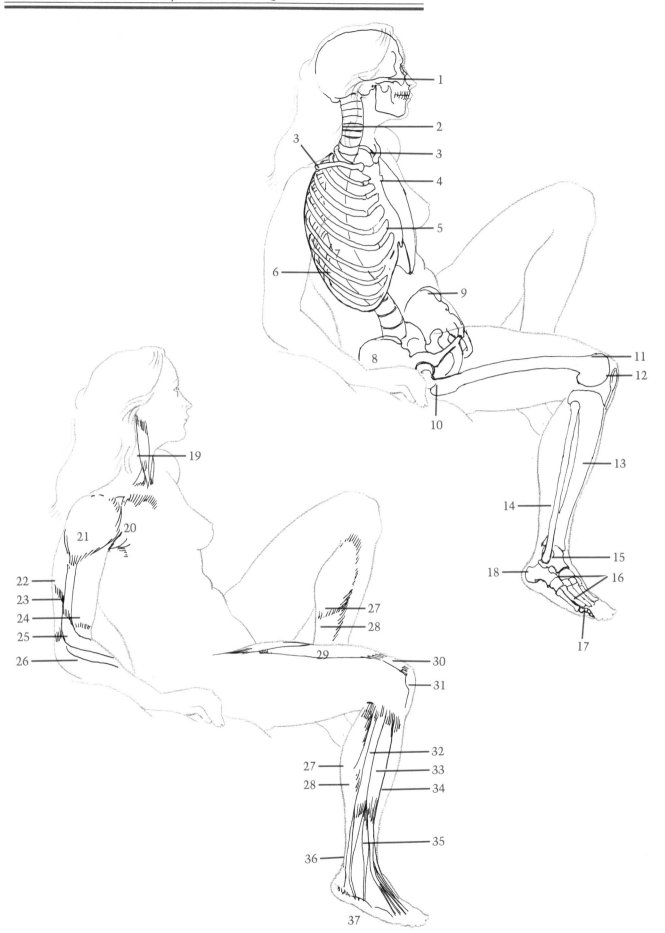

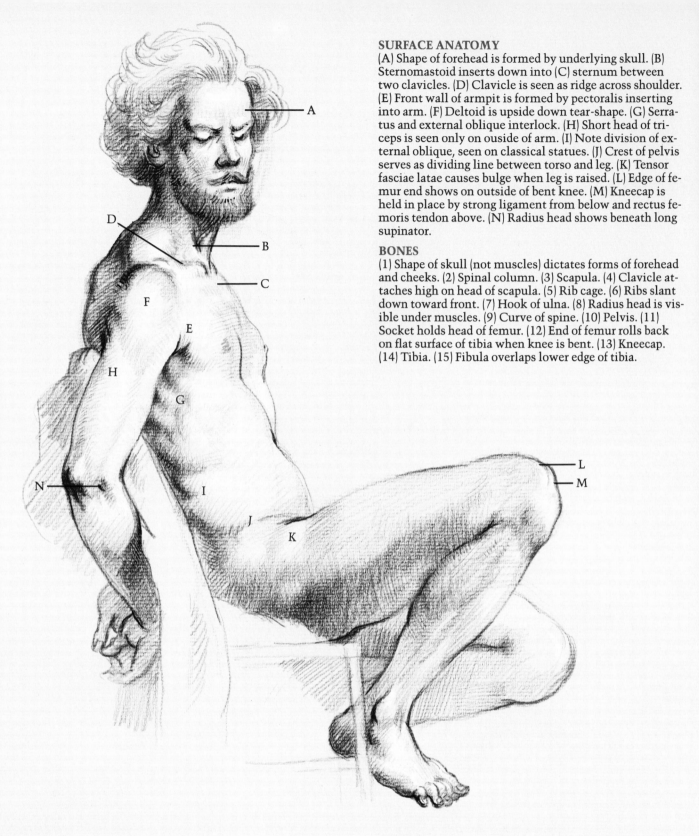

SURFACE ANATOMY

(A) Shape of forehead is formed by underlying skull. (B) Sternomastoid inserts down into (C) sternum between two clavicles. (D) Clavicle is seen as ridge across shoulder. (E) Front wall of armpit is formed by pectoralis inserting into arm. (F) Deltoid is upside down tear-shape. (G) Serratus and external oblique interlock. (H) Short head of triceps is seen only on ouside of arm. (I) Note division of external oblique, seen on classical statues. (J) Crest of pelvis serves as dividing line between torso and leg. (K) Tensor fasciae latae causes bulge when leg is raised. (L) Edge of femur end shows on outside of bent knee. (M) Kneecap is held in place by strong ligament from below and rectus femoris tendon above. (N) Radius head shows beneath long supinator.

BONES

(1) Shape of skull (not muscles) dictates forms of forehead and cheeks. (2) Spinal column. (3) Scapula. (4) Clavicle attaches high on head of scapula. (5) Rib cage. (6) Ribs slant down toward front. (7) Hook of ulna. (8) Radius head is visible under muscles. (9) Curve of spine. (10) Pelvis. (11) Socket holds head of femur. (12) End of femur rolls back on flat surface of tibia when knee is bent. (13) Kneecap. (14) Tibia. (15) Fibula overlaps lower edge of tibia.

MUSCLES

(16) Trapezius top attaches to base of skull, clavicle, and spine of scapula. (17) Sternomastoid. (18) Deltoid. (19) Pectoralis inserts under deltoid into humerus. (20) Serratus is more evident when arm is drawn back or up. (21) Rectus abdominis. (22) External oblique attaches to pelvic crest, inserts between serratus to ribs. (23) Gluteus. (24) Tensor fasciae latae. (25) Short head of triceps is flexed. (26) Triceps tendon. (27) Long supinator. (28) Long extensor of wrist. (29) Rectus femoris creates contour of top of leg. (30) Vastus. (31) Iliotibial band. (32) Group of three muscles appears on outside of calf.

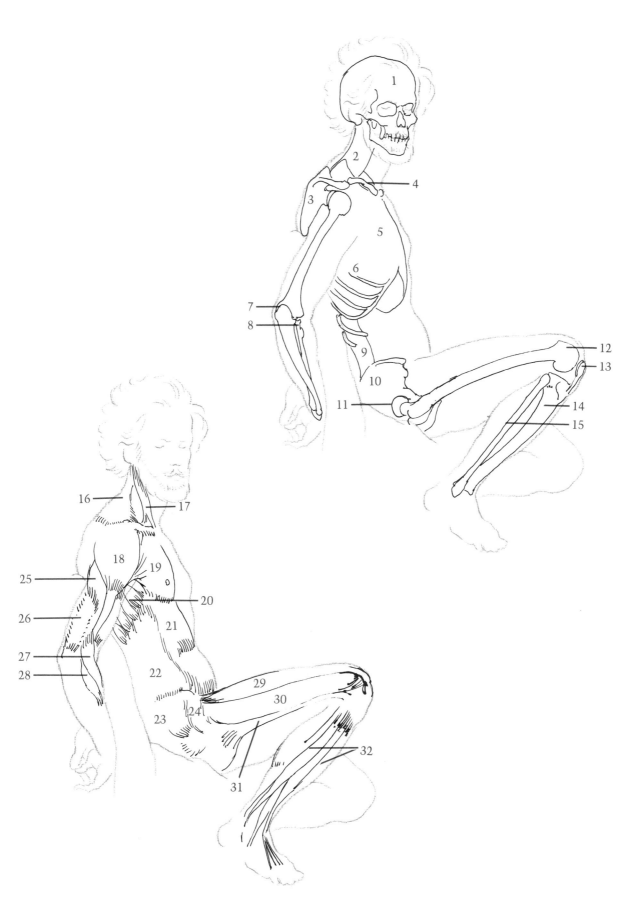

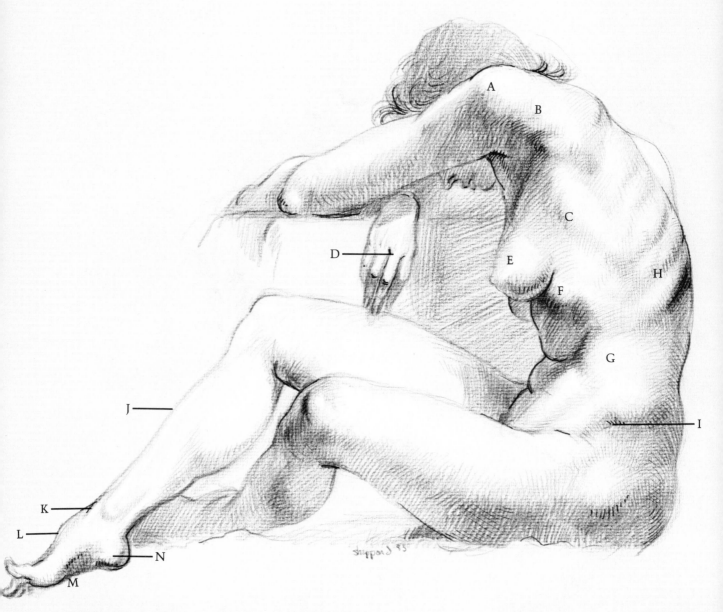

SURFACE ANATOMY
(A) Deltoid displays bulge of humerus within. (B) Muscles of scapula insert into arm. (C) Edge of lattissimus dorsi is visible. (D) Middle knuckle and middle finger are longest. (E) Breasts attach on top of pectoralis muscle. (F) Note edge of ribcage cavity. (G) Fat covers external oblique. (H) Ribs show through muscle. (I) Fat covers pelvic crest; small indentation is visible. (J) Edge of tibia (shinbone) creates contour of front of lower leg. (K) Tendon of tibialis anterior crosses over into instep. (L) High arch on top of foot is on big toe side. (M) Instep arch is pronounced when top is raised. (N) Heel is on little-toe side of foot.

BONES
(1) Radius. (2) Ulna. (3) Humerus. (4) Head of humerus is ball-shaped. (5) Scapula. (6) Rib cage. (7) Spinal column. (8) Middle finger is longest and straightest; ring finger is next in length; index finger is shorter still; little finger is shortest. Arch is formed by line of knuckles; middle finger is highest point. (9) Crest of pelvis. (10) Ends of femurs are like spools. (11) Kneecap. (12) Tibia. (13) Talus. (14) High arch is on big toe side. (Foot is in two separate parts. Line of bones on big-toe side makes one part. Bones of other toes and heel make the second part.)

MUSCLES
(15) Deltoid. (16) Long head of triceps. (17) Triceps tendon. (18) Infraspinatus. (19) Teres major, plus latissimus dorsi, inserts into humerus under long head of triceps. They help rotate arm. (20) Latissimus dorsi. (21) Pectoralis, with latissimus dorsi, form front and back walls of arm pit. (22) External oblique is covered by fat tissue. (23) Tensor fasciae latae. (24) Gluteus. (25) Rectus femoris. (26) Tendon of rectus femoris. (27) Iliotibial band. (28) Vastus is made rounder by underlying end of femur. (29) Gastrocnemius. (30) Soleus. (31) Tibialis anterior crosses over from other side of leg. (32) Extensor of big toe. (33) Flexor of toes inserts into underside of foot.

FEMALE FIGURE, SIDE VIEW

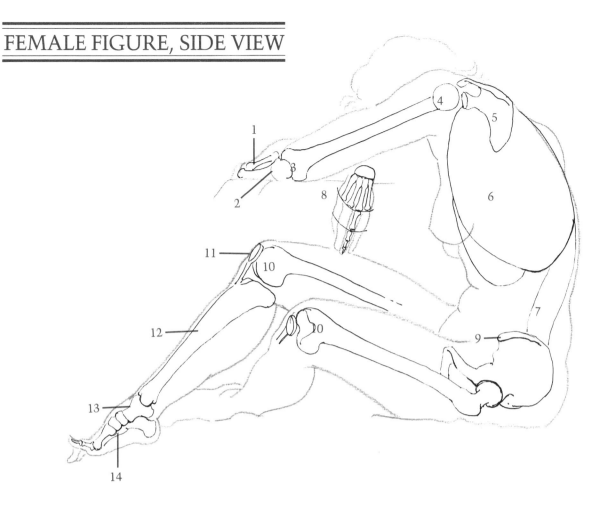

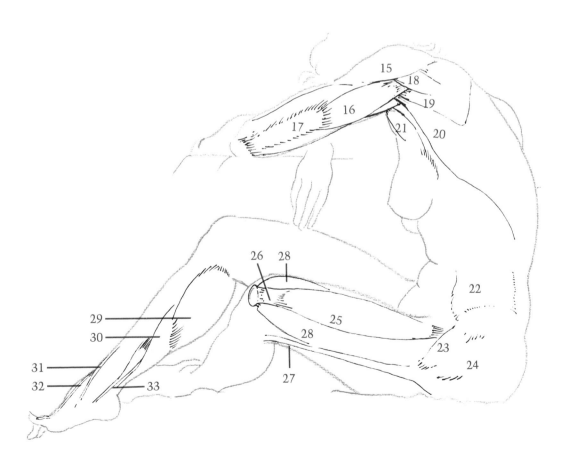

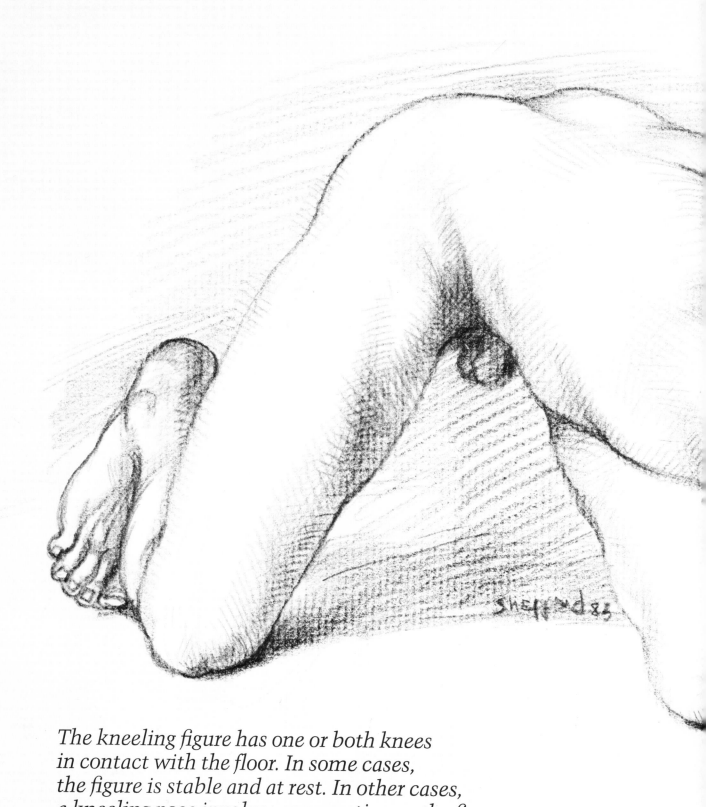

The kneeling figure has one or both knees
in contact with the floor. In some cases,
the figure is stable and at rest. In other cases,
a kneeling pose involves some action as the figure
tilts, bends, or reaches outward.

KNEELING FIGURE

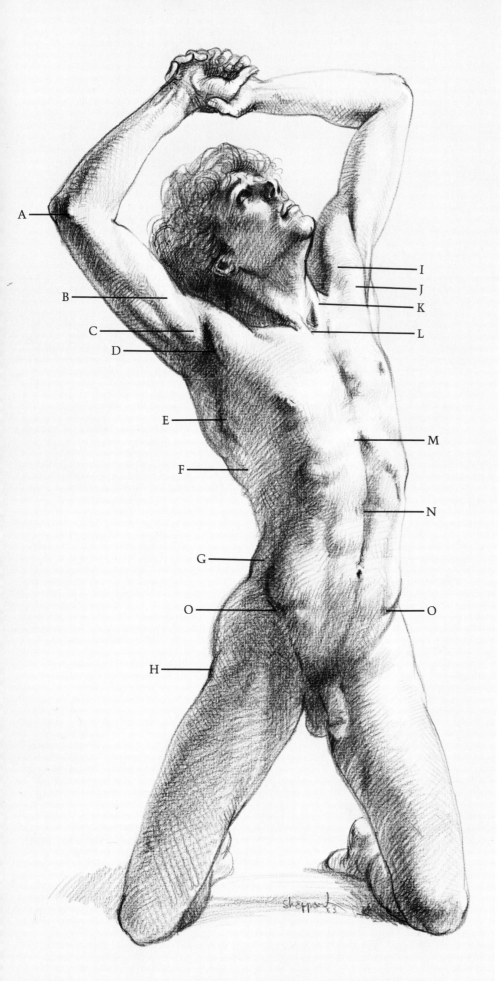

SURFACE ANATOMY

(A) End of humerus protrudes on inside of elbow. (B) Biceps and (C) coracobrachialis insert under (D) ledge created by deltoid and pectoralis. (E) Serratus attach to underside of scapula, insert down into ribs. Serratus muscles are round, intersecting with flat (F) insertions of external oblique. (G) Note round, full pad of external oblique. (H) Hipbone protrudes, is always next to surface, either protruding or causing depression. (I) Deltoid and (J) pectoralis form front wall of armpit. (K) Sternomastoids meet at pit of neck. (L) "V" shape is created by insertion of two sternomastoids. (M) Arch is formed by rib cage cavity. (N) Rectus abdominis is divided. (O) Crests of pelvis form basin to hold stomach.

BONES

(1) Group of wrist bones. (2) Ulna. (3) Radius is on thumb side and longer at wrist. (4) Hook of ulna. (5) Humerus end protrudes on inside of elbow. (6) Humerus head is ball-shaped. (7) Scapula. (8) Acromion process is part of scapula that extends away from center of body. (9) End of clavicle. (10) Coracoid process is part of scapula that extends forward from underside. (11) Rib cage. (12) Crests of pelvis curve forward to surround and hold stomach. (13) Hipbone protrudes on lean figure. (14) End of femur. (15) Kneecap is slender when seen from top.

MUSCLES

(16) Triceps. (17) Biceps. (18) Coracobrachialis is seen only when arm is raised. (19) Deltoid. (20) Latissimus dorsi. (21) Pectoralis flattens and stretches when arm is raised. (22) Serratus. (23) External oblique. (24) Sternomastoids. (25) Rectus abdominis displays vertical and horizontal divisions. (26) Flank of external oblique is bulky; upper part of muscle is flat. (27) Sheath of rectus abdominis also stretches and flattens.

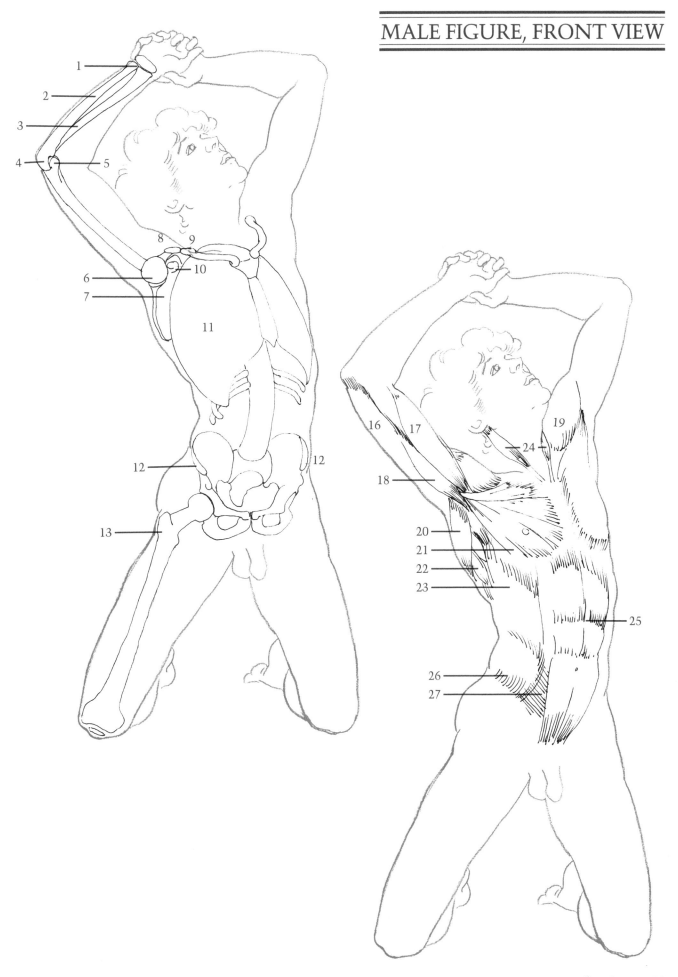

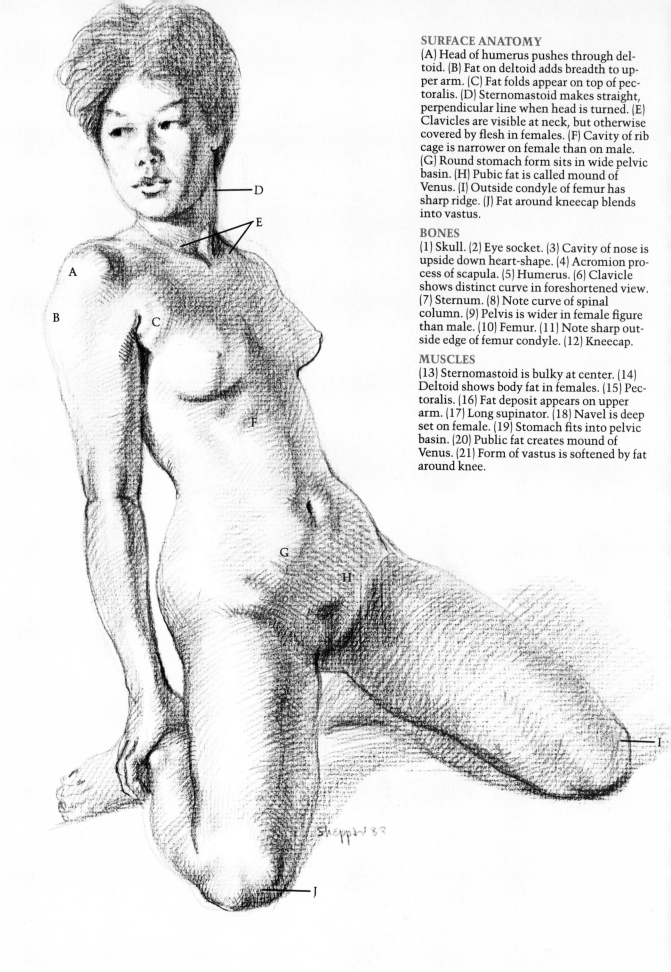

SURFACE ANATOMY

(A) Head of humerus pushes through deltoid. (B) Fat on deltoid adds breadth to upper arm. (C) Fat folds appear on top of pectoralis. (D) Sternomastoid makes straight, perpendicular line when head is turned. (E) Clavicles are visible at neck, but otherwise covered by flesh in females. (F) Cavity of rib cage is narrower on female than on male. (G) Round stomach form sits in wide pelvic basin. (H) Pubic fat is called mound of Venus. (I) Outside condyle of femur has sharp ridge. (J) Fat around kneecap blends into vastus.

BONES

(1) Skull. (2) Eye socket. (3) Cavity of nose is upside down heart-shape. (4) Acromion process of scapula. (5) Humerus. (6) Clavicle shows distinct curve in foreshortened view. (7) Sternum. (8) Note curve of spinal column. (9) Pelvis is wider in female figure than male. (10) Femur. (11) Note sharp outside edge of femur condyle. (12) Kneecap.

MUSCLES

(13) Sternomastoid is bulky at center. (14) Deltoid shows body fat in females. (15) Pectoralis. (16) Fat deposit appears on upper arm. (17) Long supinator. (18) Navel is deep set on female. (19) Stomach fits into pelvic basin. (20) Public fat creates mound of Venus. (21) Form of vastus is softened by fat around knee.

FEMALE FIGURE, FRONT VIEW

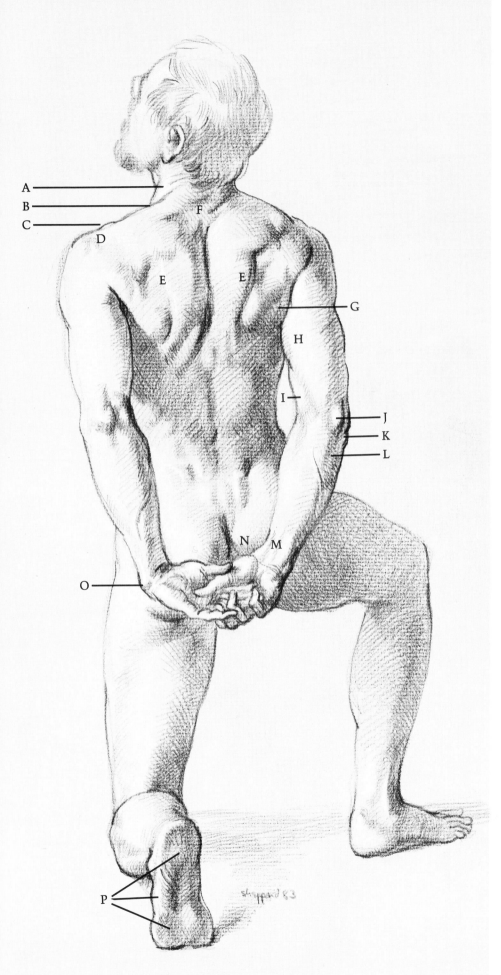

SURFACE ANATOMY

(A) Sternomastoid attaches behind ear. (B) Ridge is caused by trapezius. (C) Clavicle connects with (D) acromion process of scapula. (E) Thickness of trapezius can be seen. (F) Note flat, diamond-shaped, tendinous surface. (G) Muscles of scapula bunch up when arm is pulled back. (H) Bulky form is molded by triceps in back of arm. (I) Twisting pose reveals biceps from front of arm. (J) Hook of ulna is obvious. (K) Head of radius protrudes on outside of elbow. (L) Edge of ulna is next to surface. (M) Tendons of wrist and finger extensors show on underside of wrist. (N) Abductor of thumb creates angle on thumb side of wrist. (O) End of ulna protrudes, especially when wrist is bent. (P) Sole of foot is made up of pads.

BONES

(1) Skull. (2) Upper spinal column curves as head tilts back. (3) Clavicle. (4) Acromion process of scapula. (5) Head of humerus. (6) End of scapula moves back with arm. (7) Hook of ulna. (8) Head of radius. (9) Spines of vertebra often show in lower back. (10) Pelvic crest. (11) Radius is on thumb side of wrist. (12) End of ulna is prominent. (13) Bones of wrist. (14) Bone of the hand on little-finger side. (15) Three bones of little finger. (16) Rib cage. (17) Inside condyle of end of humerus protrudes.

MUSCLES

(18) Sternomastoid. (19) Trapezius contains flat diamond-shape. (20) Trapezius. (21) Group of scapula muscles is bunched because arm is pulled back. (22) Long head of triceps runs down center line of arm. (23) Short head of triceps is bulky and most prominent. (24) Internal head of triceps is seldom seen, except in this view. (25) Biceps. (26) Long supinator. (27) Flexor of wrist. (28) Extensors of wrist and fingers. (29) Abductor of thumb draws thumb toward back of hand. (30) "Ball" of thumb. (31) "Heel" of hand shows pad on little-finger side. (32) Heel pad. (33) Pad on little-toe side of foot. (34) Ball of foot. (35) Arch. (36) Pad of toes.

1

2

3

4

5

6

7

8

9

10

11

12

13

14

15

16

17

18

19

20

21

22

23

24

25

26

27

28

29

30

31

32

33

34

33 34

35

36

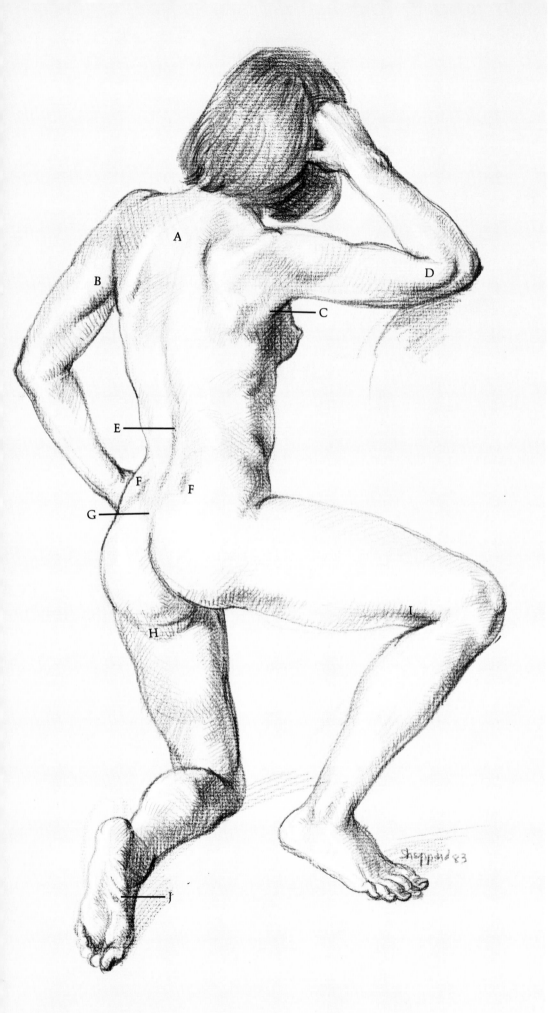

SURFACE ANATOMY
(A) Flat area appears in trapezius. (B) Note fullness of triceps. (C) Latissimus dorsi inserts into arm along with scapula muscles. (D) Long supinator bulges when arm is bent. (E) Groove is created by spinal column. (F) Dimples show at end of pelvic crests. (G) Sacrum is flat heart-shape. (H) Female fat develops under buttocks. (I) Biceps femoris tendon is sharp form. (J) Creases are evident in arch of foot.

BONES
(1) Skull. (2) Spinal column shows characteristic "S" curve. (3) Scapula. (4) Rib cage. (5) Sacrum. (6) Pelvis is shown in three-quarter view. (7) Longest knuckle. (8) Bones of wrist. (9) Radius. (10) Observe how ulna fits over end of humerus. (11) Humerus. (12) Note curve of femur. (13) Kneecap. (14) Fibula. (15) Tibia.

MUSCLES
(16) Deltoid. (17) Triceps. (18) Biceps. (19) Long supinator causes bulge at elbow. (20) Trapezius. (21) Latissimus dorsi. (22) Sacrospinalis follows inward curve of lower spine. (23) Heart-shape. (24) Creases are caused by bent leg. (25) Fat deposit. (26) Fat shows on inside of thigh. (27) Tendon of biceps femoris. (28) Tendons of toe extensors.

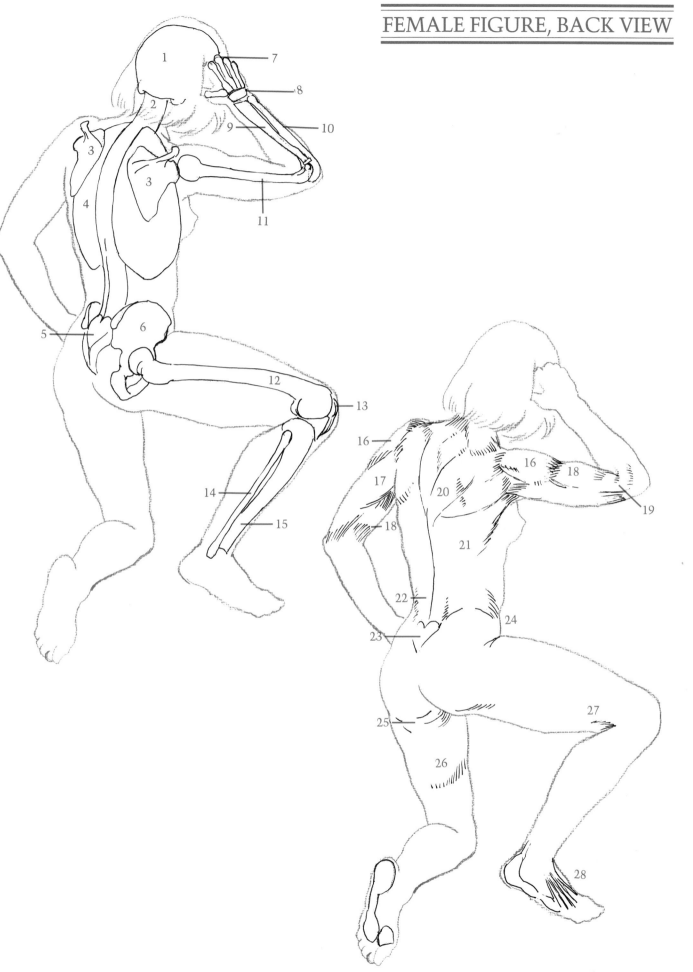

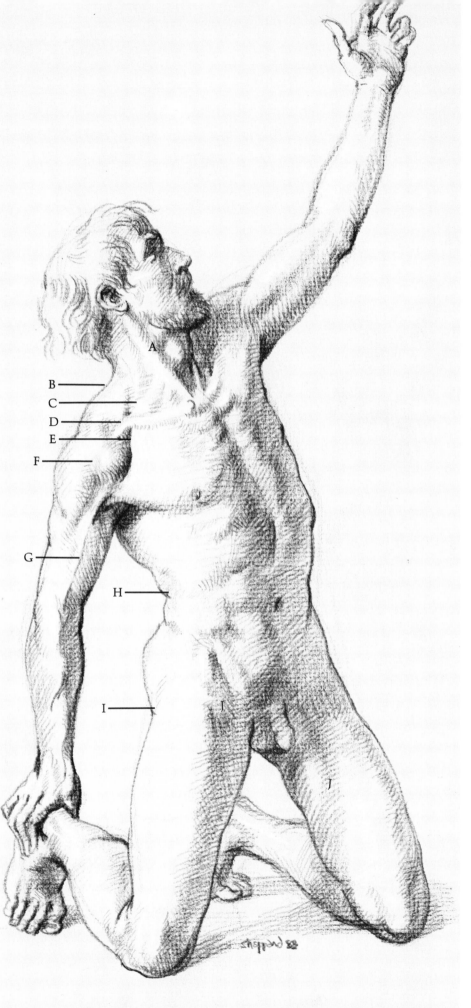

SURFACE ANATOMY
(A) Sternomastoid makes perpendicular line from behind ear to sternum when head is turned. Edge of (B) trapezius is interrupted by clavicle. (C) Underlying muscles show when neck is strained or turned. (D) Clavicle is shaped like "S" curve. (E) Continuous line is formed by deltoid and trapezius. (F) Division reveals two parts of front deltoid. (G) Strong vein is seen on males, dividing biceps and brachialis. (H) External oblique folds on itself. (I) Hipbone appears next to surface. (J) Sartorius crosses over front of thigh.

BONES
(1) Spinal column. (2) Clavicle. (3) Acromion process of scapula wraps around end of clavicle. (4) Humerus. (5) Rib cage is shown in simplified form. (6) Coracoid process. (7) First rib moves upward. (8) Second rib moves straight across. (9) Sternum shows rib attachments clearly. (10) Lumbar part of spinal column. (11) Pelvis. (12) Hipbone is next to surface.

MUSCLES
(13) Sternomastoid attaches to skull behind ear. (14) Underlying muscles. (15) Trapezius forms line with (16) deltoid. (17) Large vein appears between biceps and brachialis. (18) External oblique folds it on itself. (19) Gluteus. (20) Tensor fasciae latae. (21) Sartorius. (22) Rectus abdominis.

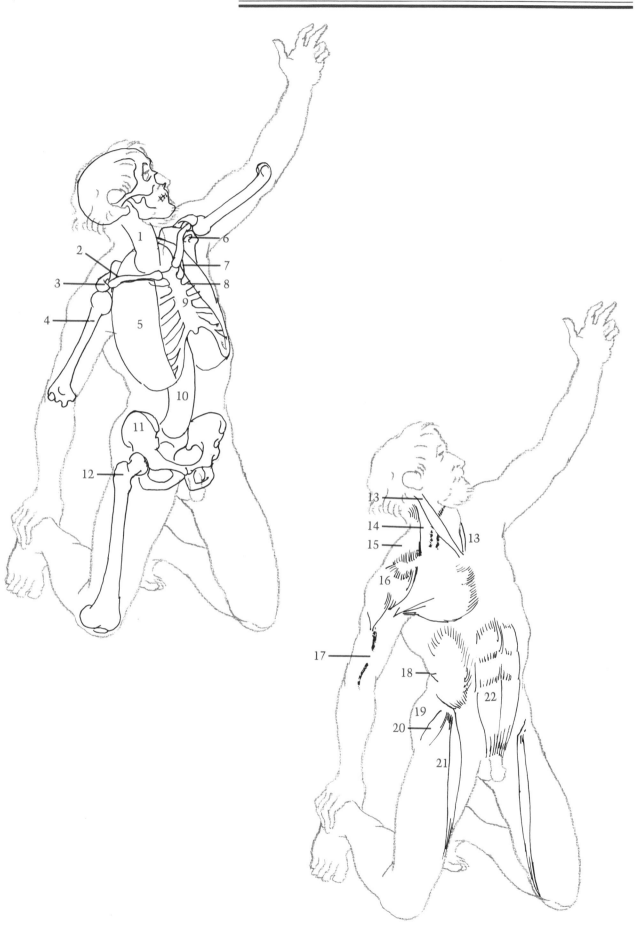

SURFACE ANATOMY

(A) Shape of hair follows curve of skull. (B) Beginning of bridge and underside of nose are bone. (C) Wrist is flat space between hand and arm. (D) Muscles are less sharply defined on female form: long supinator and long extensor seem one form. (E) Breast sits on top of pectoralis muscle. (F) Inside of calf sits behind tibia. (G) Shinbone (front of tibia) is next to skin.

(H) Outside of bent knee has sharp edge. (I) Inside of bent knee is round and full. (J) Tendon group creates one round form. (K) Kneecap is very distinct on bent knee.

BONES

(1) Skull determines profile of forehead. (2) Beginning of nose is bone. (3) Ring finger is second longest. (4) Fingers have three bones, except thumb which has two. (5) Bones of hand vary in length; bone of middle finger is longest. (6) Wrist bones are seen as flat group. (7) Radius crosses over ulna from outside of elbow toward thumb side of wrist. (8) Hook of ulna rides on humerus. (9) Humerus. (10) Inside condyle of femur end. (11) Outside condyle of femur end. (12) Kneecap. (13) Inside protuberance of ankle is higher than outside. (14) Hipbone.

MUSCLES

(15) Ulna extensor of wrist. (16) Extensor of fingers. (17) Long extensor of wrist. (18) Long supinator. (19) Pectoralis is beneath breast, which sits on top of muscle. (20) Biceps. (21) Brachialis is shown as flat surface on outside of upper arm. (22) Triceps. (23) Deltoid. (24) Tensor fasciae latae. (25) Rectus femoris. (26) Femur shows through vastus muscle, creating sharp edge. (27) Rectus femoris tendon attaches to kneecap. (28) Vastus is bulky on inside of knee, make shape higher and rounder than outside. (29) Sartorius. (30) Adductor muscles become bulky when leg is bent. (31) Tibialis anterior. (32) Long extensor of toes. (33) Long peroneus.

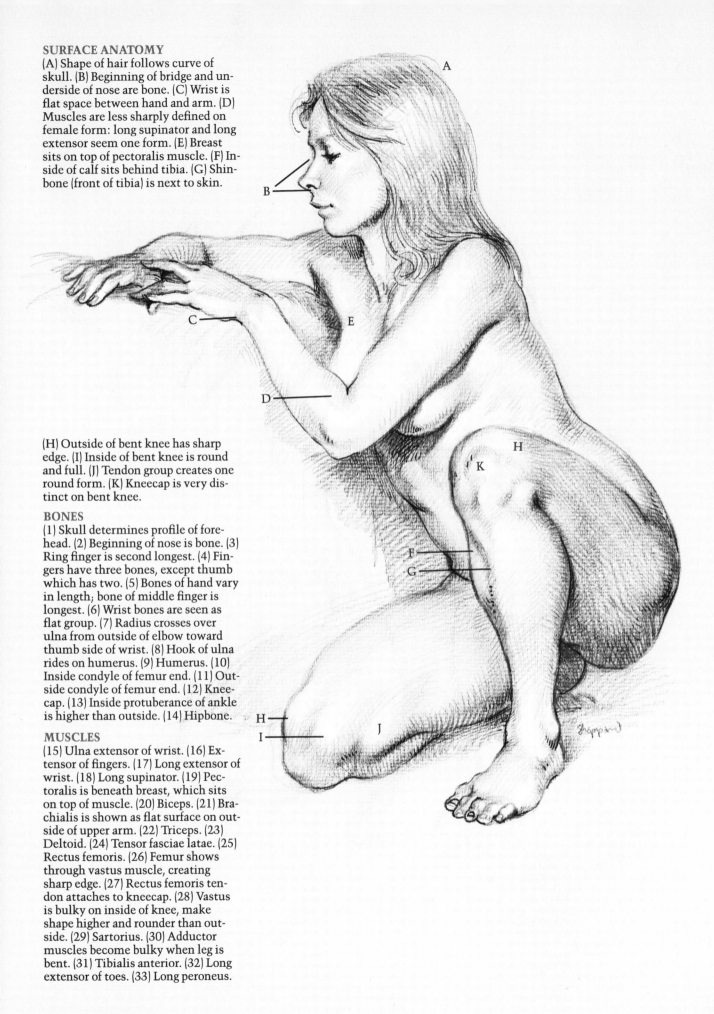

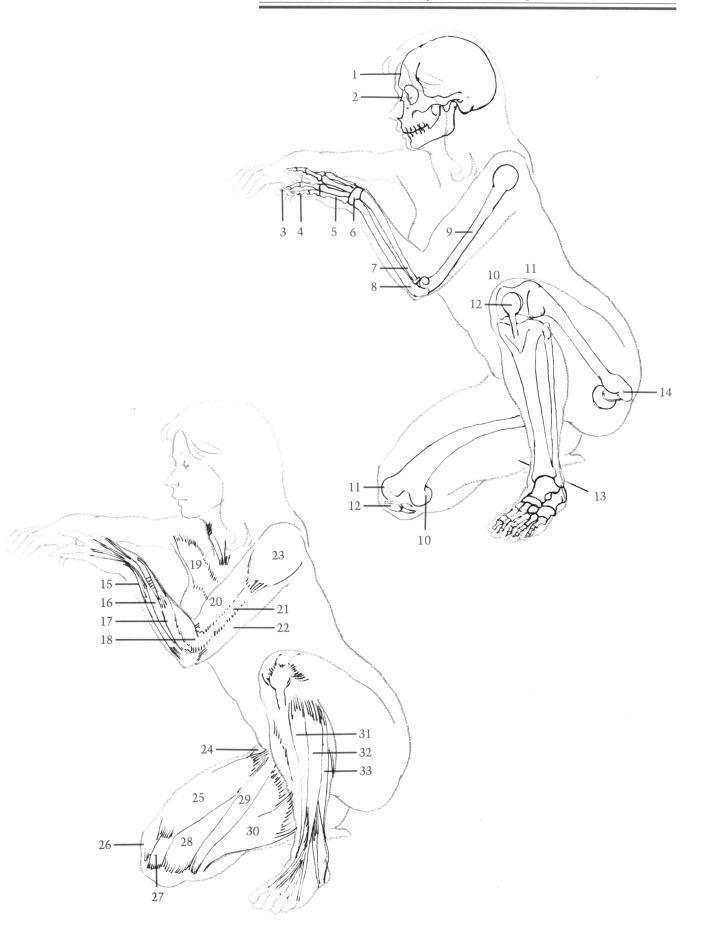

1
2

3 4 5 6

7
8

9

10 11
12

14

11
12

10

13

19 23

15
16 20
17 21
18 22

24 31
 32
 33

25 29

26 30

28

27

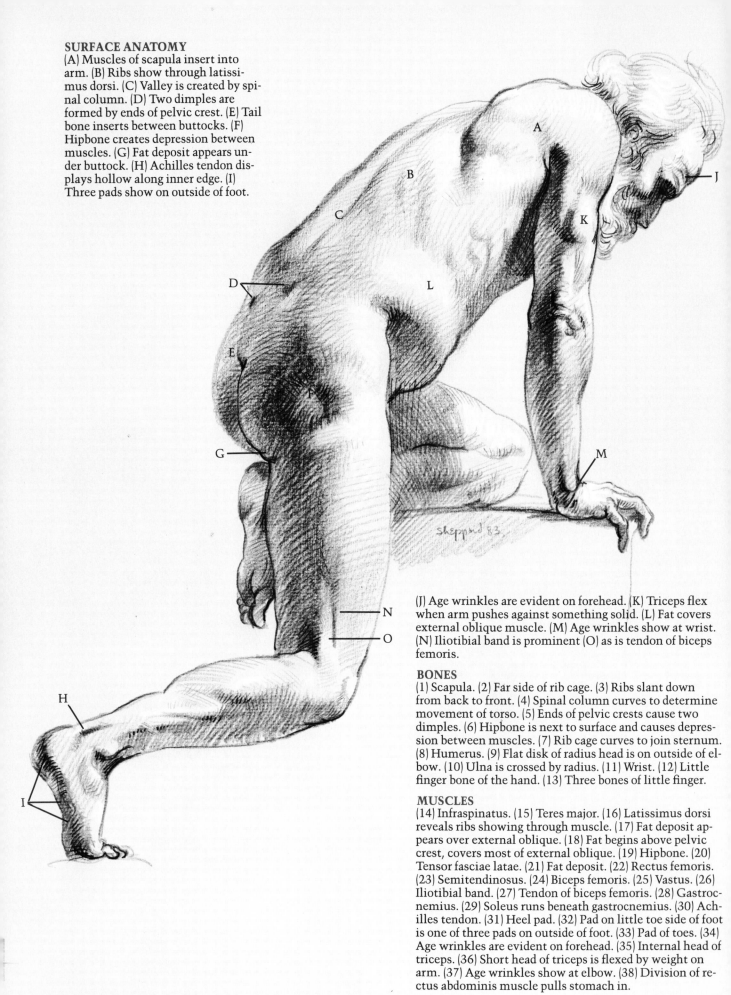

SURFACE ANATOMY

(A) Muscles of scapula insert into arm. (B) Ribs show through latissimus dorsi. (C) Valley is created by spinal column. (D) Two dimples are formed by ends of pelvic crest. (E) Tail bone inserts between buttocks. (F) Hipbone creates depression between muscles. (G) Fat deposit appears under buttock. (H) Achilles tendon displays hollow along inner edge. (I) Three pads show on outside of foot.

sheppard 83

(J) Age wrinkles are evident on forehead. (K) Triceps flex when arm pushes against something solid. (L) Fat covers external oblique muscle. (M) Age wrinkles show at wrist. (N) Iliotibial band is prominent (O) as is tendon of biceps femoris.

BONES

(1) Scapula. (2) Far side of rib cage. (3) Ribs slant down from back to front. (4) Spinal column curves to determine movement of torso. (5) Ends of pelvic crests cause two dimples. (6) Hipbone is next to surface and causes depression between muscles. (7) Rib cage curves to join sternum. (8) Humerus. (9) Flat disk of radius head is on outside of elbow. (10) Ulna is crossed by radius. (11) Wrist. (12) Little finger bone of the hand. (13) Three bones of little finger.

MUSCLES

(14) Infraspinatus. (15) Teres major. (16) Latissimus dorsi reveals ribs showing through muscle. (17) Fat deposit appears over external oblique. (18) Fat begins above pelvic crest, covers most of external oblique. (19) Hipbone. (20) Tensor fasciae latae. (21) Fat deposit. (22) Rectus femoris. (23) Semitendinosus. (24) Biceps femoris. (25) Vastus. (26) Iliotibial band. (27) Tendon of biceps femoris. (28) Gastrocnemius. (29) Soleus runs beneath gastrocnemius. (30) Achilles tendon. (31) Heel pad. (32) Pad on little toe side of foot is one of three pads on outside of foot. (33) Pad of toes. (34) Age wrinkles are evident on forehead. (35) Internal head of triceps. (36) Short head of triceps is flexed by weight on arm. (37) Age wrinkles show at elbow. (38) Division of rectus abdominis muscle pulls stomach in.

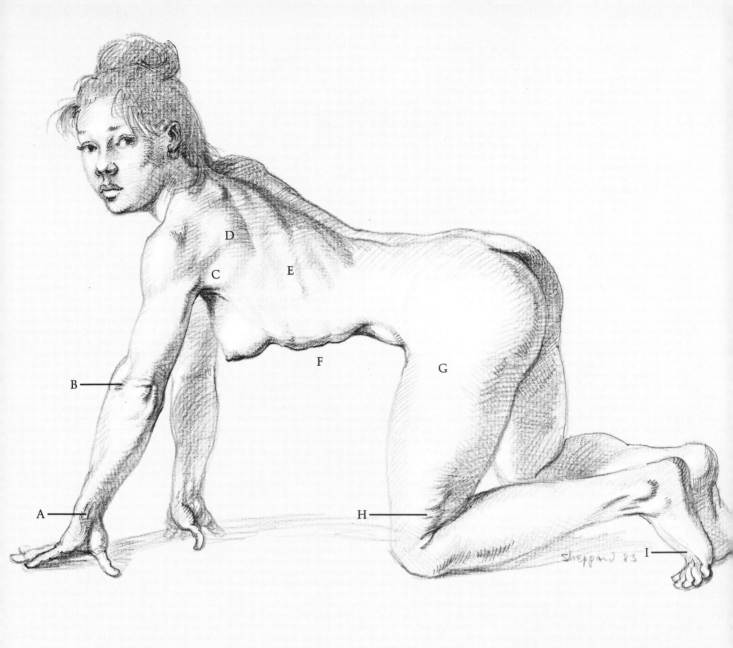

SURFACE ANATOMY

(A) Tendon of wrist flexor. (B) Groove appears under long supinator. (C) Edge of latissimus inserts into arm. (D) Scapula muscles are seen as one muscle mass. (E) Ribs slant downward showing through muscle. (F) Shape of ribs can be seen. (G) Fat on hips covers hipbone and muscles. (H) Fat dimples show on thigh. (I) Tendons of toe extensor are prominent when toes are bent up.

BONES

(1) Bones of palm. (2) Bones of wrist. (3) Bones of fingers. (4) Radius crosses ulna to rotate hand. (5) Ulna. (6) Humerus. (7) Skull determines profile of back of head. (8) Edge of scapula. (9) Spinal column is arched. Notice deep curve in lower spine. (10) Scapula. (11) Rib cage. (12) Pelvis. (13) Femur. (14) Kneecap. (15) Tibia. (16) Talus. (17) Heel bone protrudes.

MUSCLES

(18) Hand has "heel" pad. (19) Extensors of wrist and fingers. (20) Long supinator attaches lower arm *high* on upper arm. (21) Biceps. (22) Deltoid. (23) Ball of thumb. (24) Flexor of wrist attaches to edge of ulna. (25) Triceps. (26) Group of scapula muscles. (27) Latissimus dorsi. (28) Trapezius. (29) Serratus. (30) Fat on hips produces female roundness. (31) Fat on thighs. (32) Gastrocnemius flattens when it releases. (33) Soleus. (34) Achilles tendon. (35) Peroneus tertius. (36) Extensor of toes are tense because of pressure on foot.

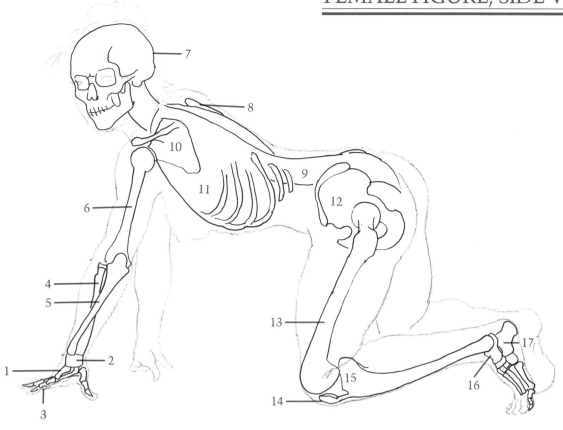

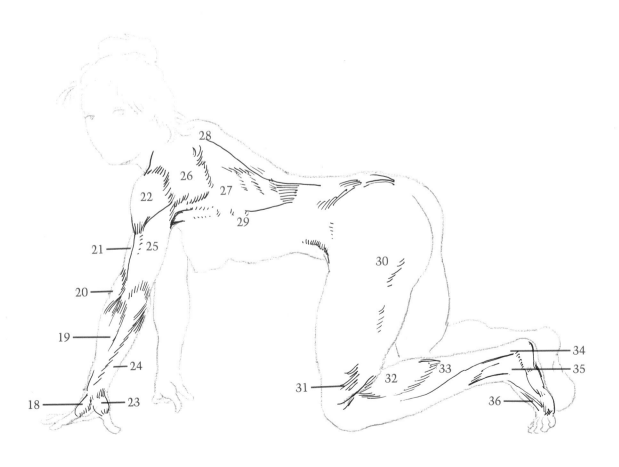

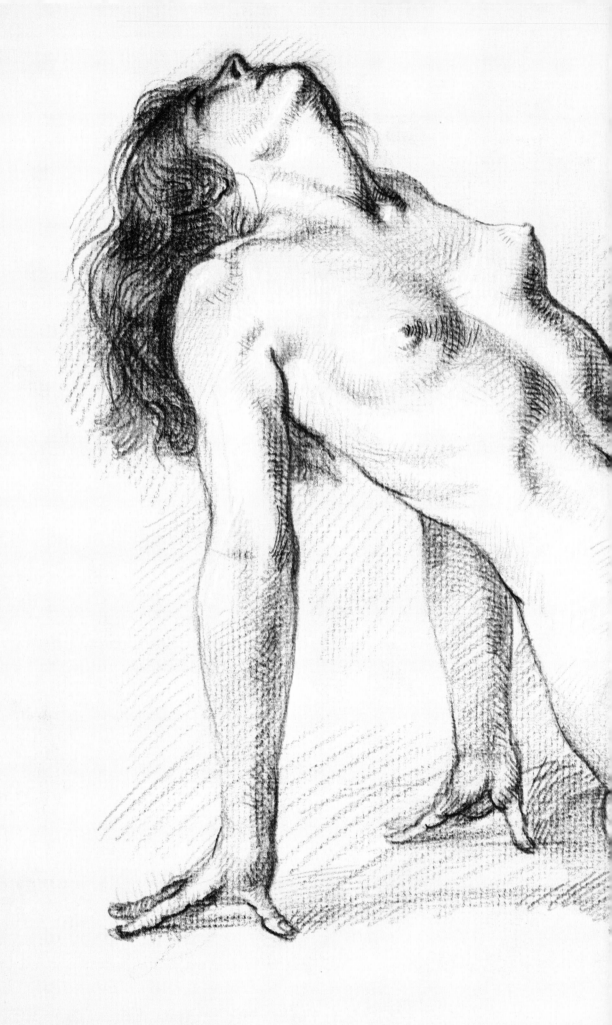

CROUCHING FIGURE

The crouching figure is one of expectant action. The weight distribution is temporary. The figure looks as though it is about to move or has just finished moving.

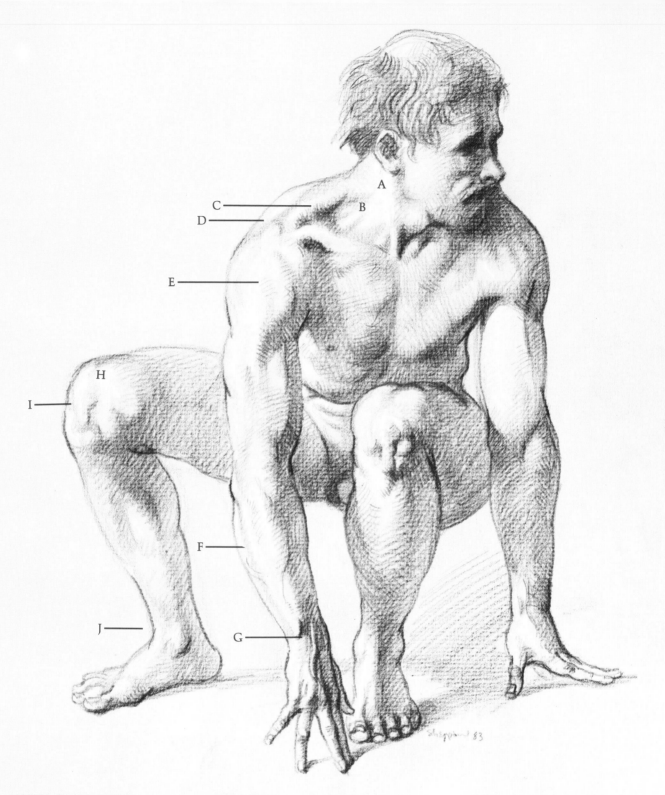

SURFACE ANATOMY

(A) Sternomastoid helps turn head. (B) Underlying neck muscles show on thin person. (C) Note triangular hollow under trapezius. (D) Acromion process wraps around clavicle. (E) Note divisions of deltoid. (F) Edge of ulna is next to surface. (G) Tendons of fingers point to center of wrist. (H) Vastus makes round, high form on inside of bent knee. (I) Kneecap is attached to tibia. (J) Tendon forms bridge at ankle.

BONES

(1) Spinal column. (2) Clavicle is "S" shape. (3) Acromion process of scapula wraps around clavicle. (4) Sternum is necktie-shape. (5) Rib cage. (6) Humerus. (7) Hook of ulna rides on spool of humerus. (8) Ulna. (9) Radius. (10) Wrist bones. (11) Shortest finger. (12) Ring finger is next to longest finger. (13) Longest finger. (14) End of femer. (15) Kneecap holds femer in place. (16) Tibia. (17) Talus. (18) Tibia makes bump on ankle. (19) Heel bone.

MUSCLES

(20) Sternomastoid. (21) Trapezius. (22) Underlying neck muscles show when neck is turned and tense. (23) Divisions of deltoid show clearly. (24) Widest point of triceps is higher than bulkiest point on biceps. (25) Brachialis. (26) Biceps. (27) Long supinator. (28) Group of finger and wrist extensors. (29) Wrist flexor. (30) Vastus produces round shape on inside of knee. (31) Rectus femoris tendon. (32) Gastrocnemius is flexed when leg is bent. (33) Soleus. (34) Tibialis anterior. (35) Extensor of big toe.

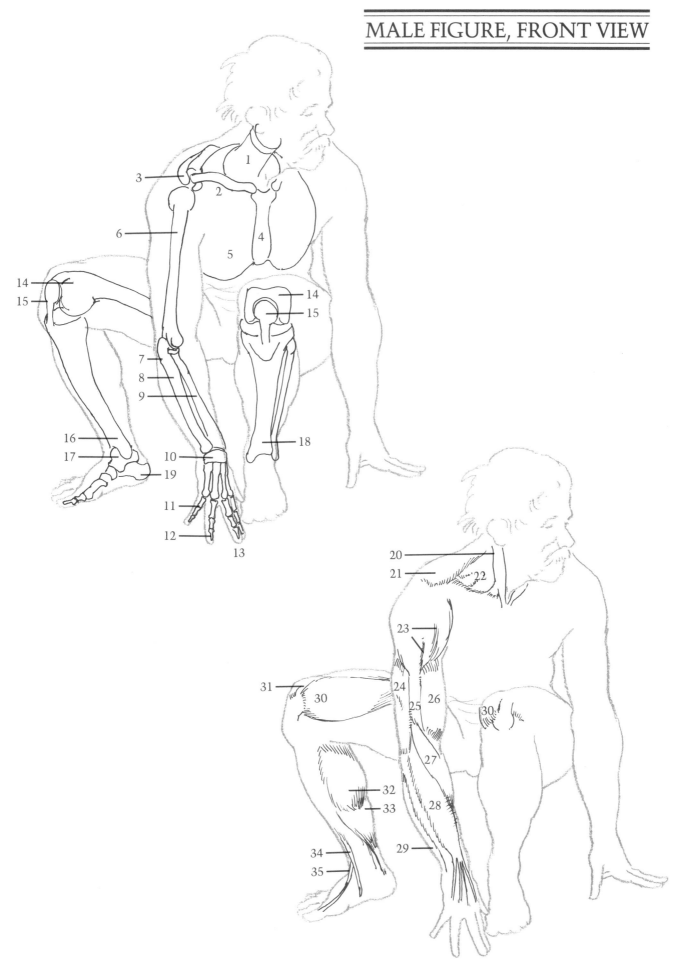

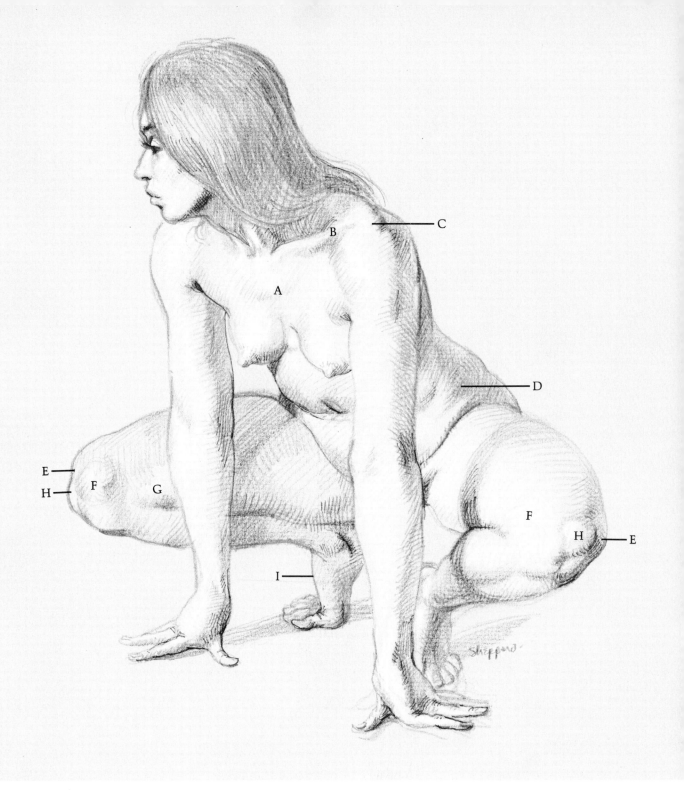

SURFACE ANATOMY

(A) Second rib runs straight across. (B) Clavicle displays "S" shape. (C) Acromion process of scapula wraps around end of clavicle. (D) Fat accumulates on hips. (E) Each knee shows sharp edge of outside condoyle at end of femur. (F) Vastus makes round form as it covers inside condyle of end of femur. (G) Adductor tendons form bulge when leg is bent. (H) Kneecap is prominent when leg is bent. (I) Bones on big toe form arch on top of foot.

BONES

(1) Second rib goes straight across. (2) Sternum. (3) Rib cage. (4) Clavicle is "S" shaped. (5) Acromion process. (6) Scapula. (7) Humerus. (8) Radius crosses ulna to thumb side of hand. (9) Wrist bones. (10) Bones of palm are always close together, do not open under pressure. (11) Three bones of finger. (12) Thumb has only two bones. (13) End of femur. (14) Kneecap is attached to tibia, does not move when leg is bent. (15) Tibia. (16) Talus, (17) Three bones form arch on top of foot. (18) Two bones of big toe.

MUSCLES

(19) Deltoid appears to attach to brachialis. (20) Pectoralis attaches to sternum. (21) Biceps insert between flexors and extensors of forearm. (22) Brachialis. (23) Triceps. (24) Long supinator has high silhouette on forearm. (25) Flexors of wrist. (26) Extensors of wrist and fingers. (27) Tendon of rectus femoris. (28) Vastus. (29) Gastrocnemius bunches when leg is bent.

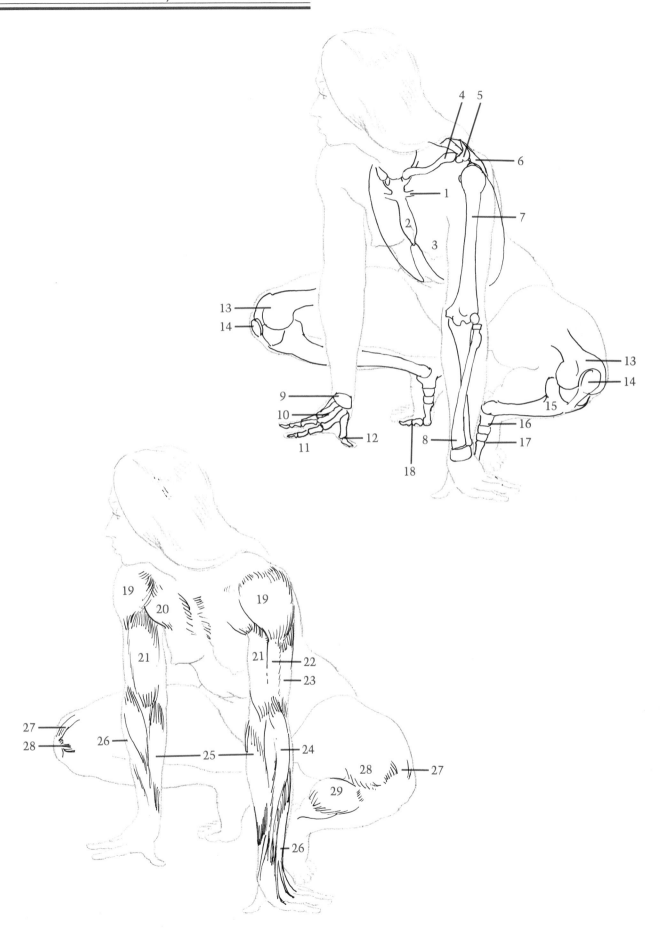

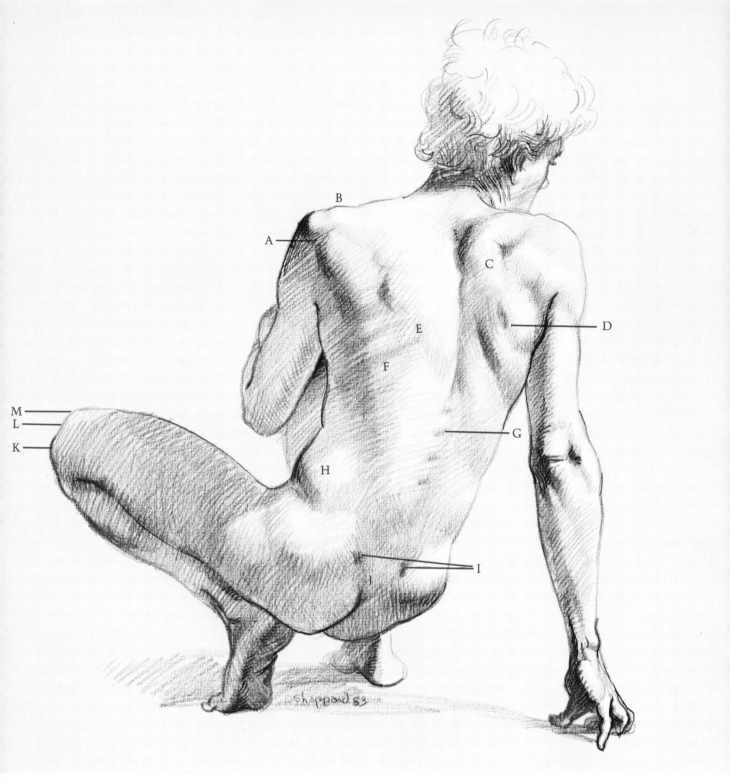

A

B

C

D

E

F

G

H

I

M
L
K

Sheppard 83

SURFACE ANATOMY
(A) Division of deltoid can be seen on surface. (B) Acromion process of scapula creates bump on shoulder silhouette. (C) Trapezius bunches up when arm is held back. (D) Muscles on scapula show shape of scapula beneath. (E) Note thickness of trapezius. (F) Ribs show through latissimus dorsi. (G) Spines of vertebrae are evident. (H) External oblique is fuller on bent side of body. (I) Dimples are caused by pelvic crests. (J) Flat area appears in sacrum. (K) Outside condyle of femur is sharp. (L) Outside

edge of kneecap is seen in front of (M) inside condyle of femur, which is round.

BONES
(1) Note "step-down" silhouette of acromion process on shoulder. (2) Seven cervical vertebrae show neck movement. (3) Cheekbone. (4) Scapula turns slightly back, following direction of arm and shoulder. (5) Humerus. (6) Shape of rib cage. (7) Ribs. (8) Spines of vertebrae are prominent on lean figure, especially when back is arched. (9) Ends of pelvic crest. (10) Tail bone (sacrum) is flat area. (11)

Outside condyle of end of femur. (12) Edge of kneecap shows in front of femur. (13) Inside condyle of end of femur.

MUSCLES
(14) Division of deltoid is evident. (15) Top of trapezius twists as head turns. (16) Note flat, diamond-shaped, tendinous surface. (17) Deltoid. (18) Infraspinatus. (19) Teres major. (20) Latissimus dorsi is kite-shaped. (21) Bulk of latissimus dorsi starts here. (22) Two columns of sacrospinalis show vertebrae between them. (23) Tensor fasciae latae. (24) Gluteus is tighter on male than on female.

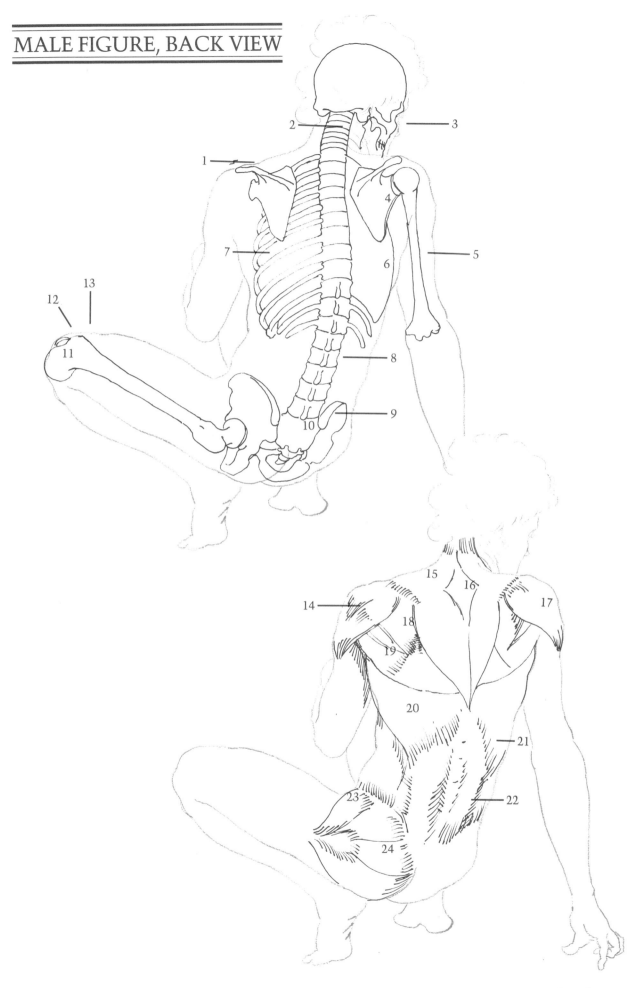

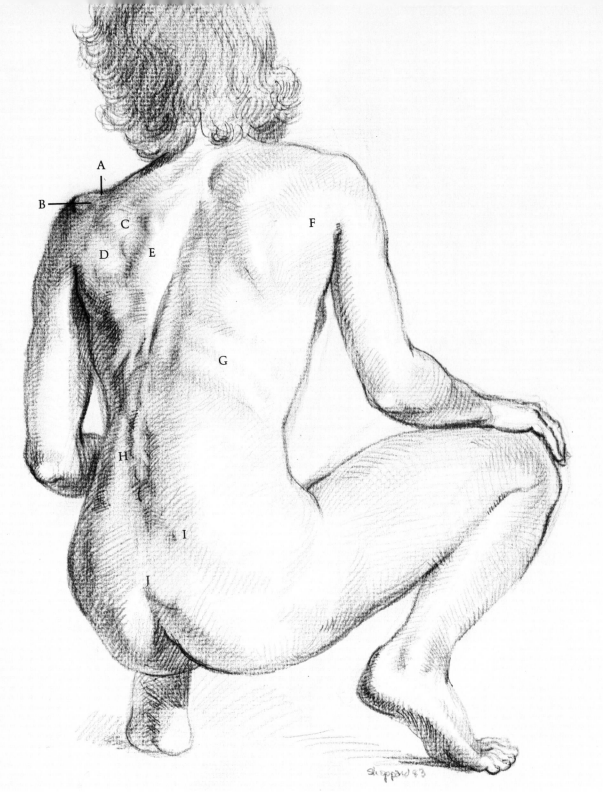

Sheppard 83

SURFACE ANATOMY

(A) End of clavicle meets (B) end of acromion process. (C) Infraspinatus creates bulge. (D) Teres major muscle bunches because arm is back. (E) Note thick edge of scapula. (F) Muscles of scapula are seen as one unit. (G) Ribs are distinct. (K) Outside of foot has three pads. (H) Spines of lumbar vertebrae show on thin model. (I) Instead of usual dimples, ends of pelvic crests protrude on lean figure. (J) End of sacrum shows on lean figure, but is rarely seen on fleshy figure.

BONES

(1) Spinal column. (2) Rib cage. (3) Scapula and (4) end of clavicle create bony bumps. (5) Head of humerus is round and balllike. (6) Head of ulna. (7) Head of radius. (8) Ribs. (9) Five lumbar vertebrae appear in spinal column. (10) End of pelvic crest. (11) Sacrum. (12) Pelvis. (13) Hipbone. (14) Kneecap. (15) Fibula attaches to back and outside of (16) tibia. (17) Talus. (18) Heel bone aligns with little toe.

MUSCLES

(19) Trapezius is kite-shaped—even as body turns. (20) Deltoids. (21) Infraspinatus. (22) Teres major. (23) Latissimus dorsi stretches out to underarm, revealing ribs beneath. (24) Sacrospinalis. (25) Group of scapula muscles are seen as one smooth unit because arm is released. (26) Heel pad, (27) outside pad on little-toe side, and (28) pad of toes form thick, rounded ridge.

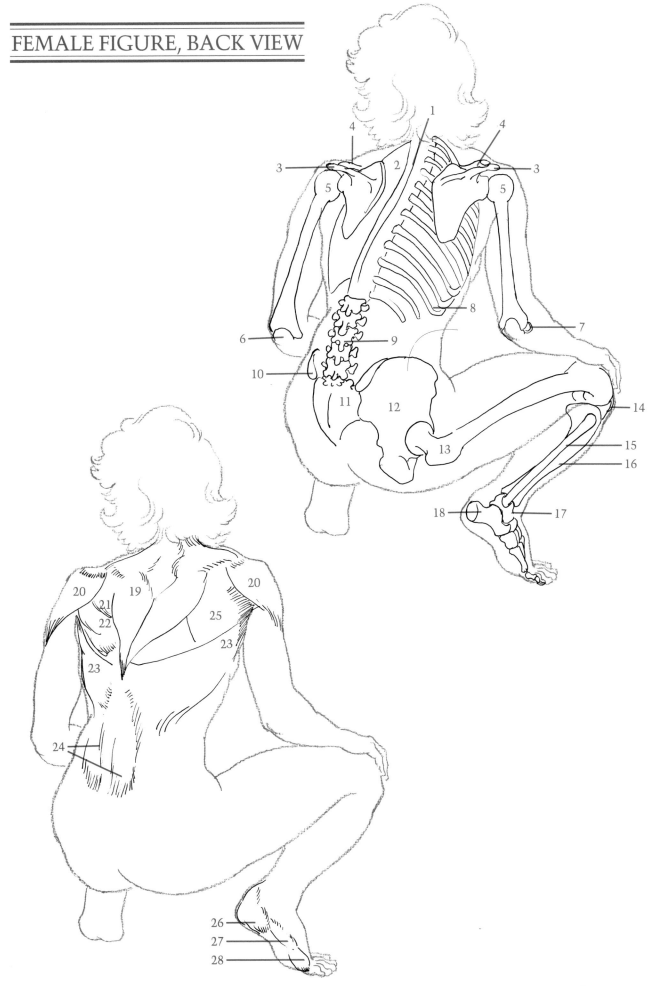

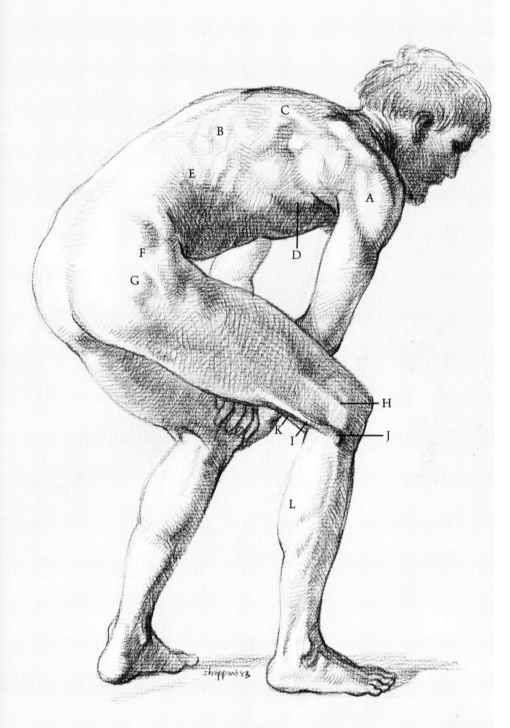

SURFACE ANATOMY

(A) Divisions of deltoid are evident on lean figure. (B) Direction of ribs can be seen through latissimus dorsi. (C) Thickness of trapezius is apparent. (D) Observe thick edge of latissimus dorsi. (E) Insertions of external oblique show on thin figure. (F) Divisions of gluteus are seen because leg is tense. (G) Hipbone protrudes between glueteus muscles. (H) Iliotibial band and (I) biceps femoris form two prominent straps on outside of knee. (J) Tendon attaches to head of fibula. (K) Semitendinosus and (I) biceps femoris wrap around (L) gastrocnemius.

BONES

(1) Ribs. (2) Far side of rib cage is convex and is seen beyond (3) spinal column. (4) End of scapula moves forward with arm. (5) Humerus. (6) Flat area of sacrum. (7) Hipbone. (8) Femur. (9) Kneecap. (10) Fibula is straight in contrast to (11) tibia, which has "S" curve.

MUSCLES

(12) Deltoid. (13) Trapezius. (14) Latissimus dorsi stretches, reveals underlying ribs and muscles. (15) External oblique. (16) Sacrospinalis (17) Gluteus. (18) Tensor fasciae latae. (19) Sartorius inserts underneath tensor fasciae latae. (20) Rectus femoris. (21) Biceps femoris is distinct bulge, and tendons form sharp ridge when leg is bent. (22) Vastus. (23) Iliotibial band is prominent ridge, especially when knee is bent. (24) Semitendinosus. (25) Gastrocnemius. (26) Long peroneus. (27) Soleus.

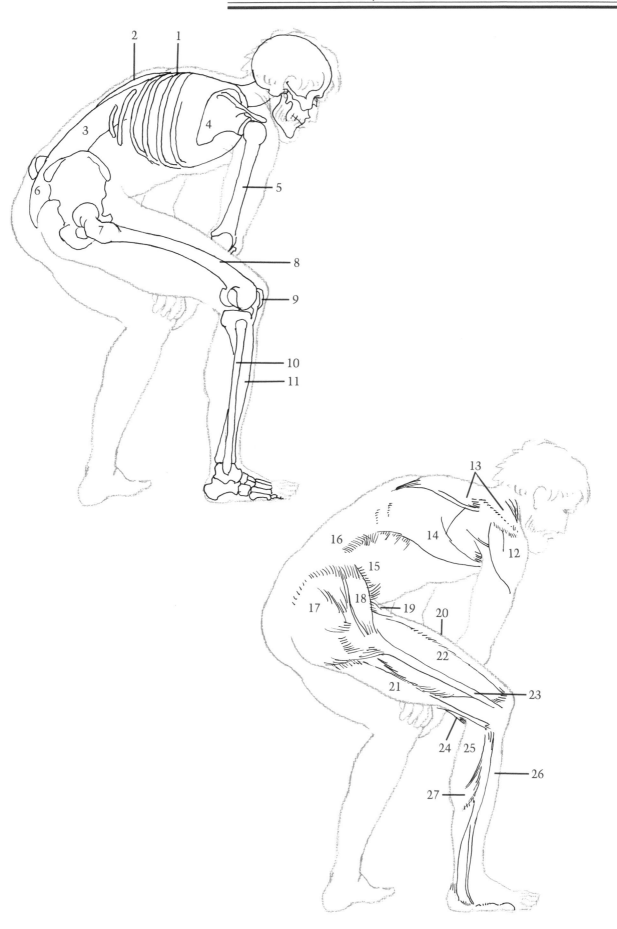

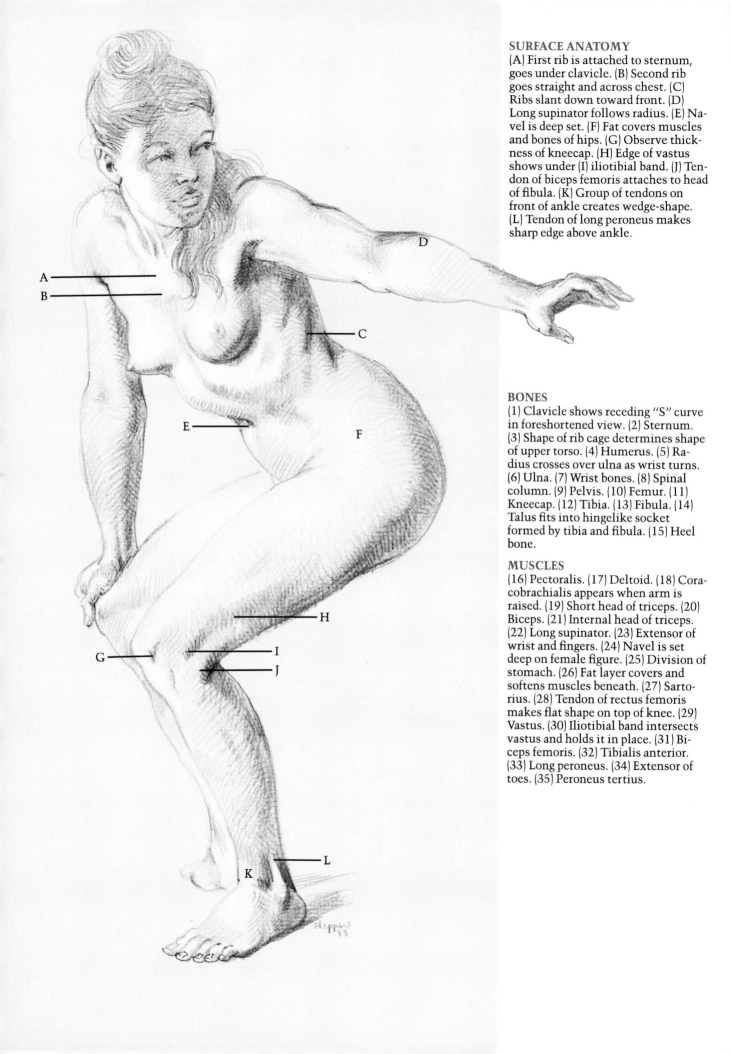

SURFACE ANATOMY
(A) First rib is attached to sternum, goes under clavicle. (B) Second rib goes straight and across chest. (C) Ribs slant down toward front. (D) Long supinator follows radius. (E) Navel is deep set. (F) Fat covers muscles and bones of hips. (G) Observe thickness of kneecap. (H) Edge of vastus shows under (I) iliotibial band. (J) Tendon of biceps femoris attaches to head of fibula. (K) Group of tendons on front of ankle creates wedge-shape. (L) Tendon of long peroneus makes sharp edge above ankle.

BONES
(1) Clavicle shows receding "S" curve in foreshortened view. (2) Sternum. (3) Shape of rib cage determines shape of upper torso. (4) Humerus. (5) Radius crosses over ulna as wrist turns. (6) Ulna. (7) Wrist bones. (8) Spinal column. (9) Pelvis. (10) Femur. (11) Kneecap. (12) Tibia. (13) Fibula. (14) Talus fits into hingelike socket formed by tibia and fibula. (15) Heel bone.

MUSCLES
(16) Pectoralis. (17) Deltoid. (18) Coracobrachialis appears when arm is raised. (19) Short head of triceps. (20) Biceps. (21) Internal head of triceps. (22) Long supinator. (23) Extensor of wrist and fingers. (24) Navel is set deep on female figure. (25) Division of stomach. (26) Fat layer covers and softens muscles beneath. (27) Sartorius. (28) Tendon of rectus femoris makes flat shape on top of knee. (29) Vastus. (30) Iliotibial band intersects vastus and holds it in place. (31) Biceps femoris. (32) Tibialis anterior. (33) Long peroneus. (34) Extensor of toes. (35) Peroneus tertius.

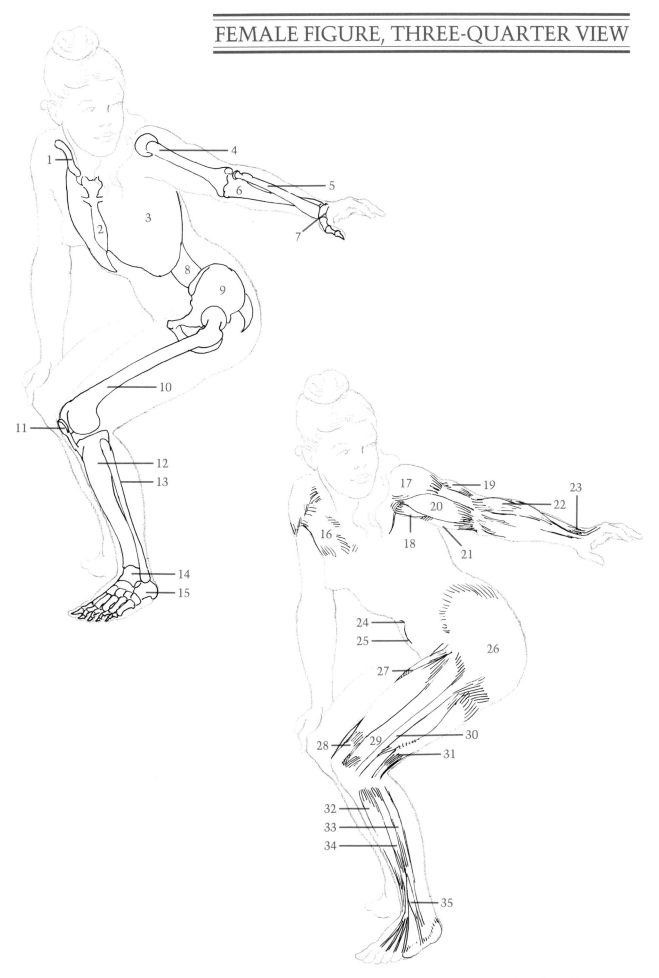

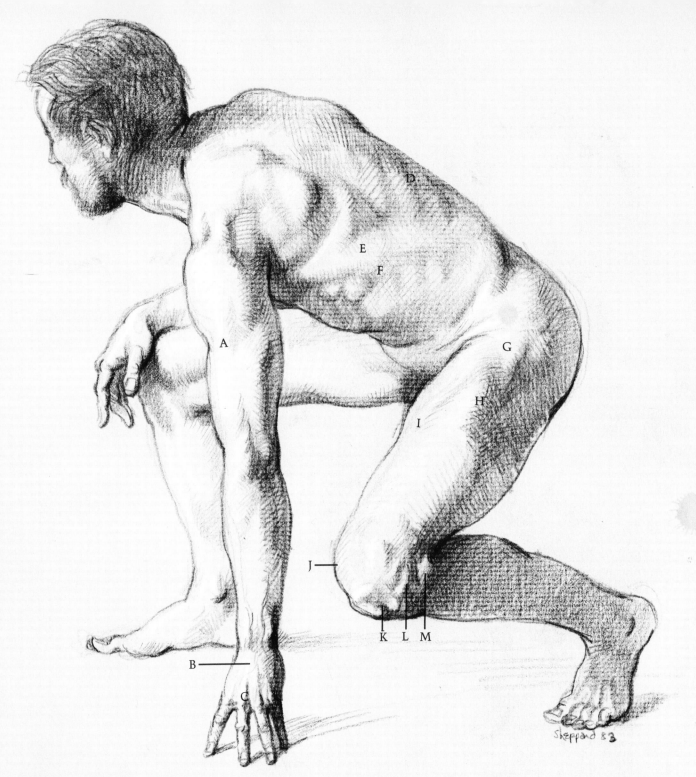

Sheppard '83

SURFACE ANATOMY

(A) Shadow is caused by brachialis. (B) Tendons of finger extensor join in one tendon in middle of wrist. (C) Middle knuckle is longest. (D) Ribs slant down from back, show through latissimus dorsi. (E) Bulk under latissimus dorsi is caused by underlying serratus. (F) Edge of latissimus dorsi shows thickness of muscle. (G) Tensor fasciae latae shows clearly under tension. (H) Edge of rectus femoris is tense because of stress of pose. (I) Sartorius runs diagonally across thigh. (J) Round form of vastus is prominent on inside of knee. (K) Note thickness of kneecap. (L) Iliotibial band attaches on outside of tibia. (M) Tendon of biceps femoris attaches to head of fibula.

BONES

(1) Adam's apple consists of two small bones. (2) Scapula. Note thin bone of scapula in foreshortened view on far side of body. (3) Rib cage. (4) Ribs. (5) Floating ribs. (6) Pelvic crest wraps around from back to front. (7) Hipbone protrudes strongly. (8) Femur. (9) Head of fibula. (10) End of fibula. (11) Top surface of tibia is flat. (12) Kneecap. (13) Hook of ulna. (14) Knuckles are at ends of bones of palm.

MUSCLES

(15) Sternomastoid. (16) Trapezius shows kite-shape even in foreshortened view. (17) Infraspinatus and (18) teres major appear as two bulges. (19) Latissimus dorsi shows underlying serratus. (20) Serratus. (21) Deltoid. (22) Triceps bunch up when weight is put on arms. (23) Brachialis. (24) Long supinator. (25) Long extensor of wrist. (26) Extensor of wrist. (27) Extensor of fingers becomes prominent because of weight on hand. (28) Vastus. (29) Adductor tendons. (30) Adductor muscles. (31) Sartorius. (32) Rectus femoris. (33) Tensor fasciae latae. (34) Gluteus (35) Biceps femoris. (36) Iliotibial band.

MALE FIGURE, SIDE VIEW

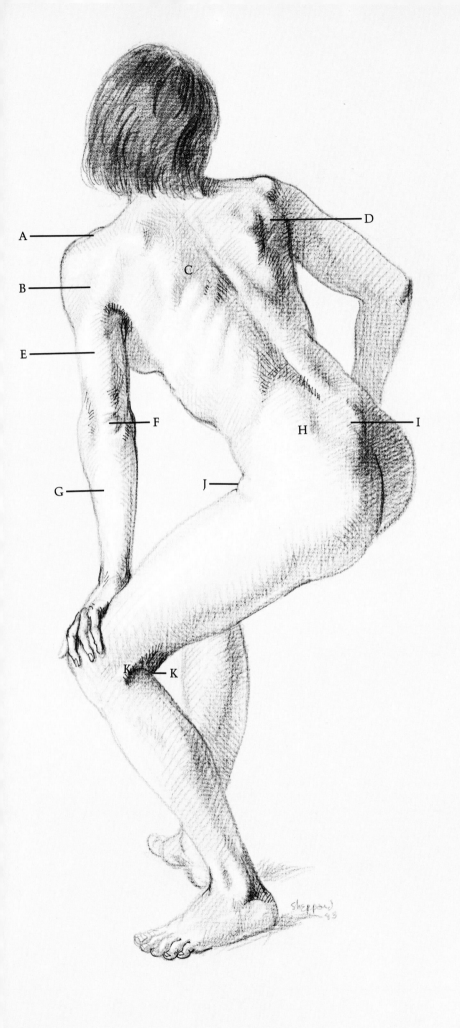

SURFACE ANATOMY

(A) Acromion process of scapula makes bump on shoulder. (B) Division of deltoid is revealed by pressure of arm on leg. (C) Edge of rhomboid creates plane from scapula to spinal column. (D) Scapula muscles (infraspinatus, teres major) bunch together when arm is back. (E) Triceps is seen as one unit. (F) Note skin wrinkles on back of ulna. (G) Extensors are seen as one unit. (H) Dimples are created by pelvic crest. (I) Spine of sacrum is visible. (J) Fat fold is caused by bent leg. (K) Tendons wrap around calf.

BONES

(1) Skull determines shape of top of hair. (2) Spinal column curves as head turns. (3) Scapula. (4) Humerus. (5) Ulna. (6) Radius. (7) Wrist bones. (8) Ribs show downward slant from spine. (9) Pelvis. (10) Sacrum displays heart-shape. (11) Femur. (12) Kneecap and (13) tibia determine profile of knee. (14) Fibula.

MUSCLES

(15) Trapezius. (16) Deltoid. (17) Triceps. (18) Rhomboid shows beneath trapezius. (19) Long supinator. Notice thickness at elbow. (20) Hand and finger extensors are seen as one smooth unit. (21) "Heel" pad of hand. (22) Scapula muscles. (23) Thickest point of triceps is higher than thickest point of biceps. (24) Sacrospinalis. (25) Vastus. (26) Iliotibial band. (27) Semitendinosus.

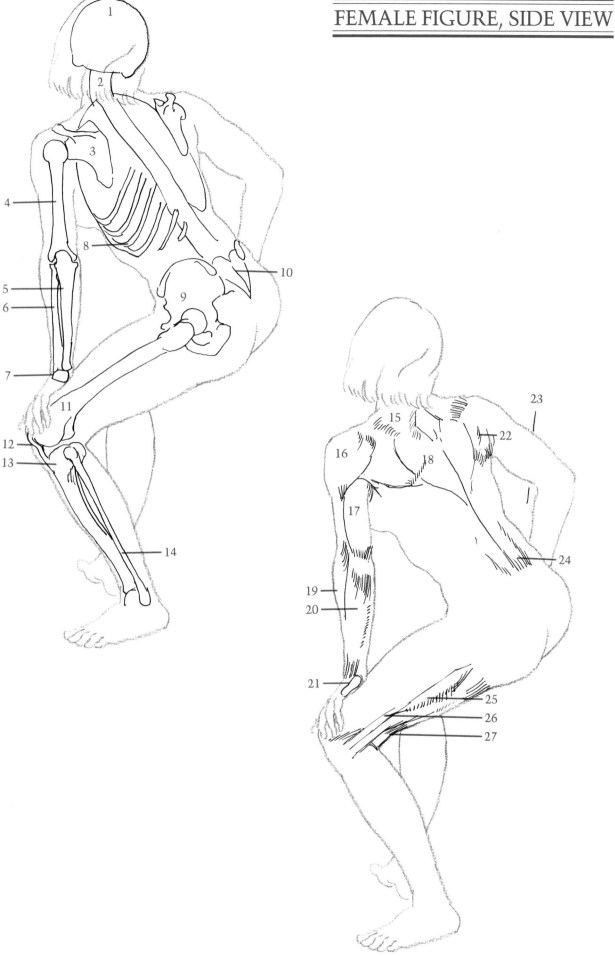

RECLINING

*Foreshortened limbs and difficult angles make the
reclining figure more challenging than other positions.*

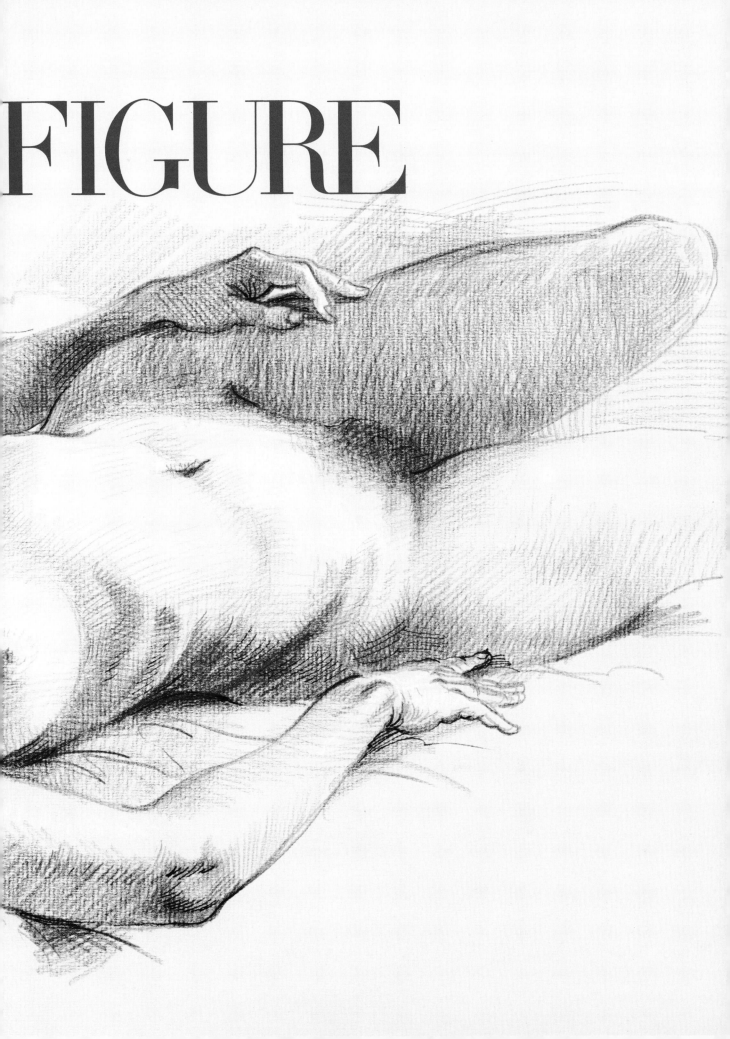

FIGURE

SURFACE ANATOMY

(A) Tendons of flexor muscles show at wrist. (B) Hook of ulna rides on (C) "spool" of humerus. (D) Coracobrachialis can be seen on male when arm is raised. (E) Pectoralis forms front wall of armpit. (F) Serratus insert down into ribs. (G) External oblique bulges over pelvic crest. (H) Edge of tibia (shinbone) is sharply defined. (I) Tendon of toe flexor appears under ankle. (J) Fat deposit is visible over (K) kneecap. (L) Kneecap ligament attaches to tibia and creates sharp ridge. (M) Extensor of big toe draws toe upwards. (N) Tendon of tibialis anterior crosses over ankle to inside of foot. (O) Extensor of big toe creates hard edge.

BONES

(1) Hook of ulna. (2) Ulna. (3) Bones of wrist. (4) Skull. (5) Humerus. (6) Rib cage forms distinct arch above abdominal cavity. (7) Ribs. (8) Crest of pelvis. (9) Tibia displays strong "S" curve. (10) End of tibia is prominent at ankle. (11) End of femur. (12) Observe thickness of kneecap in foreshortened view.

MUSCLES

(13) Flexor group of wrist and fingers. (14) Deltoid. (15) Biceps are relaxed and soft when not flexed. (16) Triceps. (17) Coracobrachialis is evident when arm is raised. (18) Latissimus dorsi curves around from back. (19) Serratus. (20) Pectoralis. (21) External oblique flattens out when body is stretched. (22) Sheath of rectus abdominis. (23) Rectus abdominis. (24) Gastrocnemius. (25) Soleus. (26) Toe flexor. (27) Extensor of big toe.

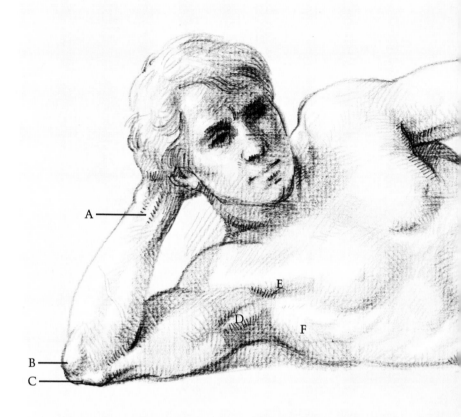

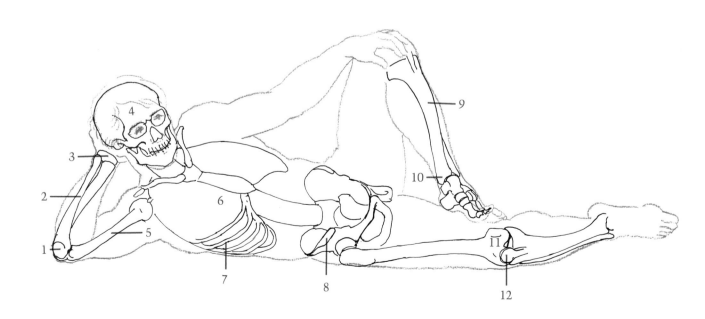

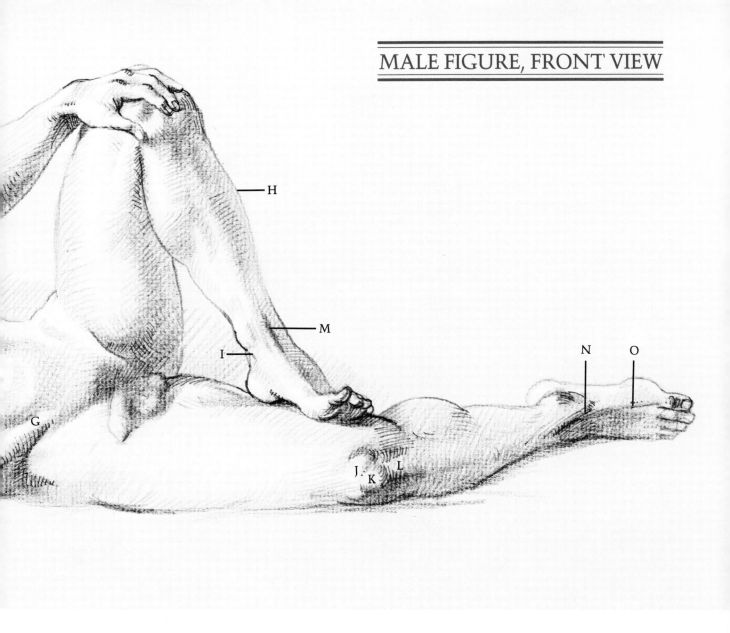

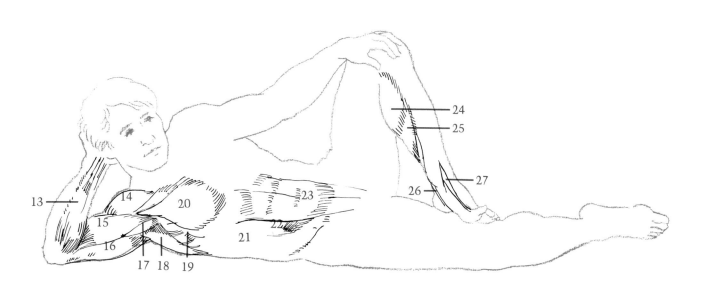

SURFACE ANATOMY

(A) Front of tibia displays triangular shape. (B) Note thickness of kneecap. (C) Sartorius divides thigh obliquely with adductors on inside, vastus and rectus femoris in front. (D) Hipbone protrudes on thin figure. (E) Tendons attach to (F) pelvic crest. (G) Note fold in external oblique. (H) Breast stretches with pectoralis muscle when arm is raised. (I) Coracobrachialis is evident even on female. (J) Hook of ulna is highest point of bent arm. (K) Observe attachments of ribs to sternum.

BONES

(1) Fibula. (2) Observe flat surface of top of tibia. (3) Triangular shape of tibia. (4) Kneecap. (5) Femur. (6) Hipbone protrudes on thin figure. (7) Crest of pelvis is evident on thin figure. (8) Ribs. (9) Humerus rotates in scapula socket. (10) Sternum clearly shows rib attachment. (11) Scapula. (12) Clavicle. (13) Hook of ulna.

MUSCLES

(14) Tendons of biceps femoris. (15) Iliotibial band. (16) Tendon of rectus femoris. (17) Vastus. (18) Rectus femoris. (19) Sartorius. (20) Adductors. (21) Tensor fasciae latae attachment is distinct. (22) External oblique. (23) Breast elongates with pectoralis. (24) Latissimus dorsi curves around from back and inserts into arm. (25) Coracobrachialis. (26) Triceps. (27) Biceps. (28) Pectoralis. (29) Rectus abdominis is stretched.

FEMALE FIGURE, FRONT VIEW

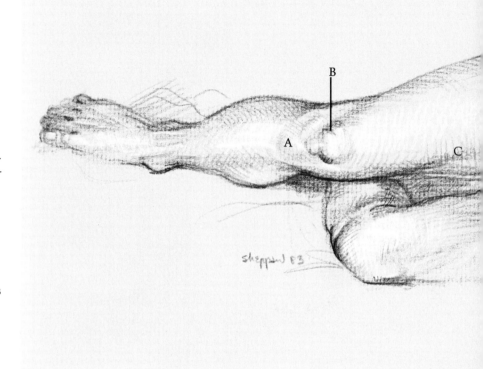

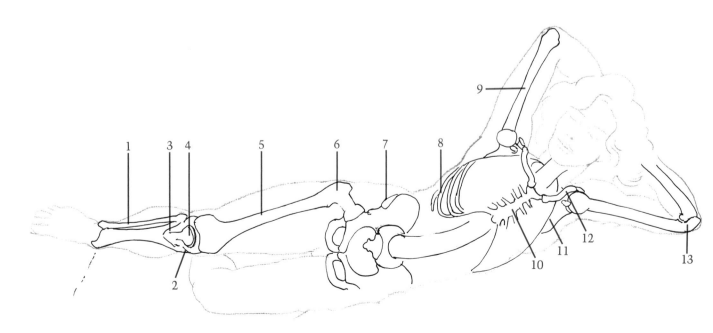

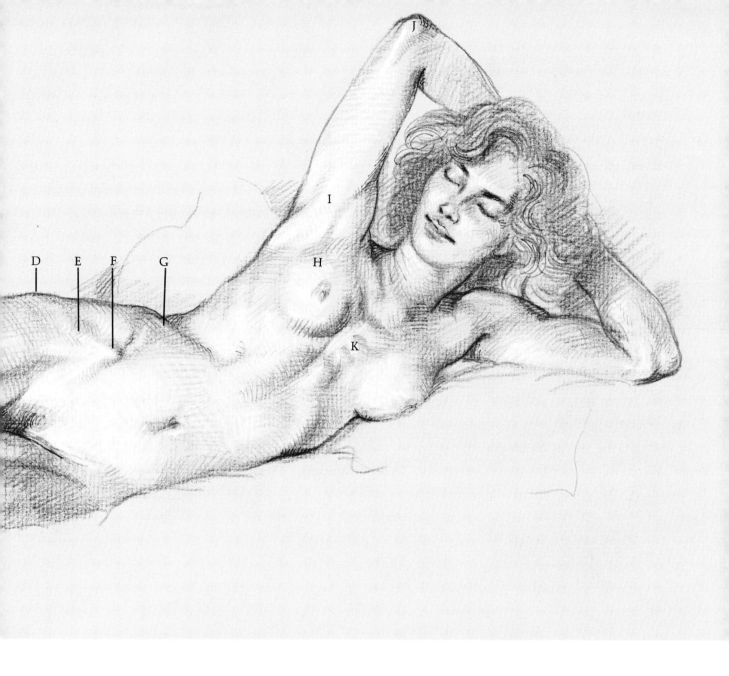

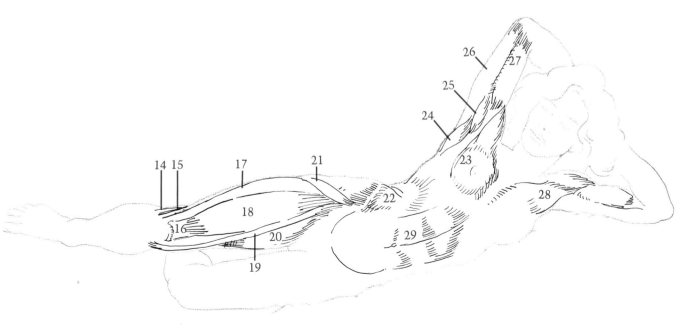

SURFACE ANATOMY

(A) Middle knuckle sits highest when first is made. (B) Extensors are on top of forearm. (C) Flexor creates curving ridge on underside of arm. (D) Radius head shows on outside of arm. (E) Observe thickness of triceps tendon. (F) Rhomboid shows when arm is extended. (G) Spines of vertebrae are seen as small indentations. (H) On thin figure, end of pelvic crest protrudes—rather than causing dimples. (I) Note ridge down center of sacrum. (J) Hipbone pushes out. (K) Divisions appear in gluteus.

BONES

(1) Knuckes. (2) Wrist bones. (3) End of ulna produces bump on wrist. (4) Head of radius. (5) Humerus. (6) Vertebrae of neck. (7) Scapula. (8) Rib cage. (9) Spinal column curves and twists to follow action of torso. (10) Pelvic crest protrudes strongly. (11) Sacrum. (12) End of femur and (13) kneecap create contour of knee.

MUSCLES

(14) Extensors of wrist and fingers. (15) Flexor of wrist. (16) Biceps are soft and relaxed when not flexed. (17) Deltoid. (18) Triceps. (19) Infranspinatus. (20) Teres major. (21) Rhomboid is stretched when scapula is pulled forward. (22) Note kite-shape of trapezius. (23) Latissimus dorsi. (24) External oblique is concave on thin figure. (25) Gluteus. (26) Iliotibial band. (27) Vastus. (28) Tensor fasciae latae. (29) Biceps femoris create rounded contour of lower thigh.

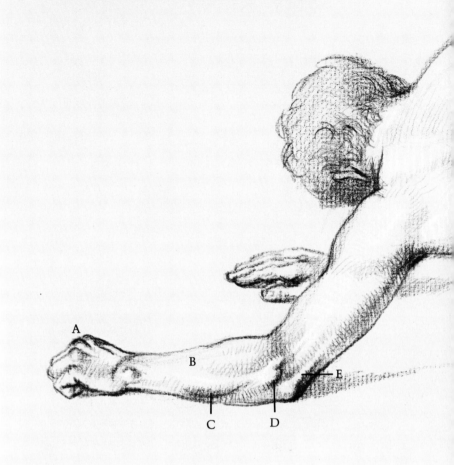

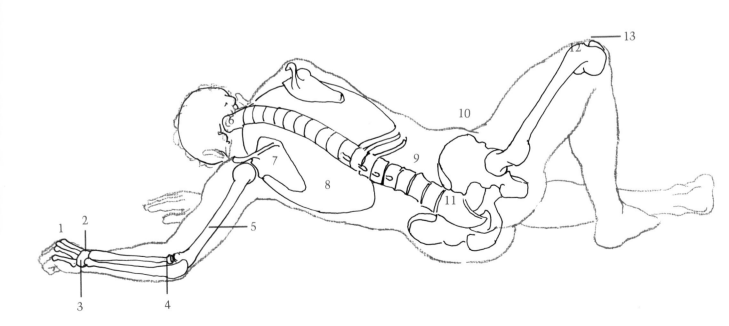

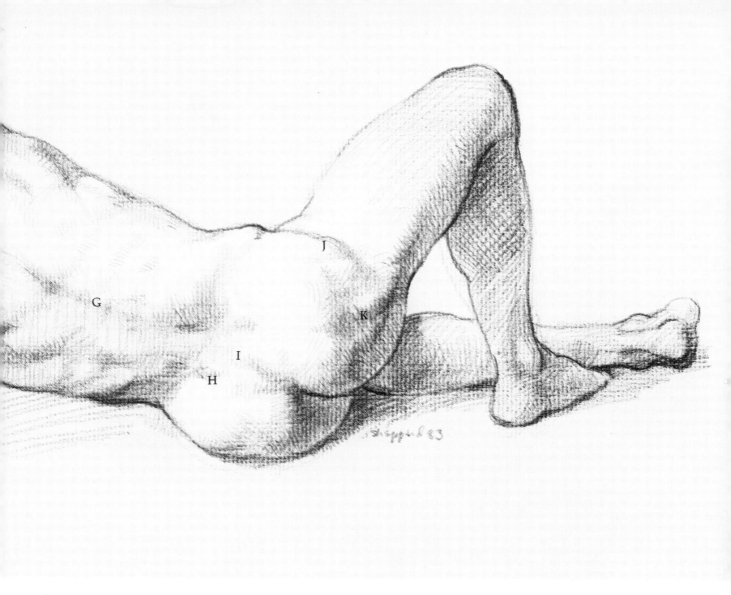

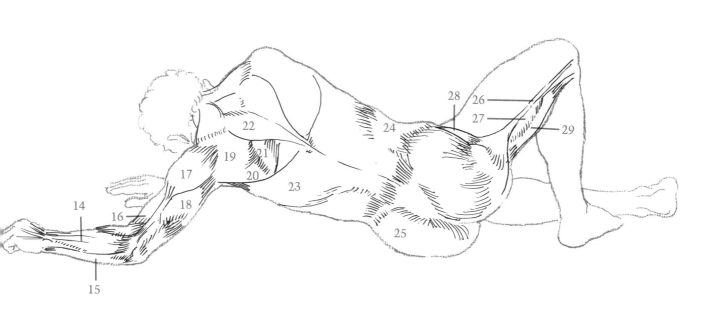

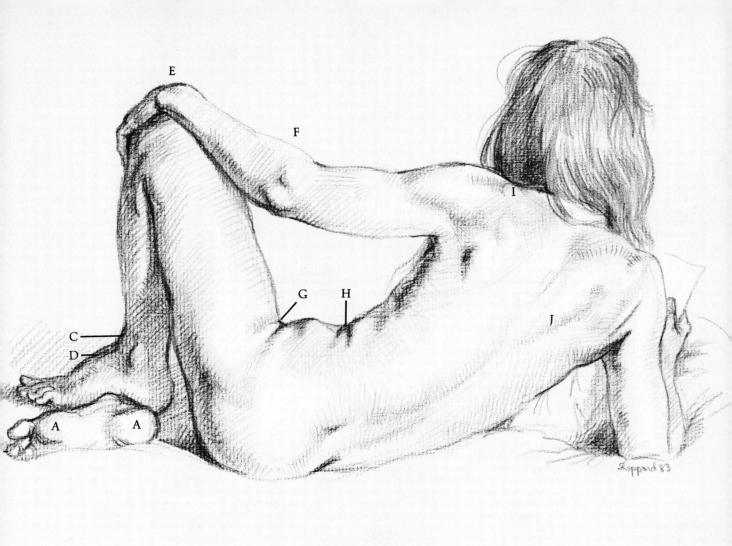

SURFACE ANATOMY

(A) Pads appear on bottom of foot. (B) First toe is usually longer than big toe. (C) Arch is prominent on top of foot. (D) Tendons create bridge between foot and leg. (E) Extensor tendons cause round form when wrist is bent. (F) Long supinator causes high silhouette on top side of forearm. (G) Fat creates folds when leg is bent up, even on thin figure. (H) Fat folds are created when body bends in on itself. (I) Acromion process on scapula shows on top of shoulder. (J) Edge of trapezius is accentuated by pressure on arm.

BONES

(1) Talus. (2) Tibia creates convex curve of shin. (3) Outside condyle of end of femur. (4) Wrist. (5) Radius. (6) Ulna. (7) Humerus. (8) Rib cage. (9) End of pelvic crest creates indentation. (10) Spinal column curves as torso bends forward and determines attitude of figure. (11) Scapula. (12) Skull.

MUSCLES

(13) Flexor of wrist. (14) Group of extensors of wrist and fingers is seen as one unit. (15) Long supinator thickens contour of forearm. (16) Biceps. (17) Brachialis. (18) Deltoid. (19) Triceps are soft and relaxed, seen as one simple form. (20) External oblique. (21) Teres major. (22) Infraspinatus. (23) Trapezius. (24) Latissimus dorsi. (25) Big-toe pad. (26) Ball of foot. (27) Heel pad. (28) Sacrospinalis.

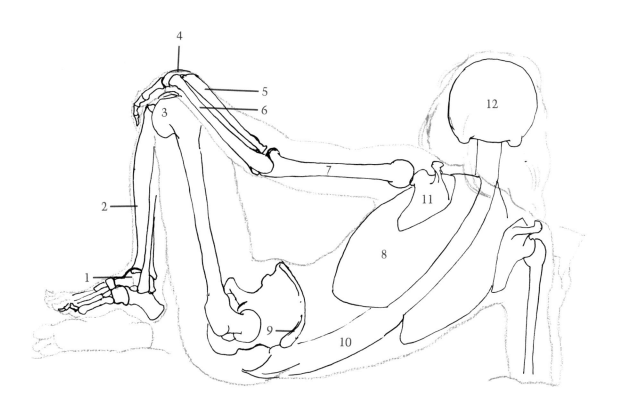

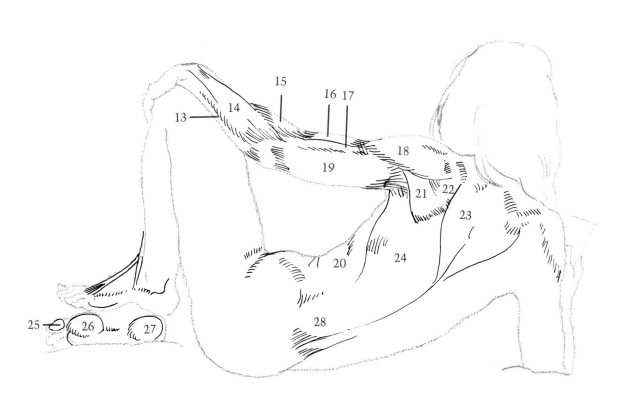

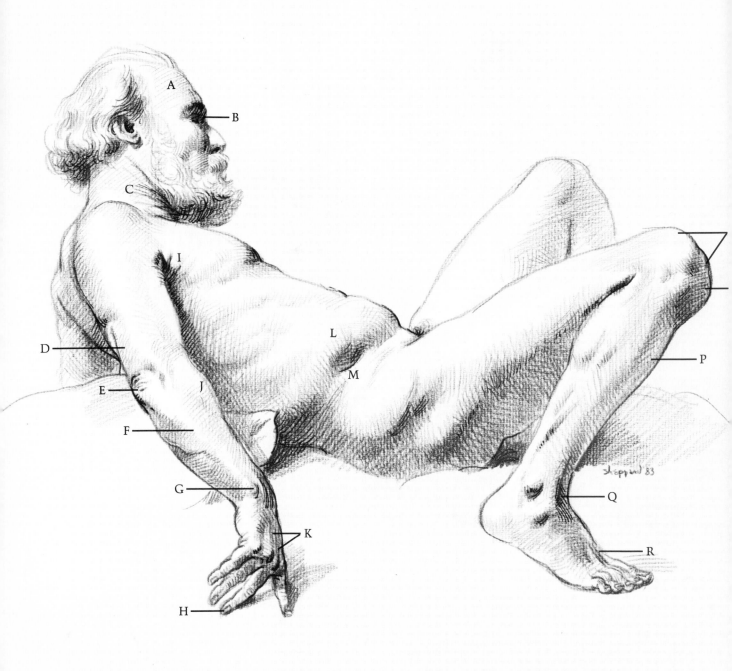

SURFACE ANATOMY

(A) Skull dictates shape of head. (B) Eye fits back into eye socket. (C) Folds tend to appear around neck after age forty. (D) Tendon of triceps is flat. (E) Folds of skin at elbow show age. (F) Ulna is next to surface. (G) End of ulna is prominent at wrist. (H) Longest finger is middle finger. (I) Age folds are evident. (J) Supinator thickens top of forearm. (K) Tendons of finger extensor are distinct. (L) Flat deposit appears above (M) pelvic crest. (N) Both condyles of end of femur are evident (O) Kneecap protrudes on bent knee. (P) Front of shin has slight "S" curve. (Q) Tendons form bridge between leg and foot. (R) Tendons of toe extensor are flexed.

BONES

(1) Head is shape of skull. (2) Eye socket surrounds eye. (3) Bridge of nose. (4) Opening for ear. (5) Ball-shape of humerus head. (6) Scapula. (7) Clavicle. (8) Ball-shape of outside of humerus end. (9) Disc-shape of radius head turns on ball-shape of humerus end. (10) Flat disc-shape of wrist. (11) Knuckles are where bones of hand and bones of fingers join. (12) Middle finger is longest. (13) Outside end of femur. (14) Inside end of femur. (15) Kneecap. (16) Front of tibia (shinbone) has slight "S" curve. (17) Fibula. (18) Talus. (19) Heel bone.

MUSCLES

(20) Folds appear in skin. (21) Deltoid. (22) Short head of triceps. (23) Long head of triceps. (24) Triceps tendon. (25) Note age wrinkles at elbow. (26) Extensor of wrist. (27) Flexor of wrist. (28) Folds in skin are caused by age. (29) Biceps. (30) Long supinator. (31) Long radial extensor of wrist. (32) Extensor of fingers. (33) Fat deposit appears above crest of pelvis. (34) Gastrocnemius. (35) Soleus. (36) Long peroneus. (37) Extensor of toes. (38) Tibialis anterior. (39) Peroneus tertius. (40) Extensor of big toe.

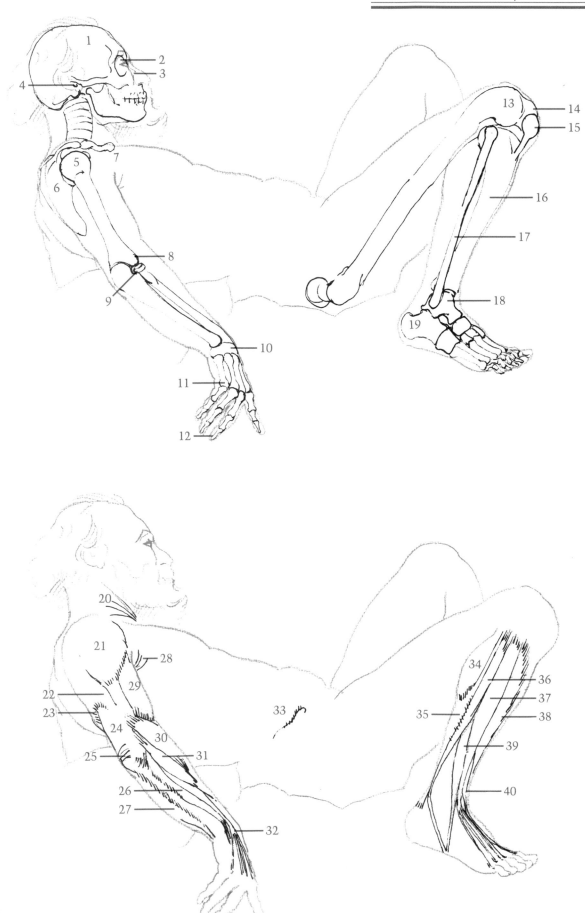

FEMALE FIGURE, FACE UP

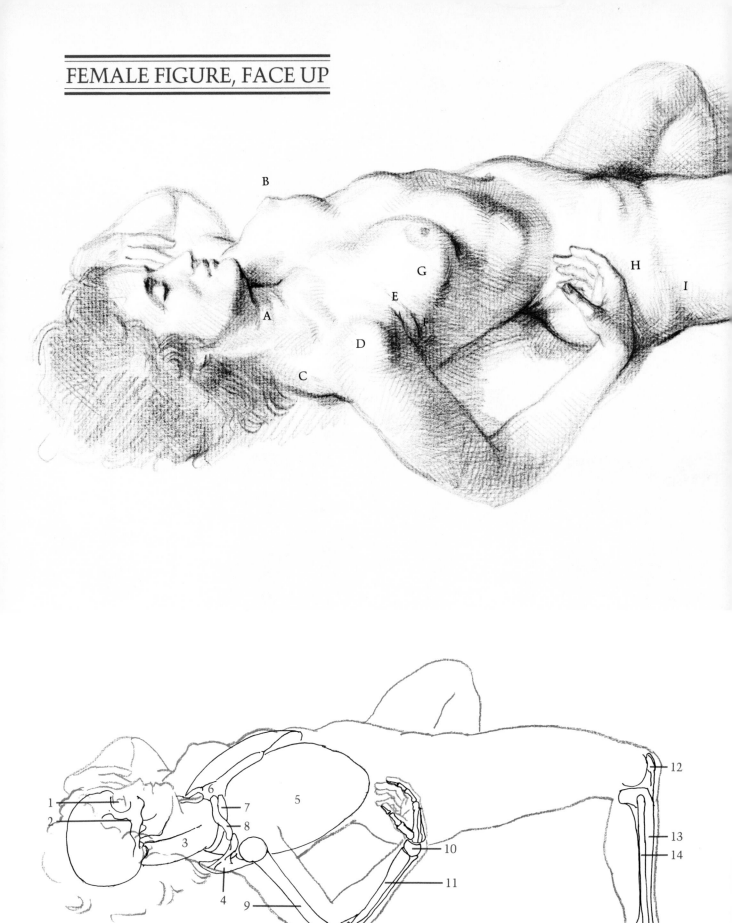

SURFACE ANATOMY

(A) So-called "Venus rings" are often seen on females. (B) Nipples point out, away from center of body. (C) Trapezius wraps around from back and creates convex curve at shoulder. (D) Head of humerus pushes through muscles. (E) Fat folds under arm on top of pectoralis. (F) Oval breast form has "tail" that dissipates under arm. (G) Breasts flatten because of pull of gravity. (H) Female fat covers muscles and bones of hips. (I) Fat shows on outside of thigh. (J) Kneecap attaches to tibia. (K) Fibula bulges on outside of ankle. (L) Three pads determine contour of outside of foot.

BONES

(1) Eye socket. (2) Cheekbone. (3) Spinal column. (4) Scapula wraps around to meet clavicle. (5) Rib cage. Note shape in foreshortened view. (6) Sternum. (7) First rib attaches to sternum, goes up under clavicle, inserts into spinal column. (8) Clavicle. (9) Humerus. (10) Radius. (11) Bones of wrist. (12) Kneecap. (13) Tibia. (14) Fibula. (15) Talus. (16) Heel bone protrudes well behind ankle.

MUSCLES

(17) Trapezius. (18) Rings on female neck are often called "Venus rings." (19) Nipples point out, away from center of torso. (20) Breasts flatten due to gravity. (21) Fat folds appear on top of pectoralis. (22) Rib cage cavity. (23) Navel is deep set. (24) Female fat accumulates on hips. (25) Female fat develops on outside of thigh. (26) Biceps femoris. (27) Gastrocnemius. (28) Soleus. (29) Achilles tendon is strongly defined. (30) Long peroneus.

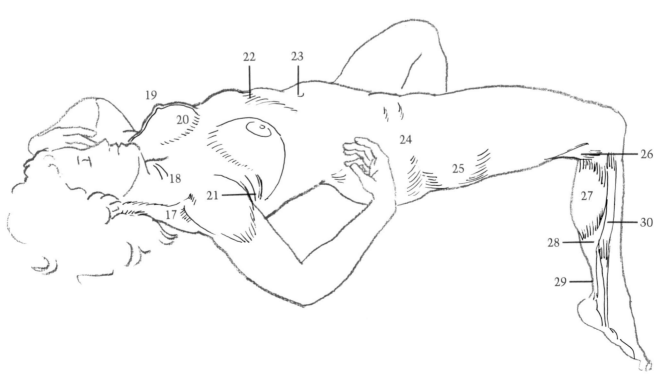

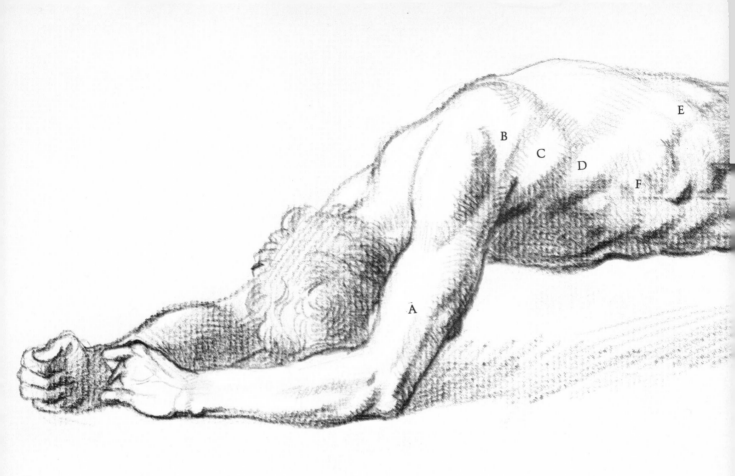

SURFACE ANATOMY

(A) Edge of brachialis appears as straight ridge down side of arm. Muscles of scapula—(B) infraspinatus and (C) teres major—insert into extended arm. (D) Latissimus dorsi inserts into arm and forms back of armpit. (E) Ribs show through thin latissimus dorsi. (F) Serratus shows clearly on slender figure. (G) Upset down "V" shaped depression shows between muscles. (H) Hip protrudes on most males. (I) Sartorius divides upper thigh diagonally. (J) Outside end of femur creates sharp edge. (K) Note round inside of knee. (L) Kneecap shows attachment of rectus femoris.

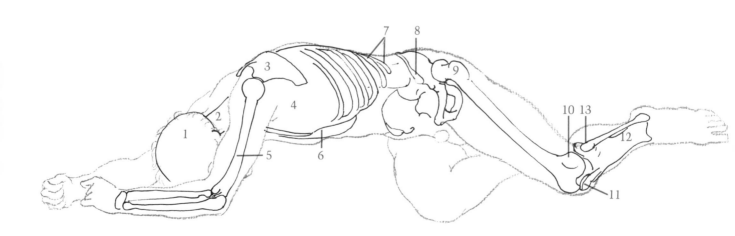

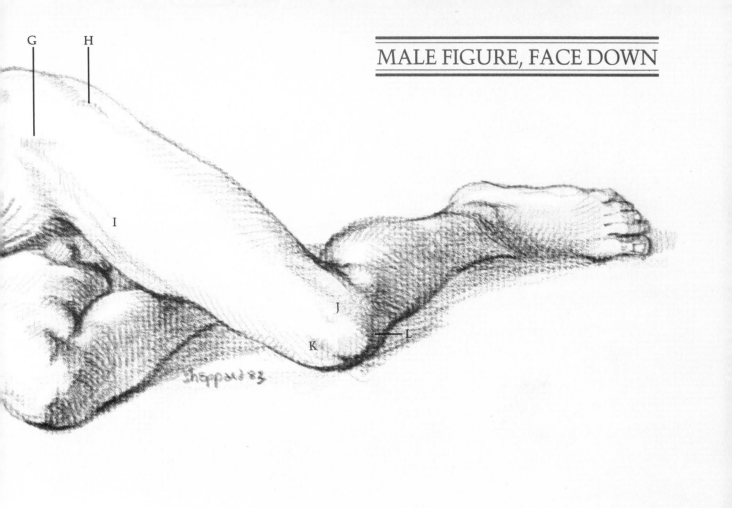

BONES

(1) Skull. (2) Spinal column. (3) Scapula rises above contour of back. (4) Rib cage. (5) Humerus. (6) Far side of rib cage. (7) Two floating ribs. (8) Top ridge of crest of pelvis. (9) Hipbone protrudes. (10) Outside edge of femur end. (11) Kneecap. (12) Tibia. (13) Head of fibula shows distinctly.

MUSCLES

(14) Brachialis. (15) Biceps. (16) Trapezius. (17) Deltoid. (18) Triceps. (19) Infraspinatus and (20) teres major are clearly defined. (21) Latissimus dorsi stretches with arm movement. (22) Pectoralis. (23) Serratus. (24) Rectus abdominis. (25) External oblique reveals ribs showing through muscle. (26) Gluteus. (27) Tensor fasciae latae. (28) Iliotibial band. (29) Vastus. (30) Rectus femoris produces fullness on front of thigh.

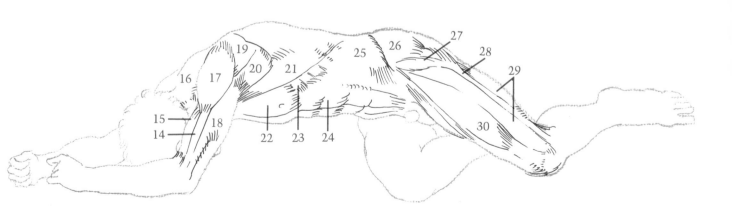

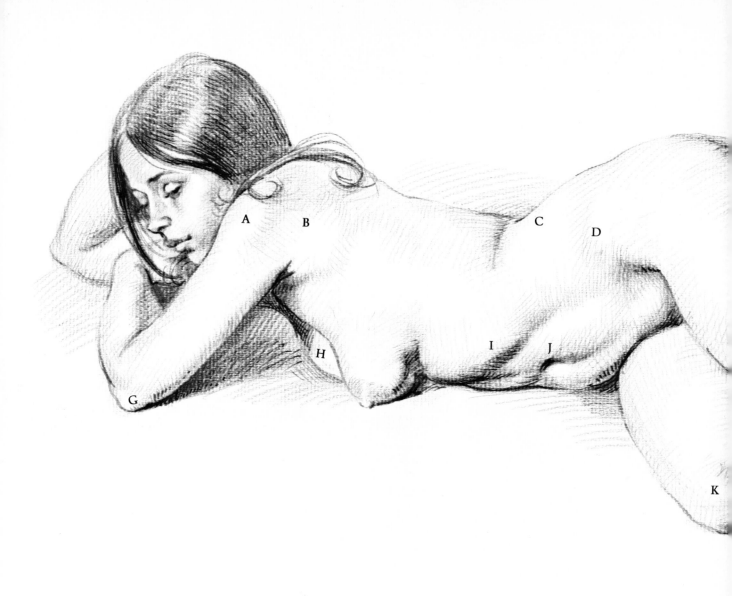

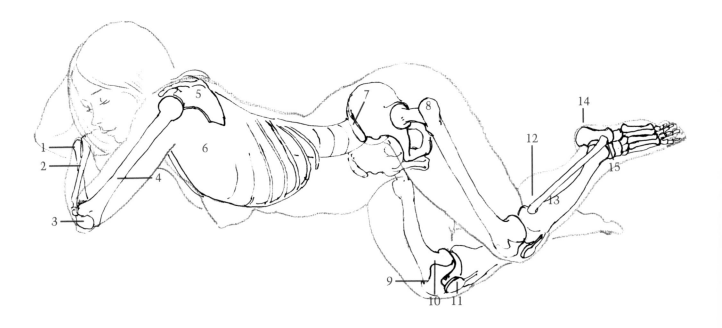

FEMALE FIGURE, FACE DOWN

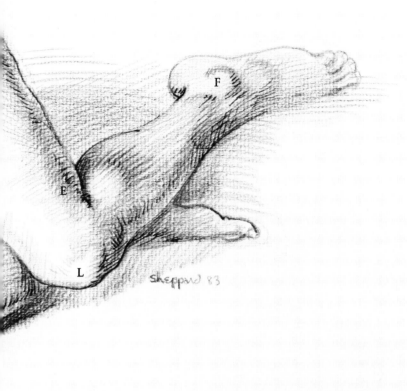

SURFACE ANATOMY

An even layer of body fat is quite common on females, covering most bones except at wrist, elbow, knee, and ankle. Fat hides muscle definition, but usually follows shape of muscles beneath. Body forms become rounded, without straight lines. (A) Deltoid is slightly defined. (B) Group of scapula muscles appear as one unit. (C) Fat covers external oblique, making waist high. (D) Pelvic crest is hardly visible. (E) Fat deposits appear under buttocks and back of knee. (F) End of fibula is prominent bulge. (G) Hook of ulna produces point at elbow. (H) Breasts are soft and flatten against supporting surface. (I) Cavity of rib cage is evident even on fleshy figure. (J) Navel is set deep in belly. (K) Vastus (over femur) causes high, round from on inside of knee. (L) Outside contour of condyle of femur is softened by female fat.

BONES

(1) Ulna is crossed by radius. (2) Radius appears outside elbow, on thumb side at waist. (3) Hook of ulna. (4) Humerus. (5) Scapula. (6) Rib cage. (7) Pelvic crest. (8) Hipbone. (9) Outside condyle of end of femur and (10) inside condyle of end of femur ride on flat surface of head of tibia. (11) Kneecap. (12) Fibula. (13) Tibia. (14) Heel bone. (15) Talus.

MUSCLES

(16) Deltoid is just slightly defined. (17) Group of scapula muscles. (18) Hip fat covers external oblique and gluteus. (19) Pelvic crest. (20) Upper outline of breast is long, slow curve to nipple. (21) Under outline is short, sharp curve. (22) Navel is set deep in belly. (23) Rectus femoris disappears in fat of thigh. (24) Sartorius and (25) adductors are covered by fat bulge on inside of knee. (26) Inside of thigh is pushed out by pressure of other leg. (27) Fat deposit appears under buttock. (28) Fat deposit shows behind knee. (29) Vastus overlaps inside condyle of femur.

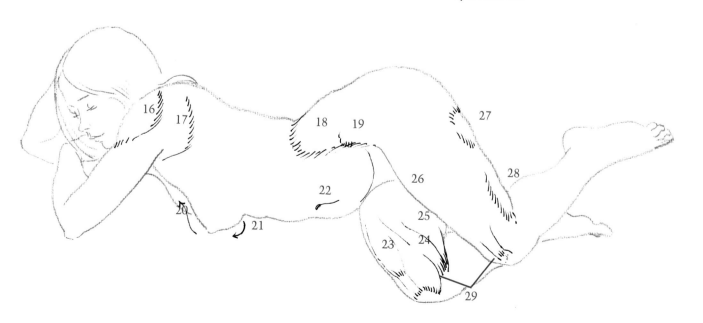

TWISTING FIGURE

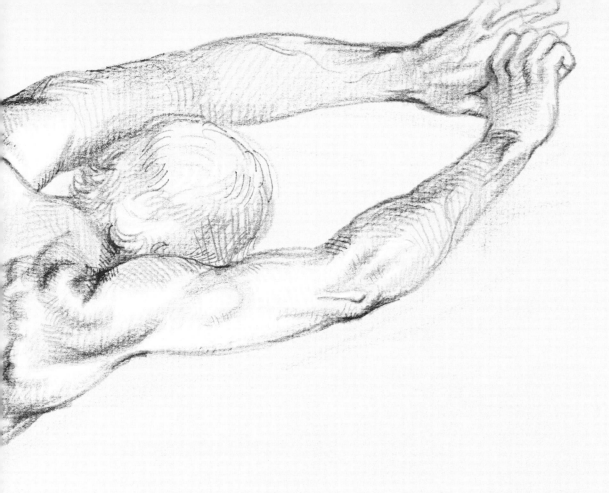

Twisting poses include more than one view
of the body, such as a side view of the hips
and back view of the shoulders or a back view
of pelvis with side view of the shoulders.
These complex positions are made possible
by the flexibility of the spinal column.

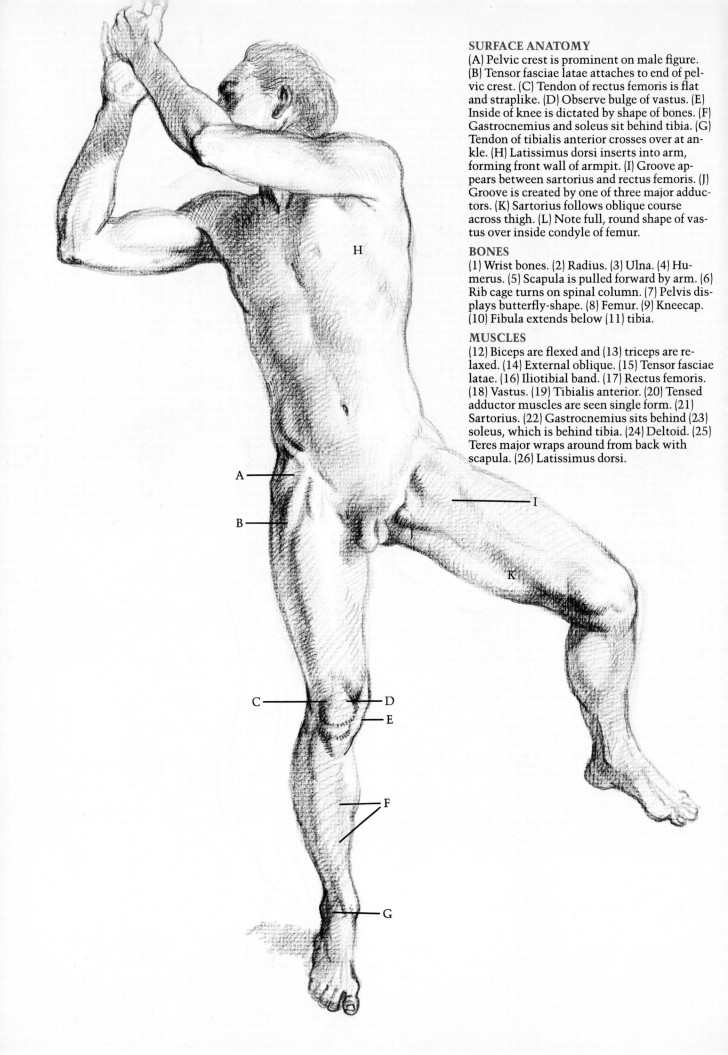

SURFACE ANATOMY

(A) Pelvic crest is prominent on male figure. (B) Tensor fasciae latae attaches to end of pelvic crest. (C) Tendon of rectus femoris is flat and straplike. (D) Observe bulge of vastus. (E) Inside of knee is dictated by shape of bones. (F) Gastrocnemius and soleus sit behind tibia. (G) Tendon of tibialis anterior crosses over at ankle. (H) Latissimus dorsi inserts into arm, forming front wall of armpit. (I) Groove appears between sartorius and rectus femoris. (J) Groove is created by one of three major adductors. (K) Sartorius follows oblique course across thigh. (L) Note full, round shape of vastus over inside condyle of femur.

BONES

(1) Wrist bones. (2) Radius. (3) Ulna. (4) Humerus. (5) Scapula is pulled forward by arm. (6) Rib cage turns on spinal column. (7) Pelvis displays butterfly-shape. (8) Femur. (9) Kneecap. (10) Fibula extends below (11) tibia.

MUSCLES

(12) Biceps are flexed and (13) triceps are relaxed. (14) External oblique. (15) Tensor fasciae latae. (16) Iliotibial band. (17) Rectus femoris. (18) Vastus. (19) Tibialis anterior. (20) Tensed adductor muscles are seen single form. (21) Sartorius. (22) Gastrocnemius sits behind (23) soleus, which is behind tibia. (24) Deltoid. (25) Teres major wraps around from back with scapula. (26) Latissimus dorsi.

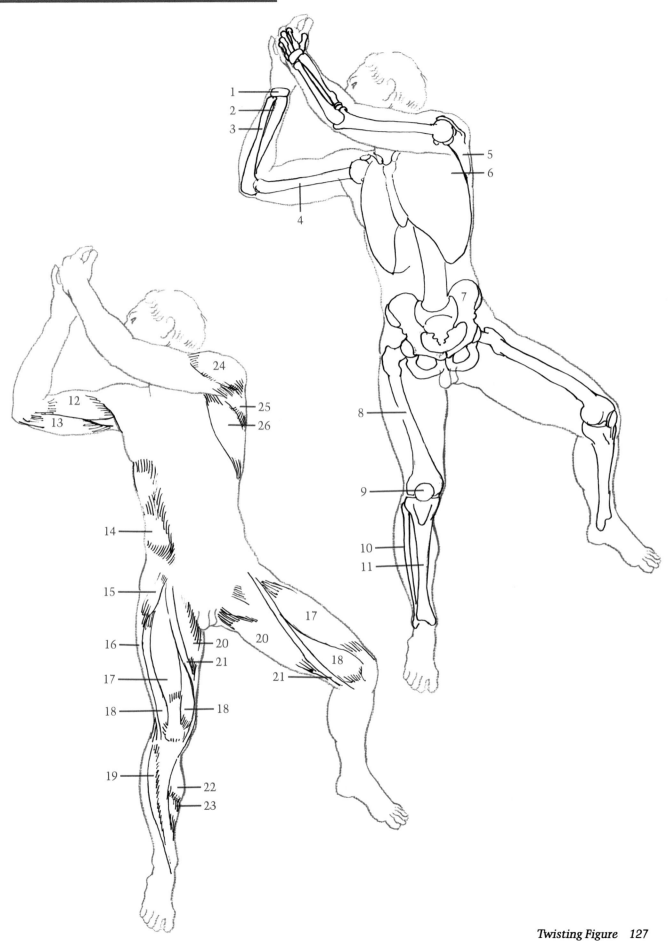

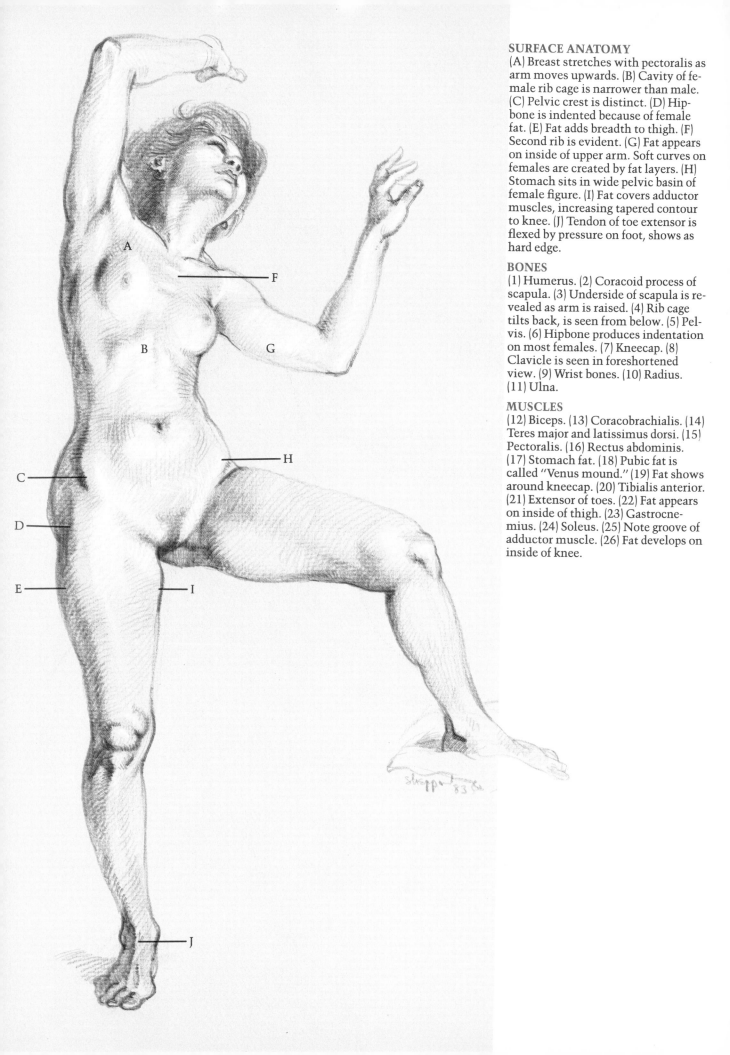

SURFACE ANATOMY
(A) Breast stretches with pectoralis as arm moves upwards. (B) Cavity of female rib cage is narrower than male. (C) Pelvic crest is distinct. (D) Hipbone is indented because of female fat. (E) Fat adds breadth to thigh. (F) Second rib is evident. (G) Fat appears on inside of upper arm. Soft curves on females are created by fat layers. (H) Stomach sits in wide pelvic basin of female figure. (I) Fat covers adductor muscles, increasing tapered contour to knee. (J) Tendon of toe extensor is flexed by pressure on foot, shows as hard edge.

BONES
(1) Humerus. (2) Coracoid process of scapula. (3) Underside of scapula is revealed as arm is raised. (4) Rib cage tilts back, is seen from below. (5) Pelvis. (6) Hipbone produces indentation on most females. (7) Kneecap. (8) Clavicle is seen in foreshortened view. (9) Wrist bones. (10) Radius. (11) Ulna.

MUSCLES
(12) Biceps. (13) Coracobrachialis. (14) Teres major and latissimus dorsi. (15) Pectoralis. (16) Rectus abdominis. (17) Stomach fat. (18) Pubic fat is called "Venus mound." (19) Fat shows around kneecap. (20) Tibialis anterior. (21) Extensor of toes. (22) Fat appears on inside of thigh. (23) Gastrocnemius. (24) Soleus. (25) Note groove of adductor muscle. (26) Fat develops on inside of knee.

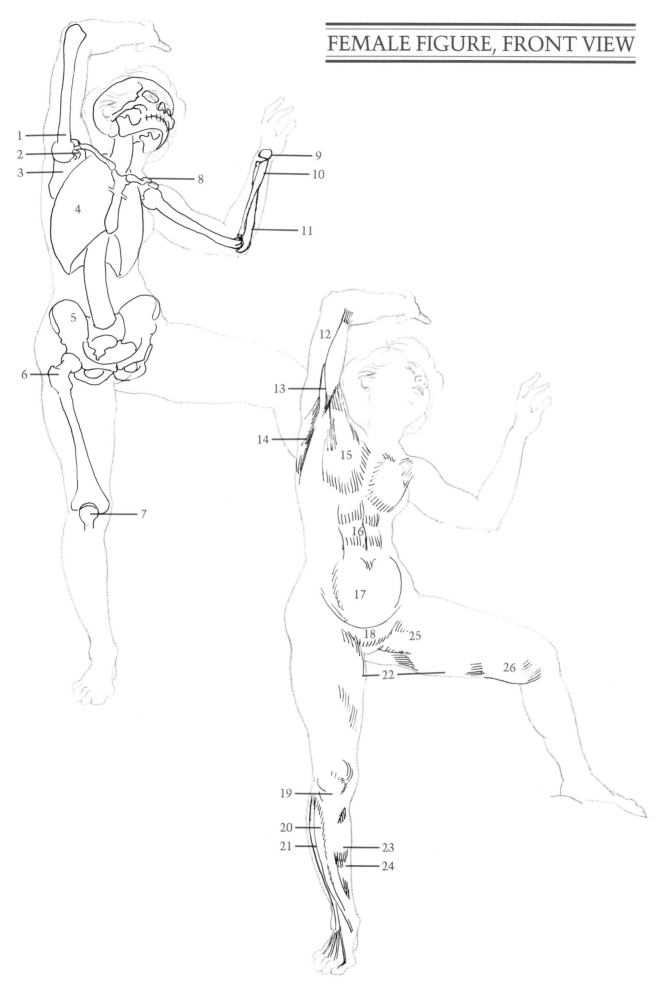

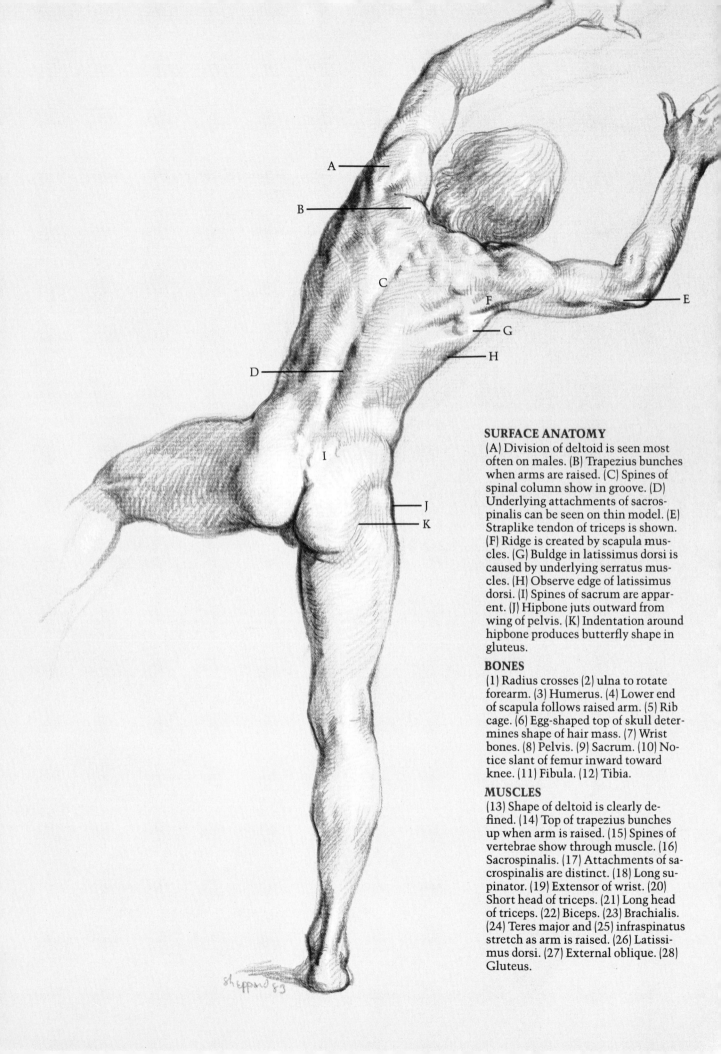

SURFACE ANATOMY

(A) Division of deltoid is seen most often on males. (B) Trapezius bunches when arms are raised. (C) Spines of spinal column show in groove. (D) Underlying attachments of sacrospinalis can be seen on thin model. (E) Straplike tendon of triceps is shown. (F) Ridge is created by scapula muscles. (G) Buldge in latissimus dorsi is caused by underlying serratus muscles. (H) Observe edge of latissimus dorsi. (I) Spines of sacrum are apparent. (J) Hipbone juts outward from wing of pelvis. (K) Indentation around hipbone produces butterfly shape in gluteus.

BONES

(1) Radius crosses (2) ulna to rotate forearm. (3) Humerus. (4) Lower end of scapula follows raised arm. (5) Rib cage. (6) Egg-shaped top of skull determines shape of hair mass. (7) Wrist bones. (8) Pelvis. (9) Sacrum. (10) Notice slant of femur inward toward knee. (11) Fibula. (12) Tibia.

MUSCLES

(13) Shape of deltoid is clearly defined. (14) Top of trapezius bunches up when arm is raised. (15) Spines of vertebrae show through muscle. (16) Sacrospinalis. (17) Attachments of sacrospinalis are distinct. (18) Long supinator. (19) Extensor of wrist. (20) Short head of triceps. (21) Long head of triceps. (22) Biceps. (23) Brachialis. (24) Teres major and (25) infraspinatus stretch as arm is raised. (26) Latissimus dorsi. (27) External oblique. (28) Gluteus.

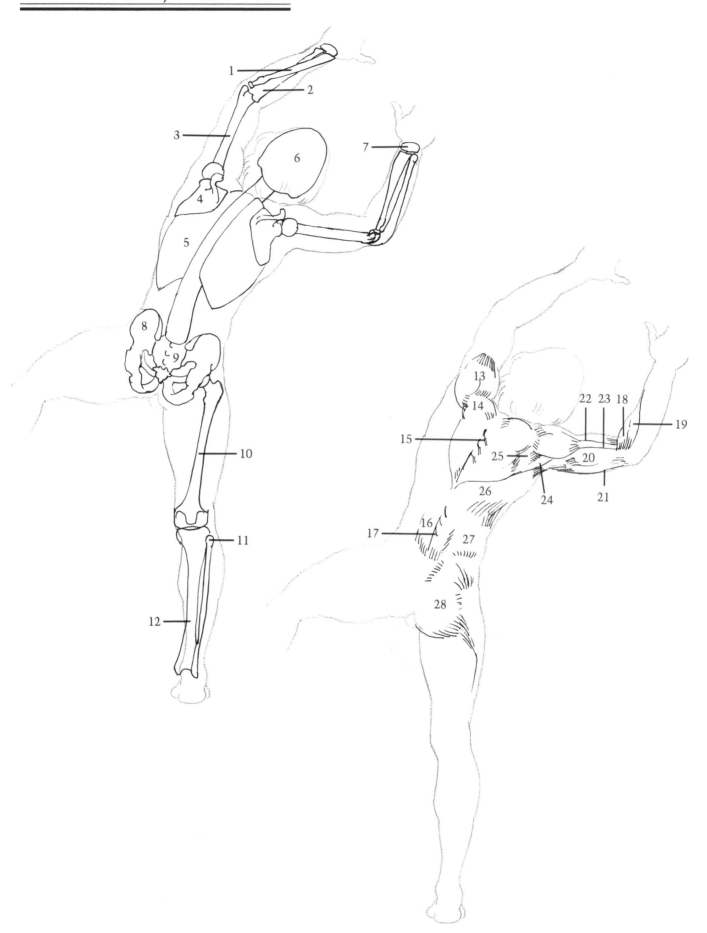

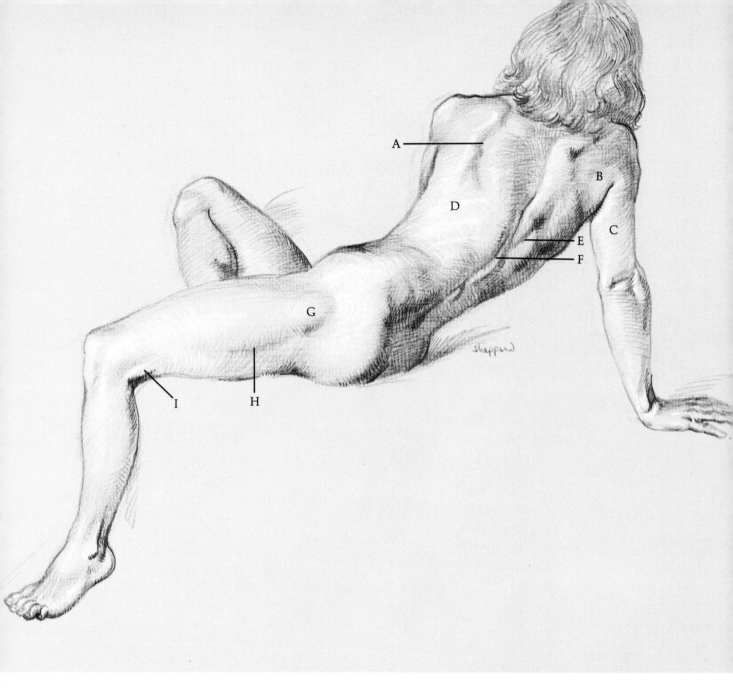

SURFACE ANATOMY

(A) Edge of scapula protrudes when arm is forward. (B) Group of scapula muscles are seen as mass. (C) Triceps appear as one unit. (D) Ribs show on thin female figure. (E) Trapezius inserts into middle of back. (F) Note ridge of spines of spinal column. (G) Hipbone shows attachment to vastus—protrudes as round bulge. (H) Edge of vastus shows as valley under bulge. (I) Biceps femoris tendon produces sharp edge.

BONES

(1) Skull. (2) Scapula turns toward front with arm. (3) Scapula turns toward back with arm. (4) Humerus. (5) Radius. (6) Ulna. (7) Wrist bones. (8) Rib cage. (9) Ribs. (10) Spinal column twists and curves. (11) Sacrum curves inward and disappears between buttocks. (12) Pelvic crest is very important in thin figure. (13) Femur. (14) Kneecap. (15) Tibia. (16) Fibula.

MUSCLES

(17) Trapezius is bunched on side where arm pulls back, but stretches on side where arm pulls forward. (18) External oblique. (19) Sacrospinalis. (20) Gluteus is still round on thin female figure, but would be flatter on male. (21) Tensor fasciae latae. (22) Sartorius. (23) Rectus femoris determines round contour of thigh. (24) Tendon of rectus femoris. (25) Vastus. (26) Iliotibial band. (27) Biceps femoris. (28) Kneecap ligament. (29) Tibialis anterior. (30) Extensor of toes. (31) Long peroneus.

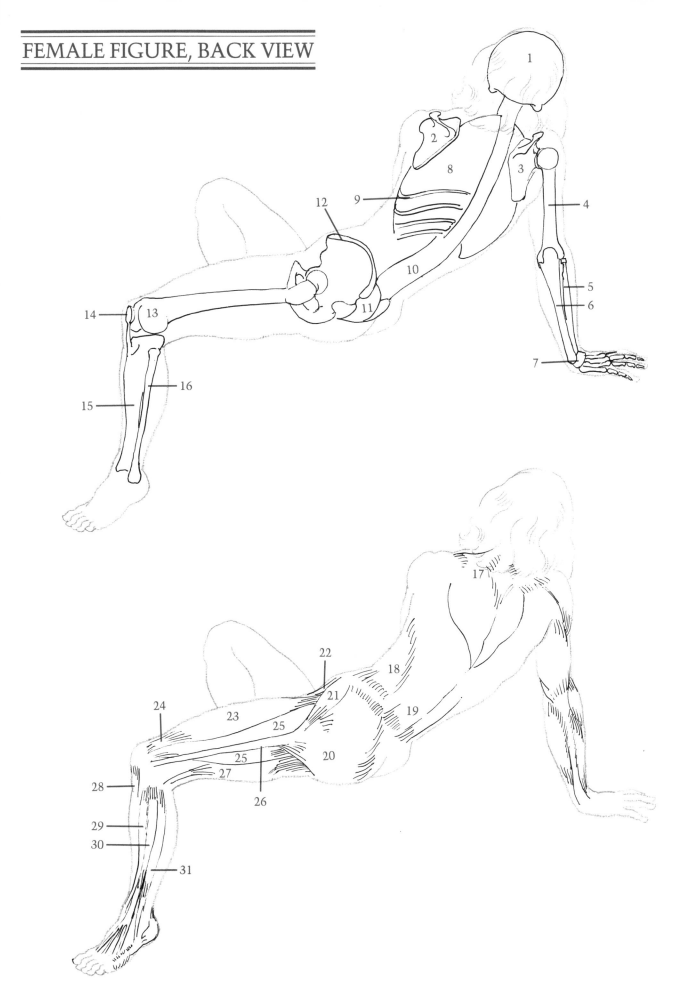

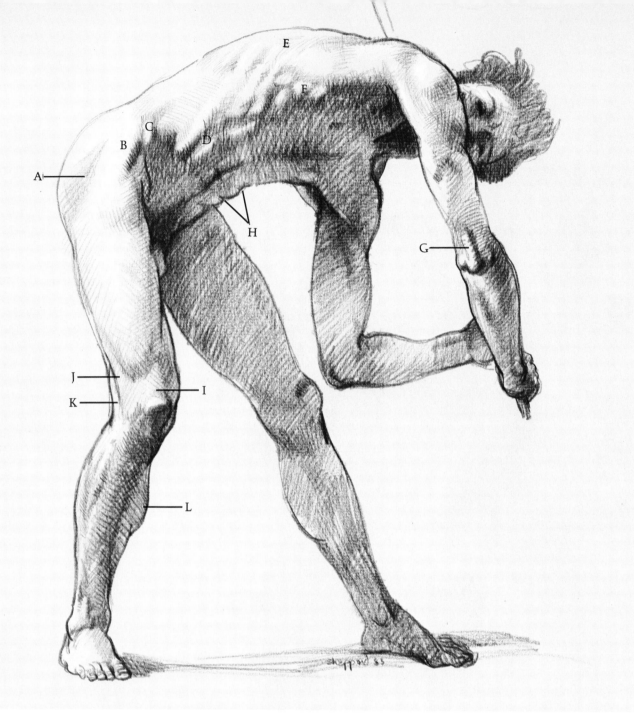

SURFACE ANATOMY

(A) Hipbone causes indentation. (B) Tensor fasciae latae crosses over in front of hipbone. (C) Crest of pelvis is evident. (D) Thickness of rectus abdominis can be seen. (E) Ribs show through lattisimus dorsi. (F) Serratus interlocks with fingerlike insertions of external oblique. (G) Note thickness of triceps tendon. (H) Rectus abdominis displays folds at bottom of rib cage and navel. (I) Tendon of rectus femoris is flat and straplike. (J) Tendon of iliotibial band and (K) tendon of biceps attach on outside of knee. (L) Muscle group on inside of leg sits behind tibia.

BONES

(1) Crest of pelvis. (2) Ribs slant down from back to front. (3) Scapula forms socket for head of humerus. (4) Head of humerus is ball-shaped. (5) End of humerus causes bump on inside of elbow. (6) Note hook-shape of head of ulna. (7) Head of radius. (8) Ulna is prominent at wrist. Both radius and ulna are shown in foreshortened view. (9) Clavicle angles back from base of neck. (10) Hipbone. (11) End of femur. (12) Kneecap. (13) Head of tibia. (14) Head of fibula. (15) Outside end of tibia.

MUSCLES

(16) Tensor fasciae latae. (17) Sacrospinalis. (18) Observe thickness of rectus abdominis. (19) External oblique inserts into ribs and interlocks with serratus. (20) Serratus. (21) Latissimus dorsi. (22) Teres major. (23) Infraspinatus. (24) Deltoid. (25) Triceps. (26) Triceps tendon is straplike. (27) Folds appear in rectus abdominis at ribs and navel. (28) Outside of vastus. (29) Rectus femoris. (30) Inside of vastus. (31) Straplike tendon of rectus femoris attaches to kneecap. (32) Iliotibial band. (33) Biceps tendon attaches to head of fibula. (34) Long peroneus. (35) Long extensor of toes. (36) Tibialis anterior. (37) Bones form angle on inside of knee. (38) Big-toe extensor.

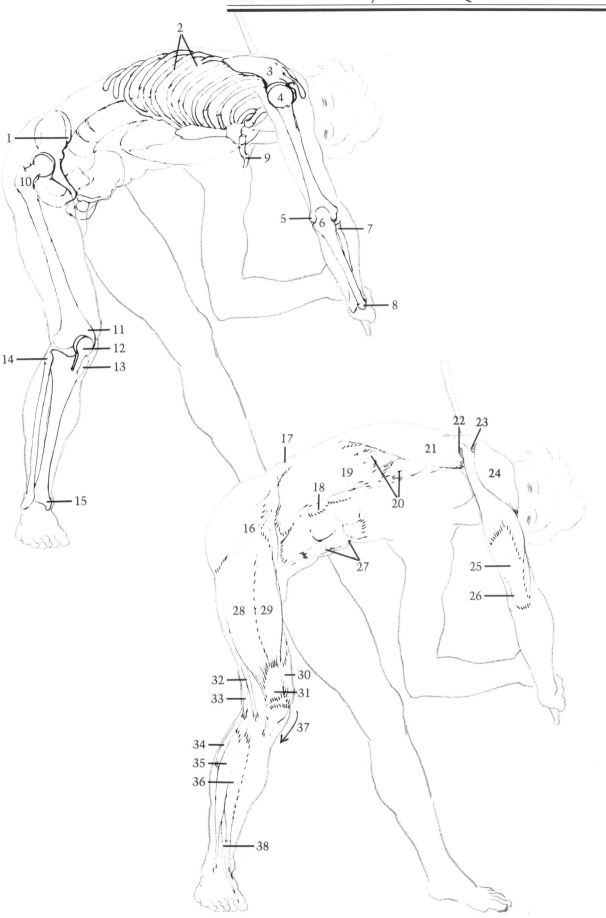

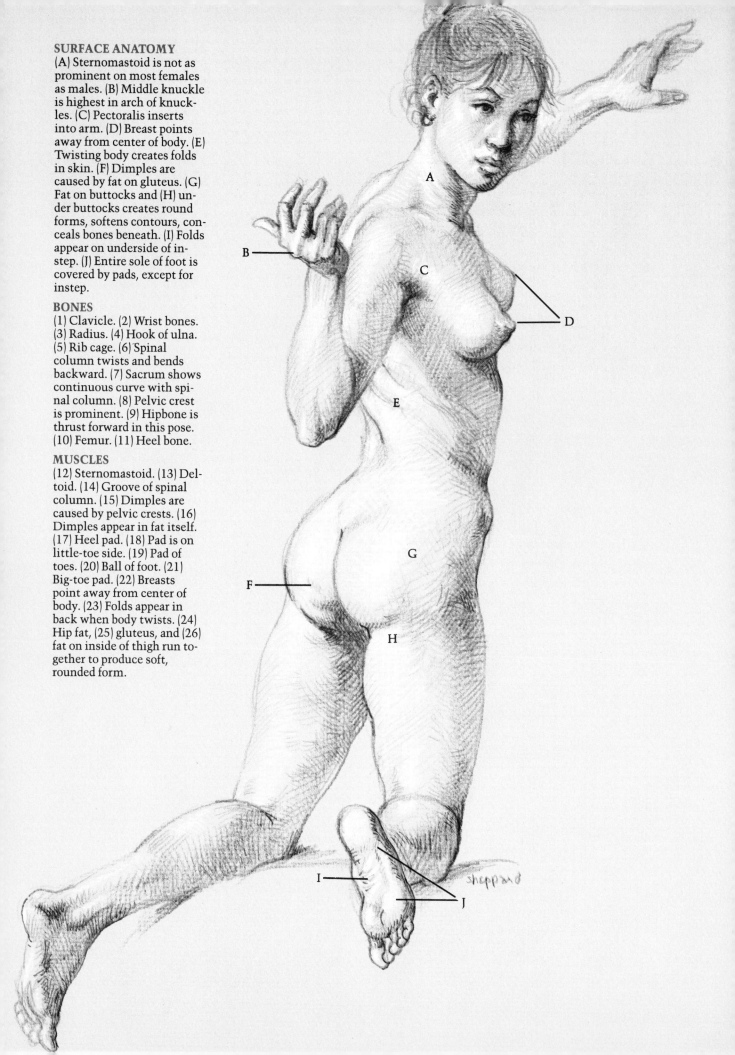

SURFACE ANATOMY

(A) Sternomastoid is not as prominent on most females as males. (B) Middle knuckle is highest in arch of knuckles. (C) Pectoralis inserts into arm. (D) Breast points away from center of body. (E) Twisting body creates folds in skin. (F) Dimples are caused by fat on gluteus. (G) Fat on buttocks and (H) under buttocks creates round forms, softens contours, conceals bones beneath. (I) Folds appear on underside of instep. (J) Entire sole of foot is covered by pads, except for instep.

BONES

(1) Clavicle. (2) Wrist bones. (3) Radius. (4) Hook of ulna. (5) Rib cage. (6) Spinal column twists and bends backward. (7) Sacrum shows continuous curve with spinal column. (8) Pelvic crest is prominent. (9) Hipbone is thrust forward in this pose. (10) Femur. (11) Heel bone.

MUSCLES

(12) Sternomastoid. (13) Deltoid. (14) Groove of spinal column. (15) Dimples are caused by pelvic crests. (16) Dimples appear in fat itself. (17) Heel pad. (18) Pad is on little-toe side. (19) Pad of toes. (20) Ball of foot. (21) Big-toe pad. (22) Breasts point away from center of body. (23) Folds appear in back when body twists. (24) Hip fat, (25) gluteus, and (26) fat on inside of thigh run together to produce soft, rounded form.

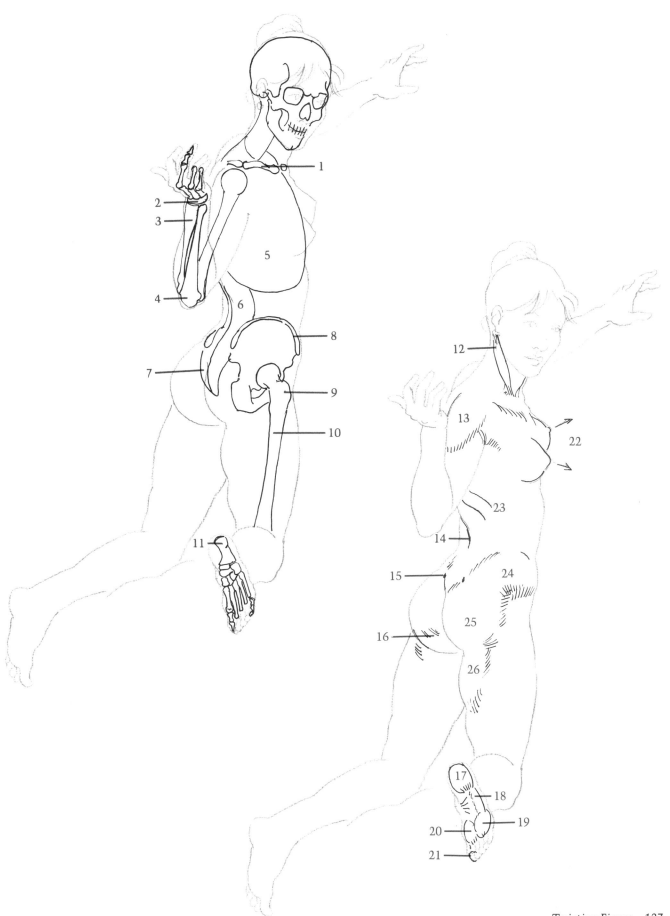

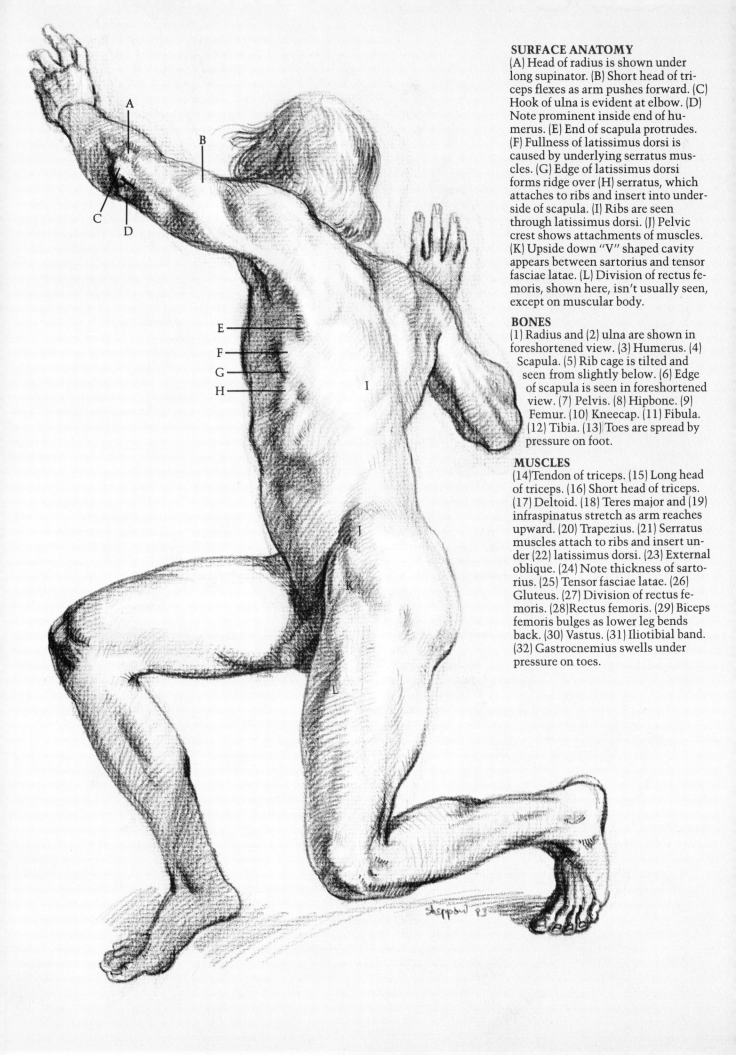

SURFACE ANATOMY

(A) Head of radius is shown under long supinator. (B) Short head of triceps flexes as arm pushes forward. (C) Hook of ulna is evident at elbow. (D) Note prominent inside end of humerus. (E) End of scapula protrudes. (F) Fullness of latissimus dorsi is caused by underlying serratus muscles. (G) Edge of latissimus dorsi forms ridge over (H) serratus, which attaches to ribs and insert into underside of scapula. (I) Ribs are seen through latissimus dorsi. (J) Pelvic crest shows attachments of muscles. (K) Upside down "V" shaped cavity appears between sartorius and tensor fasciae latae. (L) Division of rectus femoris, shown here, isn't usually seen, except on muscular body.

BONES

(1) Radius and (2) ulna are shown in foreshortened view. (3) Humerus. (4) Scapula. (5) Rib cage is tilted and seen from slightly below. (6) Edge of scapula is seen in foreshortened view. (7) Pelvis. (8) Hipbone. (9) Femur. (10) Kneecap. (11) Fibula. (12) Tibia. (13) Toes are spread by pressure on foot.

MUSCLES

(14) Tendon of triceps. (15) Long head of triceps. (16) Short head of triceps. (17) Deltoid. (18) Teres major and (19) infraspinatus stretch as arm reaches upward. (20) Trapezius. (21) Serratus muscles attach to ribs and insert under (22) latissimus dorsi. (23) External oblique. (24) Note thickness of sartorius. (25) Tensor fasciae latae. (26) Gluteus. (27) Division of rectus femoris. (28) Rectus femoris. (29) Biceps femoris bulges as lower leg bends back. (30) Vastus. (31) Iliotibial band. (32) Gastrocnemius swells under pressure on toes.

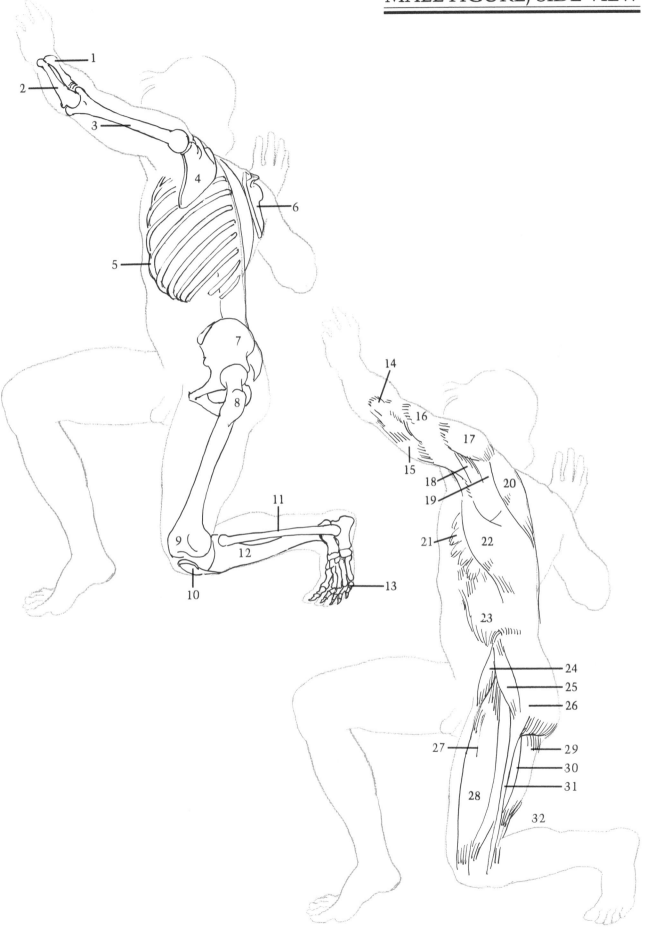

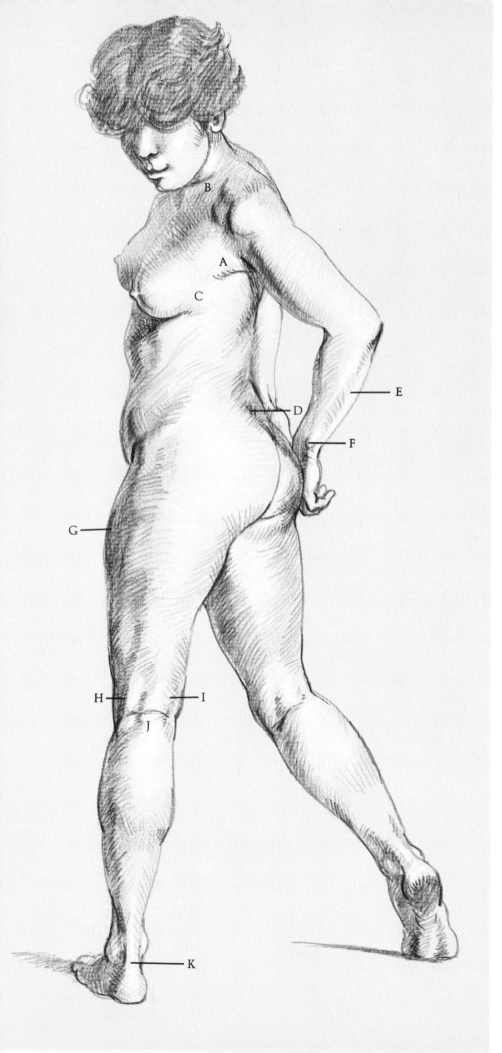

SURFACE ANATOMY
(A) Pectoralis runs from breast to underarm. (B) Clavicle is almost completely covered by fat. (C) Breast has axillary tail that attaches over serratus muscles. (D) Dimples are produced by end of pelvic crest. (E) Flexors behind ulna bone. (F) End of ulna. (G) Fat is shown on flank. (H) Biceps femoris, (I) semitendinosus and (J) crease in back of knee create "H" shape. (K) Achilles tendon attaches to heel.

BONES
(1) Clavicle. (2) Scapula (shoulder blade) dictates contour of upper back. (3) Humerus. (4) Hook of ulna. (5) Radius. (6) Note flat shape of wrist bones between forearm and hand. (7) Rib cage. (8) Pelvis. (9) Hipbone protrudes, but is covered by fat layer. (10) Fibula. (11) Tibia. (12) Talus. (13) Heel bone is shaped like ball.

MUSCLES
(14) Deltoid. (15) Biceps. (16) Long supinator. (17) Flexors. (18) Extensors. (19) Pectoralis is broad, curving plane. (20) Breast points outward toward side, away from center of torso. (21) Axillary tail of breast runs over serratus muscles. (22) External oblique. (23) Fat appears on pelvic area and smooths out form. (24) Biceps femoris. (25) Semitendinosus. (26) Note "H" shape. (27) Gastrocnemius runs into (28) soleus, which attaches to (29) Achilles tendon, which attaches to (30) heel pad.

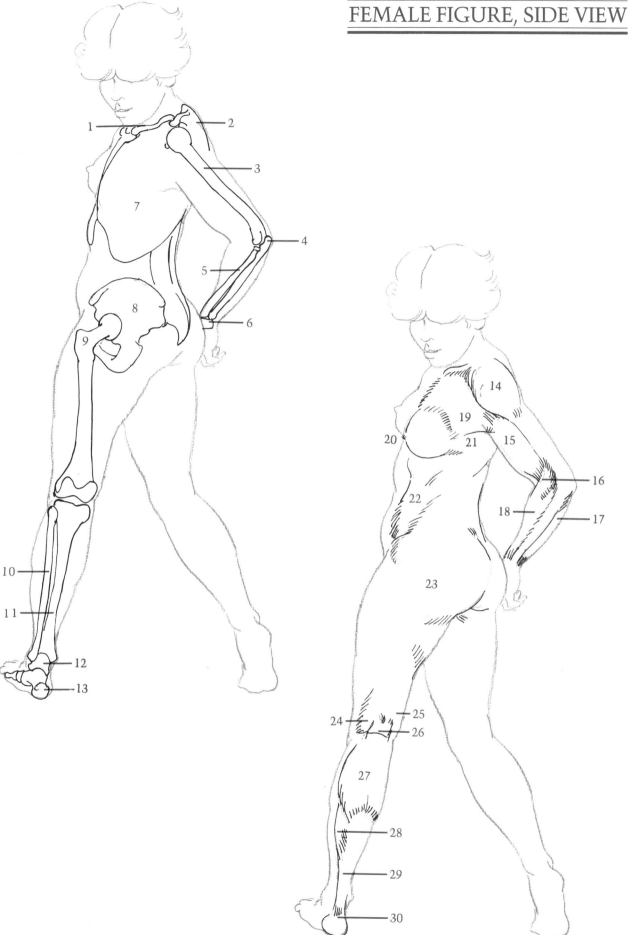

SUGGESTED READING

Marsh, Reginald. *Anatomy for Artists.* Dover 1970.

Peck, Stephen Rogers. *Atlas of Human Anatomy for the Artist.* New York: Oxford University Press, 1951.

Richer, Paul. *Artistic Anatomy.* Translated and edited by Robert Beverly Hale. New York: Watson-Guptill, 1971. London: Pitman 1973.

de C. M. Saunders, J. B. and O'Malley, Charles D. *The Illustrations from the Works of Andreas Vesalius.* Cleveland, Ohio: The World Publishing Company 1950.

Sheppard, Joseph. *Anatomy: A Complete Guide for Artists.* New York: Watson-Guptill, 1975. London: Pitman, 1975.

Sheppard, Joseph. *Drawing the Female Figure.* New York: Watson-Guptill, 1975. London: Pitman, 1975.

Sheppard, Joseph. *Drawing the Male Figure.* New York: Watson-Guptill, 1976. London: Pitman, 1976